Avoiding the Subject

Avoiding the Subject

Media, Culture and the Object

Justin Clemens
Dominic Pettman

AMSTERDAM UNIVERSITY PRESS

Cover illustration: Merritt Symes

Cover design: Sabine Mannel, N.A.P., Amsterdam
Lay-out: PROgrafici, Goes

ISBN 90 5356 716 X
NUR 736

Table of Contents

Table op Contents

6

Acknowledgments

Some of these chapters have appeared in different incarnations in different journals and forums:

"A Break in Transmission: Art, Appropriation and Accumulation," first appeared in *GENRE* (a publication of the English Department, University of Oklahoma), vol. 34, no.3/4, Fall/Winter 2001, pp. 279-90.

A much shorter version of "Relations with Concrete Others (or How We Learned to Stop Worrying and Love the Berlin Wall)" is slated for the 21(5) issue of *Theory, Culture and Society*, October 2004.

"From September 11 to the 7-11: Popular Propaganda and the Internet's War on Terrorism," was published online in a somewhat different form at both *Largeur* magazine (translated into French by P. Grosjean, December 2001), and *Crikey* magazine, Australia – where it endured the title "Jihad for Dummies."

"The Floating Life of Fallen Angels: Unsettled Communities and Hong Kong Cinema," was first published in *Postcolonial Studies*, vol. 3, no.1, April 2000, pp. 69-80.

An earlier version of "Abandoned Commonplaces: Some Belated Thoughts on Big Brother" was first published as a catalogue essay to *Poly-Articulate*, a collaborative exhibition by J. Clemens, C. Henschke, J. Meade, and A. Trevillian at WestSpace Gallery Melbourne, October 2002.

An earlier version of "Sovereignty, Sacrifice and the Sacred in Contemporary Australian Politics" was presented at the Post Colonial Institute, University of Melbourne, May 25, 2000.

8

We gratefully acknowledge the financial assistance provided by an Australian Research Council Grant for Justin Clemens, Russell Grigg and Henry Krips; by the School of Communication and Creative Arts at Deakin University; by the Department of English with Cultural Studies at the University of Melbourne; and by the Australian Academy of the Humanities.

Dominic would like to thank "friends in deed" in vague spatio-temporal clusters. In Amsterdam, Thomas Elsaesser, Joost Bolten (and family), Wim Staat, Jan Simons, Catherine Lord, Richard Rogers and the AUP team. In Geneva, Rick Waswo, Michael Röösli, Pierrine Jan, Pierre Grosjean, Gabrielle Sigrist, and Charles Antoine-Courcoux.

There is also an "un-" or "dis-"placed group who serve as constant companions (actual and/or virtual) and regular sources of inspiration, including Wanda Strauven, Malte Hagener, Drehli Robnick, Gabu Heindl, Francesco Pitassio, Eddie Maloney, Kylie Matulick, Todd Mueller, Rob Crompton, Ned Rossiter, David Odell, and Steven Shaviro.

People in or around the academy who have shown generous and unflinching support include Geert Lovink, McKenzie Wark, Toby Miller, Simon During, and Wlad Godzich.

Notwithstanding the generosity of the aforementioned persons, journals, galleries and institutions, Justin would, above all, like to thank Rachel Hughes. If people still thought of texts as symbolic acts susceptible to varieties of human intervention, he would dedicate this book to her. He would also like to thank Geoff Boucher, Chris Feik, Oliver Feltham, Russell Grigg, Chris Henschke, Ann McCulloch, Henry Krips, John Meade, Michael Meehan, Peter Otto, Brian Stagoll and Andy Trevillian.

Others, who have not been listed here for a variety of reasons, are no doubt grateful that they have escaped this shame-by-association. It does not mean, however, that we are any less grateful to them.

The Influence of Anxiety

Introduction: The Influence of Anxiety

We now know that future presents will bring other things than the present future can express, and when we speak of the future we express this discrepancy by dealing only with probabilities or improbabilities.
 NIKLAS LUHMANN[1]

1. I Object

This is a book about objects. More precisely, it is about the fate of objects in the contemporary world. Such objects are extraordinarily peculiar, volatile cocktails of media, genres, things, forms, materials, fantasies and phantasms. This book tries to confront these objects with three sets of interrelated questions. First, what is the status of objects in a "virtual" world? How are they produced, distributed and consumed? How do they differ from previous "epochs of objectness"? Second, how is the status of affect transformed by these objects? What sorts of subjective investments in objects are now possible or impossible? And how are these affects mediated and dispersed across communities? Third, what are the emergent possibilities for thought and action given these new relations between objects and affects – especially when considered under the intersecting signs of "art," "politics" and "media"? We are, in other words, interested in the possibilities of tracking the mutations of contemporary objects and in discerning the political and aesthetic consequences of such mutations for and on human subjects. But we try to begin with the object.

"Object" is a peculiar word, and what it purports to designate is no less peculiar. Deriving from the Latin *obicere* – to throw against, to expose, to present, to cast, to hold up as a defence – the modern English *object*, as both noun and verb, retains the traces of this etymology. An object can be a thing presented or a thing external to the mind, an oppositional statement, a charge or accusation, an aim or goal, something upon which one operates, a grammatical category, an obstacle, and so on. This polyvalency entails both a certain incoherence and the proliferation of intransitive specializations. Philosophy, linguistics, theology, law, art, psychoanalysis, mathematics and logic, science and modern administration constitute and treat their "objects" in specific ways, which have little or nothing to do with

each other. Yet it is surely symptomatic that, in discourses as different as museum studies and fundamental ontology, there is today a widespread conviction that all traditional formulations and presentations of the object – no matter the specialization – have fallen into disrepute.[2]

So the difficulties are multiplied by the times. Whether one calls it risk society, postmodernity, late capitalism, a new imperium, or globalization, we currently find ourselves in the uncanny position of living in the future itself. The exhaustion of this situation does not necessarily signify a lack of social, political, or cultural dynamism or energy. On the contrary, such exhaustion seems to entail rapid, radical, unpredictable transformations in every department of existence. As Thomas Pepper notes: "To feel exhausted is to know that one is alive."[3] Such exhaustion suggests that these transformations occur at a threshold-without-beyond, where we are at once witness to the dissolution of the grounds of all traditional practices, yet incapable of progressing elsewhere. To advert to a suggestion of Giorgio Agamben's, today all remains in force – but without significance.[4]

Our guiding questions – inspired by meditations on the relationships between objects, media and politics – entail a certain diversity of objects and approaches. Since we are attempting to prognosticate from the scattered entrails of media culture, this very diversity can run the risk of appearing just as scattered. Our introduction briefly outlines some examples of the developments that necessitate a re-examination of the object. The line we follow is essentially that of post-Kantian, Romantic thought, which binds together aesthetics and politics according to conceptual axioms and methodologies which now seem to have reached their limit. It is at this limit that we attempt to position ourselves. Drawing on a now-familiar rogues' gallery of thinkers, such as Giorgio Agamben, Georges Bataille, Maurice Blanchot, Gilles Deleuze and Felix Guattari, Jacques Derrida, Martin Heidegger, Jacques Lacan, Philippe Lacoue-Labarthe and Jean-Luc Nancy, Jean-Paul Sartre and Slavoj Žižek, we isolate a number of key topics – objectum-sexuality, traumatology and hauntology, the political sacralisation of objects, public transport, do-it-yourself porno-propaganda, and electronic sampling – that will concern us throughout this book.

So let's begin with a preliminary delineation of the multi-dimensional force-fields that embody the dizzy realm of contemporary objects.

2. The Most Photographed Barn in America

In Don DeLillo's media-saturated novel *White Noise* (1984), the narrator, Jack Gladney, discovers a popular tourist attraction known as The Most Photographed

Barn in America. Along with his friend and colleague Murray, Jack makes a pilgrimage to this minor postmodern Mecca. Once they arrive, these two culturally sensitive professors attempt to take in the spectacle (or lack of) as best they can. Murray, however, soon insists that "No one sees the barn":

> "Once you've seen the signs about the barn, it becomes impossible to see the barn."
>
> He fell silent once more. People with cameras left the elevated site, replaced at once by others.
>
> "We're not here to capture an image, we're here to maintain one. Every photograph reinforces the aura. Can you feel it, Jack? An accumulation of nameless energies."
>
> There was an extended silence. The man in the booth sold postcards and slides.
>
> "Being here is a kind of spiritual surrender. We see only what the others see. The thousands who were here in the past, those who will come in the future. We've agreed to be part of a collective perception. This literally colors our vision. A religious experience in a way, like all tourism."[5]

Unlike those fairground fakers – who claim to be able to capture your personal aura for five dollars – these tourist photographs won't reveal a halo of gaudy colours around the object, but a banal reproduction of the "barn itself," whatever that may mean in the age of mechanical reproduction, and, moreover, digital simulation.

> "What was the barn like before it was photographed?" asks Murray. "What did it look like, how was it different from other barns, how was it similar to other barns? We can't answer these questions because we've read the signs, seen the people snapping the pictures. We can't get outside the aura. We're part of the aura. We're here, we're now."

In our own post-Benjaminian mediascape, the question of "aura" is a particularly vexed and elusive one, threading itself both between and within every claim for authenticity, attraction, excitement or interest. Indeed, it could be claimed that the entire marketing industry is a mega-machine designed to produce the simulation of lost aura – a frantic attempt to fabricate the kind of magnetic presence that today's objects simply do not possess. This is partly due to their ubiquity and conformity, but also because of the reified methods which brought these objects into being in the first place.[6]

Prior to its replication, the auratic object represents more than just a useful

or (fleetingly) desirable object, but an opaque doorway to "something else". Something seductive and beckoning, both intimate and aloof – whether we think of it in the terms of Rilke's archaic torso or Lacan's sardine can.[7] Something beyond the boring, everyday world, yet at once immured within it. An alien trophy or souvenir. Or even an ambassador from another time, another space, another – less alienated, more considered and selective – way of being. The aura of an object compels attention: "as if it had the power to look back in return" (Benjamin).

Indeed, we can better appreciate the notion of aura by visiting another compelling monument: Stanley Kubrick's and Arthur C. Clarke's monolith in *2001: A Space Odyssey*. In a certain sense, this indecipherably alien black slab lies at the opposite end of a continuum from DeLillo's Most Photographed Barn in America. The monolith is not preceded by freeway billboards, or word-of-mouth hype; and once people (or chimps) are confronted with its presence, they *cannot help* but see it, interact with it, attempt to grasp it through the sense of touch. Moreover, in one almost comical scene, the astronauts who first come in contact with the monolith attempt to take a group photo in front of this mysterious object. But before the camera can capture the moment, the monolith emits a piercing shriek, like an interstellar car alarm, preventing the picture from being taken. (A scene which obviously echoes the superstition – either real or attributed – that certain non-Western peoples believe photography "steals the soul" of its subject.) The utterly unnatural monolith – but how many monoliths are there? – is imaged by Kubrick as the exemplum of the auratic multiple, incomprehensibly beyond both natural and technological reproducibility, at once right there and somehow out of reach...

Most of our interactions with objects, in fact, unfold within this space, forged between a celebrity barn which laps up photographic attention, and a camera-shy monolith. (That is to say, between Anna Nicole Smith and Greta Garbo.) And it is also within this space that we can sketch a schematic caricature of that auratic force-field which informs and influences our relationship with all objects, including each other. Love, for instance, plays the same role as marketing, in the sense that this affective complex manufactures an aura for someone who previously had none – at least for the person now smitten.

Of course, aura is also something made or unmade depending on cultural context (or more accurately, *inter*-cultural contexts). The patronising and racist film, *The Gods Must Be Crazy*, for instance, at least has the benefit of illustrating how something as quotidian as a Coca-Cola bottle can become an object invested with multiple earthly uses, as well as maleficent sacred power. Never mind that this presumed "power" is bequeathed to the object by the scriptwriters, and not by the

Kalahari bushmen who are expected to shoulder the naïveté of such logic. The joke is thus on the filmmakers themselves, who dreamed up such a perverse Benjaminian premise in the first place. Yet the filmmakers are not alone in this. These days, we often find an object generated in such a way as to make it appear that the Other *still* believes the object has an aura that we ourselves know it does not – and those Others must clearly subsist in a hallowed zone of this *no-longer-that-somehow-still-insists*.

In short, the inter-cultural commerce of objects, especially those that get themselves tangled up in varied symbolic economies simultaneously, is something that will preoccupy us in the following chapters. Historical specificity is a major guide in calibrating our observations about this mediated traffic of things. For instance, Andy Warhol's serialization of the Campbell's soup can is often read as a deliberate attempt to destroy the aura of the canonical work of art, and as a kind of material meditation on Benjamin's thesis. Ironically, perhaps, the cultural capital which this gesture accumulates in its very media success has created a supplementary or prosthetic aura out of something which seems to lack the conditions to qualify as an auratic object in the first place. It's not such a great leap from Benjamin to Baudrillard, when a soup can is horizontally exchangeable – as artistic subject – for Marilyn Monroe, at one time, "the most photographed woman in America."

Speaking historically for a moment longer, it is worth noting that aura is a relative phenomenon; not only relativized by culture, but also by accumulative exposure. In other words, the bare passage of time is sometimes enough to bestow aura on an object, which – at the moment of conception – had none to speak of. For instance, the famous Shroud of Turin is a fake, but it is a thirteenth-century fake, and thus it generates its own "invisible remainder" over time. A more recent example would be The Spice Girls. When Ginger, Posh, Sporty, Scary, and Baby first entered the popular consciousness, they were portrayed in the press as the ultimate manufactured, inauthentic publicity stunt. Five ciphers in search of a demographic. Several years later, and this "group" already seem to have at least a minimal simulacral aura, at least in relation to the slew of pale clones who emerged in their wake.

Obviously, the discursive structural tensions between concepts like aura, mystique, hype, (commodity) fetishism, and reproduction take on a different significance depending on the site, the text, or the semiotic and material conditions of production-reception (for instance, is it analogue or digital; museum or multiplex?). Such calculations also depend on who we select to be our guide and navigator (for instance, Benjamin or Luhmann). However, the tensions and contradictions are emphatically *there* – there to be exposed and re-presented – whenever,

say, a fan waxes lyrical about their obsession, a curator waffles on about their decisions, an architect wanks on about their inspirations, or a cultural critic warbles on about "the ontological consistency of the object's material substrate". It is our claim, then (contra DeLillo's Murray), that you *can* see the barn. We may, however, need a specially-designed set of imaging equipment and hypotheses in order to do so.

Such equipment does not itself exist outside the media, as if it could simply be rolled into position in order to bring the phantasmagoria of objects into sharp focus – but is itself a feature of the multi-screens and windows of our virtual environment. As everyone from Debord to the Wachowski Brothers have insisted, the spectator does not stand outside the spectacle, but is deeply embedded within it. In fact, each individual can be considered little more than a product of the media's algorithmic processes (cf. Friedrich Kittler's "discourse networks"). Such a realization becomes inescapable whenever we surrender to the temptation to visit an IKEA store, and grasp the extent to which the object has been relieved – or robbed – of its aura. For the romantic humanist, this is a depressing scandal. To the cyborg postmodernist, this is a liberation from the delusional demand to be unique.

Which is why, in David Fincher's *Fight Club*, "Jack," the narrator (Edward Norton), squanders his already limited reserves of energy and enthusiasm on ordering items over the phone from IKEA. "Like everyone else, I had become a slave to the IKEA nesting instinct," confesses Jack's voice-over. "If I saw something like clever coffee tables in the shape of a yin and yang, I had to have it."

He continues:

> ... like the Johanneshov armchair in the Strinne green stripe pattern ... Or the Rislampa wire lamps of environmentally-friendly unbleached paper. Even the Vild hall clock of galvanized steel, resting on the Klipsk shelving unit. ... I would flip through catalogs and wonder, "What kind of dining set *defines* me as a person?" We used to read pornography. Now it was the Horchow Collection. ... I had it all. Even the glass dishes with tiny bubbles and imperfections, proof they were crafted by the honest, simple, hard-working indigenous peoples of ... wherever.[8]

One of the many insights of *Fight Club* is that, in the millennial marketplace, pseudo-folk objects replace the role of those famous shells, which both bound and regulated the peoples of the Trobriand Islands. The difference, in the case of IKEA, is that these objects circulate on a planetary scale according to consumerist principles alone – and are thus completely emptied of symbolic, communal, *auratic* significance. Commodity fetishism is thus simultaneously opposed to, *and* a faint echo of, the pure, profitless circulation of goods. In other words, these IKEA glass

dishes are made by unspecified, locationless indigenous people, who themselves are forced to form the quasi-opposite side of the single plane of globalized capitalist culture.

If the post-Kantian aesthetic tradition has been a prolonged meditation upon virtual objects, linking these to the possibility of a non-essentialist politics, what happens when the environment of these objects itself becomes virtual? Walter Benjamin has provided several indications, Guy Debord and Theodor Adorno have proffered others.[9] But while these writers certainly discerned, like sensitive temporal seismographs, the impending super-quake of the information revolution, they could not have anticipated the extent and intensity of network society.[10] As Manuel Castells asks, in a very clear formulation of the situation:

> What is then a communication system that, in contrast to earlier historical experience, generates real virtuality? *It is a system in which reality itself (that is, people's material/symbolic existence) is entirely captured, fully immersed in a virtual image setting, in the world of make believe, in which appearances are not just on the screen through which experience is communicated, but they become the experience.*[11]

Experience is no longer regulated by "faculties" (whether psychological, logical, formal, or otherwise); Kant's careful discriminations between sensibility, imagination, understanding and reason, as well as his related divisions (such as those between gratification, disinterested pleasure, and respect) are essentially meaningless. The virtual objects of aesthetics are today as real as it gets – as Friedrich Kittler has argued, Lacan's *objet a* is nothing other than an attempt to theorize what becomes of the logics of object-manipulation when nature disappears absolutely, and reveals itself as always already *real*.[12]

That mobile, flexible, ubiquitous apparatus referred to as "the media" has been busy turning the world into a virtual environment, and as it does so, the virtual object of subjective operations begins to mutate, deterritorialize – even disappear. If everything is now in an ontological flux, then one can never fetishize the same object twice (to confuse Freud, Deleuze and Heraclitus).[13] Hence the particularly postmodern twist of millennial cults; that they conduct age-old anxieties through increasingly volatile discourse networks.

As Peter Sloterdijk points out: "[F]rom now on the question of how a person can become a true or real human being becomes unavoidably a media question, if we understand by media the means of communion and communication by which human beings attain to that which they can and will become." Furthermore, "Man, who is confronted with a library, becomes a humanist. Man, who is confronted

18

with a computer however, becomes someone for whom we have no name yet. Here a post-literary, post-humanist type of man is developed."[14] (The computer, of course, being an exemplary meta-object.)

Bernard Stiegler also emphasizes the political implications of a situation whereby, "Technics evolves *more quickly* than culture."[15] The hegemonic media's attempt to project, produce and control "event-ization" [*événementialisation*] – of which September 11 has already become the standard reference point – suggests that discussions of "globalization" can no longer habitually separate objects from subjects, neither technology from the world on which it purportedly operates, if it wishes to account for the shifting sands of the twenty-first century. For his turn, Samuel Weber has dedicated several books to demonstrating the modern mani-festations of the "self-fulfilling prophecy" of this particular question concerning technology. For "[i]f the institutionalization of the subject/object relation – the matrix of representational thinking – is a result of the emplacement that goes on in and as modern technology, then those very same goings-on undermine the objectivity upon which the matrix depends."[16]

And hence the almost pathological popularity of *The Matrix*, which nostalgi-cally links the Cartesian questioning of seemingly solid objects (such as tables), to the virtual-media environment of today. For in the latter, we inhabit a false fan-tasia of animated objects encouraging us to be happy, to smile, to relax, and most importantly, to spend more money in order to do so successfully. Ironically (not to mention, achronistically), the circuits of millennial capital – cut ever deeper by the infrastructural technologies of the information economy – enable a vision of the world depicted as long ago as 55 BC. For this is what the philosopher-poet Lucretius imagines in *On the Nature of the Universe*, explaining that objects are not the inert things they initially seem, but are in fact in a constant state of molecular agitation: hurling atoms, odours, "films," and a "perpetual stream ... of matter, spreading out in all directions."[17] What's more:

> When this happens, [speaking specifically now about dream-images] it means that one film has perished and is succeeded by another formed in a different pos-ture, so that it seems as though the earlier image had changed its stance. We must picture this succession as taking place at high speed: the films fly so quick-ly and are drawn from so many sources, and at any perceptible instant of time there are so many atoms to keep up the supply.[18]

And so, centuries before the Lumière Brothers unveiled their magic machine, the world was chugging along at roughly 24 frames per second: a historical anomaly which frames Deleuze's statement: "the whole world turns to film."[19] Yet even if

we grant these conceptual coincidences, it seems that "the world" and its objects are no longer only captured on celluloid, but dubbed onto Digital Video Disc, uploaded onto the Internet, and preserved in bit-stream for the patient archiving (or perhaps the perplexed amusement) of future generations. As the following chapters explain, this process of virtualization is currently the most popular way to deal with the excess of tangible, inscrutable objects – the kind of objects that gather dust.

3. Chapter Synopses

The chapters of this book can be considered autonomous, and indeed stand alone as strategic interventions in certain contemporary debates and discussions regarding visual culture, philosophy and politics. Taken together, however, they form a cross-referenced feedback loop revolving around pressing questions concerning identity, representation and culture; aiming to assemble a framework for thinking beyond the inherent limitations of these concepts (or at least the way they are utilized in such debates). Each chapter thus reflects on the role of "the media" or "the spectacle" in simultaneously constituting and destabilizing those discourses which are deployed in the services of defining "us" from and against "them" – the most fundamental of which is the ontological distinction between subject and object.

 Chapter 1 seeks to question the prevalent assumption of contemporary art theory that appropriation signifies the presence of a certain postmodernist conversation with the past. Accordingly, the anxiety of influence which has haunted artists of the twentieth century has intensified into a paralyzing panic in the twenty-first: centered around the vexed question of the **aesthetic object**. This chapter suggests that we are currently witnessing the symbolic triumph of sampling over appropriation; an aesthetic strategy (perhaps, ironically enough, most visible in music) which finally achieves the much-vaunted erasure of any latent distinctions between original and copy, artist and thief. The work of musical artists such as Beck, DJ Shadow, Negativland and Bisk, represent very different attitudes to The Archive, although they all attest to the trans-generic bleeding of categories afforded by sampling. This chapter, therefore, argues that appropriation has lost its force as the dominant aesthetic discourse on the meaning and legacy of tradition and that the ubiquity of "sampling" and "design" represent the limit-point of "mere accumulation" (Agamben).

 Chapter 2 focuses our investigation through an account of Eija-Riitta Eklöf-Berliner-Mauer, a Swedish woman who "married" the Berlin Wall in 1979. Ranging from this (apparently extreme) case of "objectum-sexuality," we expand on the

existential life of objects within narratives of self-identity and self-fashioning. Leaning heavily on the key chapter of Sartre's *Being and Nothingness*, entitled "Concrete Relations with Others" (possibly the longest ever answer to the aggressive question "what are you looking at!?"), we ask if relations with concrete others, or at least the erotic acknowledgment of non- and/or post-humans, might point the way beyond increasingly obsolete Cartesian-Romantic modes of love – pointing toward the **love object**.

Chapter 3 begins with a decoy question: why bunny rabbits? Certainly the bunny rabbit looms large in the Anglo-American imaginary as a virtual totem for ontological uncertainty; and it is this thematic consistency of the role played by rabbits in cultural texts and discourses which interest us here. For while a discursive map of any given animal could yield interesting hermeneutic patterns, the rabbit has proven itself to be a catalytic-yet-**elusive object** for dialectical questions of presence and absence, as well as metaphysical explorations of madness, sanity, and those existential forms of psychic liminality which lie between these relative poles. Beginning with the prototypical magic act of pulling a rabbit appear from out of a hat, and moving through the roles of rabbits in texts such as *Alice in Wonderland, The Matrix, Donnie Darko, Harvey* and *Who Framed Roger Rabbit?*, we explore the role of the bunny in facilitating the remarkable transition from not-there to there – a transition which subliminally initiates the children into the basic philosophical question: "Why is there something and not nothing?" All the while another, altogether different, question attempts to pull itself out of the hat, drawing our methodological focus in the opposite direction. Since "looking at the bunny" has become a common term for the process of being distracted from more important events unfolding nearby, then what is it that we are *not* seeing – as a culture in general – when we become too entranced by the antics of real or imagined bunny rabbits?

Chapter 4 notes how in the weeks following the September 11 terrorist attacks on the United States, an increasing amount of politically and emotionally-charged images relating to this event began to appear in Newsgroups and email inboxes around the world. The overwhelming majority of these images were blatantly hostile to Muslims in general, or Osama Bin Laden in particular, and smuggled within the pixels a constellation of assumptions about cultural difference and what is now characterized through shorthand via Huntington's "clash of civilizations." This chapter focuses on some of the more representative of these images downloaded off the Net, and argues that relatively new digital manipulation technologies, combined with an increased popular access to the Web, has resulted in profound changes in the way "the community," "the people," and/or "the public sphere" respond to traumatic political events via **media(ted) objects**. One of the

most significant shifts resulting from this unprecedented situation is in the production and transmission of propaganda: for this Machiavellian science was once the domain of the military and governmental elites, but is now moving towards the hands and the hard-drives of those people who were historically simply the *consumers* of propaganda. Our argument thus begins with the premise that such an important shift in production and transmission leads to fundamental (even fundamentalist?) questions concerning the role of technology in relation to political expression and ideology in the information age.

Chapter 5 turns to multimedia art in order to examine the fate of the "commons" and "commonplaces" in contemporary global discourses of aesthetics. Examining the franchise reality-TV show *Big Brother*, this chapter suggests how the often-pathologising dismissals of such shows can be usefully deployed to rethink what happens to communities "after the orgy." Drawing on psychoanalysis and linguistics to support its interpretation, this chapter argues that contemporary communities are not so much hybrid, precarious, and shifting assemblages as they are collections of icons of institutional power ("symbolic investiture" in Eric Santner's terms), bound together by "snarls of interruptions." This chapter discusses some of the ways in which **shared objects** attempt to function as "informational irritants" in such a way as to produce and expose new senses of community.

Chapter 6 begins by asking who or what constitutes the "public" of public transport, noting that thinkers from Kafka to Sartre to Heidegger employ the trope of the tram or the train to consider the transductive relationship between "the they" and the "we-object." Focusing especially on Heidegger's landmark essay "The Age of the World Picture," we examine how the emergence of Man as *metron* is intimately related to the contemporary political coding of refugees as **moveable objects**. This link is effected by Alfred Bester's astonishing science-fiction novel *The Stars My Destination* (1954). Telescoping times and texts in this way, we arrive at the political furor over the fate of the *HSS Tampa*, whose cargo of largely Afghan refugees was left floating in extra-legal limbo for several weeks, forcing the Australian government's severely compromised immigration policy into an international consciousness.

Chapter 7 considers two films by Hong Kong directors – Wong Kar Wai and Clara Law –, both of whom have moved further and further afield in order to achieve their respective visions. Framing *Fallen Angels* and *Floating Life* through the writings of Michel de Certeau, Ackbar Abbas and Massimo Cacciari, this essay constructs a hauntology of diasporic spaces as well as a traumatology of lost and **foreign objects**. Both films reflect on "post-colonial" situations where geography seemingly has great ontological power; summoning and/or denying specific spir-

its for a generation which experiences itself as somehow belated or abandoned. Qualified moments of redemption are found through "asymptotic encounters" with both people and things; nevertheless, there is a sense that both Law's and Kar Wai's characters somehow embody Don DeLillo's recent observation that "all terror is local now."

Chapter 8 examines how particular political contexts often drive centrally at the sacralisation of arbitrary and irrelevant objects; and how, in this sacralisation, human beings find themselves forcibly divided into two classes of objects – the living-dead object of inestimable worth, and the discounted object. The primary focus in this chapter is on the post-colonial Australian state, and how floral wreaths, tie-pins, and drinking fountains can come to bear a literally ethnocidal significance. Drawing from the writings of Walter Benjamin, Carl Schmitt, Jacques Derrida and Giorgio Agamben on the relations between "sovereignty," "sacrality," and the "friend-enemy" relation, this chapter shows how the Australian state's foundation on the double negation of *terra nullius* – "neither blood nor soil" – has led to a world almost exclusively populated by **abject objects**.

The conclusion draws the ramifying tendrils of the chapters together, arguing for the integral compatibility of aesthetics and politics, visual culture and power-generating practices. It does so, by examining the relationship between, on the one hand, the obligation to produce or find so-called meaning in things, and, on the other, our daily commerce with and amongst objects. The unstable category of "the human," thus becomes the *point de capiton* for the gigantic cabinet of curiosities known as "the world." And so when Heidegger enlists his unrivalled capacity to turn almost any noun into a verb, by claiming that "the thing *things* a world," what he actually means is that a thing things a world *for* a (human) subject. But perhaps it is now possible to tentatively transcend such a meta-humanistic horizon?

If the discussion up to this point seems somewhat abstract, this is a reflection of canonical thought on the object, which shies away from specific case scenarios for fear of losing sight of what is structural or formal in the process of subject-object interaction. The remainder of this book, however, attempts to move beyond this very shyness, in order to acquire a more intimate understanding of concrete examples – both figuratively and literally speaking. This is partly due to the fact that we believe it is useful to approach the object (as with a sculpture, for instance) from different angles in the encounter; to see it in different lights, spaces and contexts. And if the guard isn't looking, we would further seek to lift it up, to ascertain if it has a signature, watermark, scar, model number, or brand name. And if this yields little, then it may even be worth shaking the object to see if it squeaks, breaks, inflates, slaps us, sulks or creates a miniature snowstorm...

The Aesthetic Object

1. A Break in Transmission: Art, Appropriation and Accumulation

The world now becomes the warehouse of jetsam where the uncanny fishes for its scarecrows.
GIORGIO AGAMBEN[1]

In Woody Allen's 1980 film *Stardust Memories*, a director is sitting in front of a live audience answering questions about his latest film. One audience member asks if a particular scene in his latest movie is an homage to the original version of *Frankenstein*. The director replies: "An homage? No, we just stole it outright." For a brief moment, this joke becomes a sly admission allowing us to glimpse the logic of appropriation in terms of aesthetic or intertextual poaching. For indeed, what separates an homage from a burglary, other than a stated intention by the artist? And who is to judge the consequences of one over the other?

In this article we would like to briefly contextualize the link between appropriation and the notion of private property (via ownership and authorship), before arguing that this link has been dissolved in the cultural logic of contemporary aesthetic production. Our motivation is itself linked to a desire to escape the categories of original and copy which, despite celebrated claims to the contrary, continue to privilege the quasi-sacral realm of artistic production – including music – while simultaneously greasing the wheels of the market.

Appropriation implies a form of violence, a taking or annexing of something to oneself with or without the sanction of the law. The dictionary definition also implies motivation, namely "To make, or select as, appropriate or suitable to," or "To make proper, to fashion suitably." Appropriation thus unfolds according to the logic of suitability, utility or relevance, and therefore smuggles in a number of notions related to aesthetic justification and indeed, to continue the equation made above, rationalizing robbery.

Here we would like to introduce a loose chronological genealogy for this wider process, beginning with allusion and moving through appropriation to sampling.

1) *allusion* is best defined in poetics and philosophies of language, in which it has had a place for over 2500 years. Whether in terms of direct nomination, turn of phrase, rhythm, form, theme or media, the new piece of work refers, either explicitly or more covertly, to one or several previous works or traditions. Allusion is just one technique among others, however; it is not a principle or necessary condition of all composition, but rather a *possibility* of linkage.

2) *appropriation* can be understood as providing an emblematically modernist slant to allusion. With appropriation, one steals, and steals explicitly – but also unapologetically, as if the evidence of this theft was essential to the appreciation of the work. This means that the audience and makers of modernist work share a tradition, a bundle of techniques, elements, and forms that have recognizable, definite, and nameable points of origin. It is these origins that are transgressed by the modernist work of art. Appropriation ruptures with the tradition in order to make you think again about tradition. Appropriation thereby makes the relation of a work to others in the tradition evident, in order to reopen the question about the very meaning, status and limits of the tradition itself. This is also to say that appropriation becomes a *principle* integral to modernist aesthetic production. To take a very famous example from modern art: Pablo Picasso at one stage returns to Velásquez's *Las Meninas*, which he submits to all sorts of painterly distortions and refigurations.

3) *sampling* is an emblematically postmodernist form of production. Whereas both allusion and appropriation are still tied, relatively directly, to the work of genius, to a work which transforms and individualizes elements that come from elsewhere, sampling makes an individual anonymity the very condition for all work. Sampling takes place by means of multiples-without-proper-names. There is no central tradition; there are no specific works that everyone has to have understood; there are no names that retain any absolute centrality. No religion, culture, nation, *ethnos*, etc. can totally dominate cultural production. There are no materials that guarantee that a particular work is, say, jewelry – which can now be made out of literally anything. Many works are composed totally of samples that have been taken as is, slowed down or speeded up, inverted or distorted beyond recognition. Sampling not only recomposes different elements, but different *ways* of recomposing elements: it is a very complex and labile procedure. In a way, sampling totally erases the distinctions between original and copy, artist and thief, the individual and the

series – in fact, it renders these distinctions secondary if not irrelevant. Sampling also presumes that there are no longer rigorous distinctions between, say, poetry, ceramics, painting, prose, design, etc. But it is therefore neither a simple *possibility* for production (as with allusion), nor a *principle* of production (as with appropriation); it is rather a *commonplace*, the universal and unexceptional basis for all production. (See chapter 5 for a more extensive discussion of such commonplaces.)

Thus, in the fields of cultural production (writing, craft, art, design), something very serious has happened, and is still happening. The value (both aesthetic and economic) of so-called "culture" has become uncertain; the places and people who produce and consume it are at once proliferating and disappearing; its future cannot be ensured. And it is the prevalence of sampling which has triggered this significant shift. Whereas both allusion and appropriation connect to the legacy of genius, incorporating elements that come from both beforehand and elsewhere, sampling threatens to dissolve all distinctions between the work and the environment from which it derives. Tradition no longer holds a central place, and there is no canon which the audience, reader or listener is assumed to be familiar with. Suddenly, every work of art is sucked into the vortex of the public domain. So while Stendhal could amiably claim to be borrowing an idea or anecdote from a friend or colleague, the nineteenth-century reader had no reason to doubt that the great author would return either the tale or the favour in good time. Nowadays we have the situation presented in *Seinfeld* where a successful businessman must buy stories from slacker *schlemiels* in order to fill-out his memoirs.

The one who appropriates does so for a reason. They perpetrate appropriation through an act of the will, for purposes more apparent than obscure. It is a dialogic response to a conversation which has usually been going on since before the artist was born. Allusion, appropriation and sampling have *always* been co-present in the field of cultural possibilities, so when we speak of a chronological basis, we are designating their relative (symbolic) dominance in the representative work of particular periods.[2] The capital-A Archive of visual art, literature or music has now splintered into a plethora of sub-archival signs and symptoms which are linked only by the idiosyncrasies of the critic and practitioner, reflecting the shattered genealogies which comprise our everyday relationship to the semiotic universe. The medium is no longer the message, but the media, plural.

In the following discussion we will rely largely on artists working with sound or music in order to illustrate the notion that appropriation is giving away to the logic of sampling, because – ironically enough – we believe that this wider aesthetic shift to be most visible in the music world, both on the fringes and the heart of the music industry.

1. Music is One Rotted Note

Transmission is forgetting. This is the Epimethean structure: the experience of accumulated faults that are forgotten as such.
BERNARD STIEGLER[3]

Consider the example of Bay Area turntablist DJ Shadow. His 1996 album *Entroducing* was hailed a masterpiece, and he himself was often referred to as a genius in the music press. The fact that he did not play one note only made the album more astonishing, given that he had sculpted a remarkably coherent symphony from the various archives of his collection: soul, funk, hip hop, heavy metal, alternative rock, sixties balladry, opera, etc. The mixing studio thus becomes a giant loom on which he has woven the musical threads of the last four decades. What is so remarkable about *Entroducing* is that once you have heard it, you find it almost impossible to believe that these heterogeneous elements came from an earlier source and completely different context. Pushing Derrida's logic of the supplement to its limit, DJ Shadow works from the palette of the past and recombines these sounds so that a subliminal one-bar keyboard refrain from Björk acts as the skeleton for a completely new composition. In contrast to allusion and appropriation, there is no feedback loop to the original Björk track; in fact, it took us at least twenty listens to recognize it. DJ Shadow's method and skill are such that he has hijacked the sample into his own aural *vision*, as if we could return to Björk's album and find the keyboard missing.

The dependence on metaphors of palette and loom already reveals something about the tradition in which DJ Shadow places himself. There is a swift double movement which takes away the notion of the auteur with one hand, while replacing it with the other. Indeed, allow us to appropriate earlier writings in the mode of breathless rock critic:

> DJ Shadow has given us the greatest movie of the 1990s. The strange thing, however, is that it comes in the form of a compact disc, and is best experienced with the eyes closed (preferably wearing headphones) ... One of the first samples is a male voice claiming that "the music's coming through me," and there is no doubt that DJ Shadow (real name, Josh Davis) is something of a channeller ... He does not use a synthesizer, he is a synthesizer – a cultural node sifting through the detritus and dejecta of postmodern America and turning it into 'solid gold.' This is a 'meta' version of the Situationist strategy of *détournment* and *bricolage*, no less political for its aesthetic aspirations. It uses technology to valorize the organic, and in doing so enacts Heidegger's elusive point that "the essence of technology is nothing technological."[4]

We admit this passage relies on the familiar notion of the Death of the Author, replacing it with a vaguely Kant-meets-Deleuzian model of author-function or node-s(h)ifter. The very gesture of writing an homage to DJ Shadow, however, speaks of the modernist impulse to identify, locate and unpack genius. It is implicitly claimed that he is a master of his materials, thereby subscribing to a barnacled notion of authorship and, by extension, ownership. On the one hand, he is merely, to quote Marshall McLuhan, "the sex organs of the machine world," and on the other, he is the fetishistic point of coalescence, making patterns out of sampled sounds.

When a band covers a song, they are borrowing it in the mode of Stendhal: a form of *allusion*. When Beck references everything from Hot Chocolate to the Rolling Stones, he is *appropriating* them for his own dialogic project; keeping them in quotation marks. When DJ Shadow uses Morriconi, he is *sampling*, because the quotation marks are dissolved and their original context effaced.

For more examples of the latter, we could quickly refer off-stage, as it were, to a loose group of recomposers: artists such as Aphex Twin, Squarepusher, Mouse on Mars, Oval, Bisk, The Avalanches, Negativland, Prefuse 73, and other proponents of the relatively new "illbient," "laptop" and "glitch" genres. These names represent a small slice of the avant-garde of recombinant music (or, to follow Paul Mann, the "avant-garde effect"). Their experiments in sound: recording the magnified mating calls of termites and then looping them to the glitch beat of a damaged CD, for instance, or insane arrhythmic beats, seem to qualify as postmodernist aesthetic practice. They seem in sharp contrast to DJ Shadow's organic coherence. (How, for instance, are we to tell a genuine processing fault from a deliberate one on our glitch CDs? Are such distinctions at all valid anymore?)

To refer back to our genealogy, however, and in contrast to DJ Shadow, they themselves are revealed as the true modernists, in their teleological, marginal approach. These artists, or at least the critics who interpret them, see this kind of sampling as building bridges to an imagined future where the distinctions between sound and music would be far less rigorous (à la *musique concrète*).[5] It could be argued, then, that DJ Shadow's majestic recompositions are thus more faithfully postmodernist, in that they no longer play the linear game of pushing the envelope, or painfully straddling the bleeding edge. *Introducing* illuminates the structure of the contemporary moment in its stagnant restlessness. *Déjà entendu.*

Postmodernity changes things again: there are no longer any ontological distinctions between matter, form, thought, etc. – there are just multiple processes, of no definite or particular value *in themselves*, and with no definite origin or direction. Hence the new priority accorded sampling, considered as inflection and

torsion of multiplicity. "Design" is the most prestigious name given to the varieties of sampling in the contemporary first world.

Negativland, however, came up against the legal limits of this statement when they sampled famous American radio disc-jockey Casey Casem talking off-air about the pompous irrelevance of U2, and worked it into a bastardized version of their single, "I Still Haven't Found What I'm Looking For." The copyright saga which followed not only exposed the snivelling hypocrisy and humourlessness of Bono and the Boys, but also the persistent power of private property in aesthetic production.

The explosion of both authorized and anonymous remixes suggests that the tension between public domain music and the struggle to retain royalties once a commodity has been launched will reach breaking point very soon, if it has not done so already. The high-profile battles surrounding Napster only emphasize this painful break with received notions of authorship and archival activity. "Ripping," as it is currently called, unmasks the logic of sampling in its complete indifference to creative control or ownership. In fact, it exposes the so-called artist as the original appropriators, since they annex the flux of sound into their own (perhaps imagined?) territory for the sake of financial gain. (A point already enacted and critiqued by Duchamp.) The viral logic of the market, the industry and cultural communication itself undoes its own desire for profit through the dissolution of juridical boundaries. The dia-logic of appropriation becomes the multivalent illogic of sampling.[6]

Questions, however, as always, remain. When we download an MP3 of Metallica's *Master of Puppets*, for instance, and proclaim it to be artistic appropriation, how are we to be distinguished from Sherry Levine? Or what if we download the entire *Entroducing* album and then release it under our own name? As Borges said, regarding the man who reproduces a fragment of *Don Quixote*: "The text of Cervantes and that of Menard are verbally identical, but the second is almost infinitely richer."[7]

2. The Girl From Ipanema vs. The Woman From Iceland

We are all obsessed with high fidelity, with the quality of musical 'reproduction.' At the consoles of our stereos, armed with our tuners, amplifiers and speakers, we mix, adjust settings, multiply tracks in pursuit of a flawless sound. Is this still music? Where is the high fidelity threshold beyond which music disappears as such? It does not disappear for lack of music, but because it has passed this limit point; it disappears into the perfection

of its materiality, into its own special effect. Beyond this point, there is nei-
ther judgement nor aesthetic pleasure. It is the ecstasy of musicality, and
its end.
 JEAN BAUDRILLARD[8]

A kind of "negative appropriation" in fact leads to the recent explosion of unau-
thorized "backyard editing," which is not only limited to the realm of music. A
quick search of the Internet will reveal various home versions of George Lucas' *The
Phantom Menace*, in which hardcore fans, true to the original trilogy, delete the
presence of the detested character Jar Jar Binks, who is commonly perceived as a
woeful comic impostor (in which case, the same process should perhaps be used
to eradicate the plague of Ewoks which infest *The Return of the Jedi*). Similarly,
video stores in the American South have taken it upon themselves to censor the
(barely steamy) scene between Leonardo di Caprio and Kate Winslet in *Titanic*;
presumably in order to make the film even more palatable for God-fearing, sex-
hating families. In these instances, copyright law seems under-prepared to deal
with parties that merely excise certain sections of a film or album, rather than the
usual threat of copying without authorization.[9]

The question then becomes inseparable from the artwork's vulnerability to
manipulation, and sovereignty itself is at stake. An email from a friend, Adam
Sebire, wrestles with the notions introduced by Baudrillard above, especially in
relation to the current overlaps between analogue and digital technologies (in
which, for instance, we hear the crackling sound of vinyl being sampled for com-
pact disc, presumably to make it sound "warmer"). Sebire admits

> I'm still troubled by an Astrud Gilberto CD I purchased last week for $20, fea-
> turing a version of "Girl from Ipanema" with quite noticeable feedback on the
> recording ... maybe this is the music industry's answer to so-called Reality TV's
> deliberately wobbly camerawork and grainy pictures? Does anybody question
> the Reality claims of the Pentagon's ghostbuster-green night-vision pool footage
> from Afghanistan? No, it's grainy and wobbly; but there are still plenty of peo-
> ple who look at the fixed, tripod shots of the moon landing and find "evidence"
> (e.g. the USA flag that looks like it's fluttering in the wind) to proclaim that it
> was all staged in a NASA studio! So does the "Girl from Ipanema" suddenly
> become so much more real if we hear her dodgy mike technique sampled 44,100
> times a second?

The question remains as valid as ever, more than half a century after Benjamin's
epoch-making inquiry into the aura of reproduction itself.

Returning to Björk, however, we can see how her latest album, *Vespertine*, represents a new triumph of mutual appropriation, sampling and collaboration. Indeed, her official website thanks a programmer who emailed "a rhythmic movement of about 32 beats in the middle eighth of the first single, *Hidden Place*." This is a very different way of incorporating the work of other people than the traditional reliance on studio musicians or established samples, benefiting from a network of technological tinkerers, all of whom make a donation to the finished product (which, of course, is never really "finished" – one of the radical consequences of digital technologies).[10]

The fact that Björk collaborates with many different people, and indeed, that they may physically be on the other side of the planet, suggests that we are dealing with an emerging twenty-first century conception of expression and artistic practice, which may eventually even alter our received notions of subjectivity. For while it is impossible to deny that Björk's album is an intensely personal statement, neither can it be ignored that it is the fruit of interpersonal penetration of one form or another.

This album was not recorded in a studio, but in private and domestic spaces, mostly on her own laptop. Thus, she could programme a beat while in her kitchen in Iceland, and then lay down some vocals while in a friend's bathroom in Spain. It therefore becomes difficult to draw the line between Björk the "genius artist," who excels in expressing her internal world through music, and Björk the organizing principle, who idiosyncratically tethers together a galaxy of contributions all which speak of the context from which they have been lifted. On the one hand, she withdraws into the comfort of domesticity and familiarity, and on the other, she encourages global affiliations which challenge and expand her aural vision.

To listen to *Vespertine* is thus to enter an alien Björkscape, à la *Being John Malkovich* (for which she wrote the signature song). It is a portal to another subjectivity, which is not in fact an autonomous and isolated world, but a psyche which is a spliced continuum; whereby no one can confidently cite a beginning or end. For while she is constantly represented in the media as unique – an eccentric star – her work is a convincing statement for the benefits of opening oneself to impersonal effects. "Björk" is just as much the product of Chris Cunningham, Matmos or any number of other collaborators, as an island unto herself. And perhaps this is how we should think of collaboration. Not as the middle-point where two individuals meet, but rather the space in which individuals are reproduced and reconfigured (since the person doing the collaborating is the fluxing sum of previous collaborations).

3. Music Has the Right to Children

To quote a text means to interrupt its context.
 WALTER BENJAMIN[11]

The legal crisis prompted by sampling actually responds to a deeper crisis surrounding the notion of cultural transmission, specifically the historical production and reception of art. Italian philosopher Giorgio Agamben pinpoints this distressingly novel situation with Walter Benjamin, and his unfinished compendium made up exclusively of quotations. In *The Man Without Content*, Agamben reads this project as a symptom of the loss of tradition, meaning:

> that the past has lost its transmissibility, and so long as no new way has been found to enter into a relation with it, it can only be the object of accumulation from now on. In this situation, then, man keeps his [sic] cultural heritage in its totality, and in fact the value of this heritage multiplies vertiginously. However, he loses the possibility of drawing from this heritage the criterion of his actions and his welfare and thus the only concrete place in which he is able, by asking about his origins and his destiny, to found the present as the relationship between past and future.[12]

According to Agamben, "the castle of culture has now become a museum," and art no longer possesses the power to transmit culture from generation to generation. The modern citizen finds himself wedged between, "on the one hand, a past that incessantly accumulates behind him and oppresses him with the multiplicity of its now-indecipherable contents, and on the other hand a future that does not yet possess and that does not throw any light on his struggle with the past."[13]

 Such a situation has the advantage (or disadvantage, depending on your perspective) of automatically disqualifying any attempt to label a work of art as "dated," or even "retro." This label – whether figured negatively or positively – relies on a sense of linear history, or at least a concept of mutually legible fashion cycles. The great aesthetic whirlpool in which we currently find ourselves neither validates nor rejects any particular recent epoch. As the catwalk proves, the 1960s, 70s, 80s, and 90s all co-exist – some revivals lasting longer than the decade which inspired it – while designers claim their own randomly idiosyncratic whims to be the spirit of the times. To dismiss someone or something on the basis of "that's so five-minutes ago," is thus more a reflection of the psyche of the person who says it than a comment on the Zeitgeist as a (fragmented) whole.

 Brian Massumi feels compelled to describe this status quo as "an entropic

trashbin of outworn modes that refuse to die,"[14] positing a will-to-accumulate within cultural garbage: the refusal of refuse, itself. Indeed, it would be an incredible challenge for a future sociologist or music critic to distinguish between, say, the Human League (as a quintessential 1980s New Romantic band), and Zoot Woman (a note-perfect pastiche of this genre, playing today). For while we have been through many cycles, evolutions and revolutions in the two decades separating these two bands – as well as several layers of irony and post-irony – any perceptible cultural "progress" is wiped clean by deadpan mimesis and appropriation.

As academics, we are only too familiar with the frustration of this incessant accumulation, and the frassic futility it seems to produce. After all, a frightening percentage of contemporary art and criticism is indistinguishable from the compulsive toilings of the dung beetle. Jacques Attali positively spins this situation as "composition," whereas Michel Maffesoli prefers the term "saturation." In *After the Orgy*, "exhaustion" is offered as a trope of paradoxical potentiality, citing all the divergent approaches of the artists mentioned above as meaningful (i.e., somehow not pointless) exercises in both de- and reconstructive bricolage.[15]

The anxiety of influence has given away to full-blown panic – to what DJ Greyboy calls "dealing with the Archive" – and few artists work outside the pressure of this accumulation. In fact, this pressure may itself be the very condition of the contemporary work, like a fast-forward cartoon of carbon into diamond. Production and appropriation have become confused to the point of fusion, as have design and art. There is no distinction between designer and artist outside the social context of production (which is relatively meaningless, if we look for immanent answers in the work of art itself).

Take the example of Michael Craig-Martin, whose work entitled *Oak Tree* consists of a glass half-full of water on a glass mantlepiece affixed to a wall. The artist claims that anybody can have this masterpiece in their house so long as they follow his guidelines. Although the so-called original can be found in the San Francisco Museum of Modern Art, other more or less identical versions can theoretically be found in houses around the world according to a principle not too far removed from that which made IKEA a giant global corporation. When interviewed on television, the artist was asked what he would do if someone assembled the same elements in the same way in order to show it in their own exhibition. "Well," he answered, smiling in acknowledgment of the niggling irony and latent logic of the art world. "That would of course be a fake."[16]

If sampling traces the horizon of Agamben's "mere accumulation," then its viral nature points to a potential breaking of the historical deadlock that we find ourselves in. Viruses, after all, don't exactly respect somatic or geographic borders.

In contrast to our opinion that *Entroducing* is our greatest movie, J.G. Ballard offers the Mona Lisa. He also believes that Gray's *Anatomy* is our finest novel. This Ebola-like transgeneric bleeding of aesthetic categories is, for some, the apocalyptic death-knell of Art and the simultaneous triumph of design.[17] (One need only glance at that Bible of aesthetic implosion, *Wallpaper** Magazine, for evidence of this perspective.) For others, this moment represents a joyful clearing of the decks to make way for new definitions and alternative modes of production. (Of course, we hesitate to use the term expression.) Indeed, perhaps sampling has already given way to ripping, underscoring William Gibson's oft-quoted maxim, the street always finds its own use for things.

4. The Stuff That Surrounds You

In keeping with the topic at hand, we feel it only appropriate to finish by appropriating somebody else. So we shall end this article by sampling J.G. Ballard's classic novel, *High Rise*:

> Reluctantly, he knew that he despised his fellow residents for the way in which they fitted so willingly into their appointed slots in the apartment building, for their over-developed sense of responsibility, and lack of flamboyance. Above all, he looked down on them for their good taste. The building was a monument to good taste, to the well-designed kitchen, to sophisticated utensils and fabrics, to elegant and never ostentatious furnishings – in short, to that whole aesthetic sensibility which these well-educated professional people had inherited from all the schools of industrial design, all the award-winning schemes of interior decoration institutionalized by the last quarter of the twentieth century. Royal detested this orthodoxy of the intelligent. Visiting his neighbors' apartments, he would find himself physically repelled by the contours of an award-winning coffeepot, by the well-modulated color schemes, by the good taste and intelligence that, Midas-like, had transformed everything in these apartments into an ideal marriage of function and design. In a sense, these people were the vanguard of a well-to-do and well-educated proletariat of the future.[18]

The Love Object

Relations with Concrete Others
(or, How We Learned to Stop Worrying
and Love the Berlin Wall)

The question "where is the thing?" is inseparable from the question "where is the human?"
 GIORGIO AGAMBEN[1]

1.

Meet Eija-Riitta Eklöf – Berliner-Mauer – for all intents and purposes a typical middle-aged woman living in the small village of Liden in Northern Sweden. The name, however, may have already alerted some readers to the fact that Eija-Riitta is not your ordinary Swedish woman, since she claims to have been married to the Berlin Wall since 1979.

Perhaps it is best to hear the story straight from her (or at least, straight from her website):

> I have built models of The Berlin Wall, also models of other things, such as Bridges, Fences etc. I have made a number of models of The Berlin Wall. Their names are The Berlin-Wall Jr. VI, Gartie, Lill-Murre, the others are called The Berlin-Walls Jr. I, Jr. III, Jr. V, Jr. VII and Jr. VIII.

> My family are The Berlin Wall, he doesn't live here, and the models of the Berlin Wall. This needs a short explanation. I am objectum-sexual that is to be sexually and emotionally attracted to objects; in my case. It is the actual Wall I love, not the border – like some intolerant people seem to think. They fail to see difference between the Wall and the purpose, which are two completely different things. If you fail to see that – well, too bad! The purpose is irrelevant to me.[2]

This statement may prompt most of us to assume that we are already in the realm of the pathological, or at least dealing with someone who should be approached under the abstract auspices of "mental health." However, we should not be overly hasty in judging Mrs Eklöf-Berliner-Mauer's love for objects, for this love may be merely an intense version of something we all feel from time to time, and thus

reveals something significant about an age which – at least since Marx – is "regulated by an ultimate object outside itself; consumption."[3]

Before exploring the various versions of objectum sexuality (both within and beyond manifestations of a "syndrome"), perhaps we should hear more about this love:

> Since many people have asked me what that is, I'll try to explain, as good as possible. It's very difficult, as feelings are always very hard to explain. It is simply to be emotionally and sexually attracted to OBJECTS, things – not human beings or similar, but if you would have any chance to understand this, or get a true picture of it, I think it is very important to know the back-ground, and the ground ideas of persons who are objectum-sexual: We believe that all objects (things) are LIVING and having a SOUL, (Animism). I think that is very important to see objects as living, if one should be able to fall in love with an object ...

> If one can see objects as living things, it is also pretty close to be able to fall in love with them. After all, there are many different sexualities – if you care to look around. To make love with a thing isn't any more difficult than having sex it with a man or woman. To be objectum-sexual and having sex with an object, is NOT the same thing as masturbation, because in masturbation one doesn't see the object as LIVING, one does often dream about a person or something. In objectum-sexuality one has sex with the object because one loves the object itself. That is a big difference.

Already we can see that for Eklöf-Berliner-Mauer, objects are not merely inert things, but are reservoirs of that most elusive of properties: life. The question of consciousness is not breached, nor is it particularly relevant, since reciprocity is not the main question. Eklöf-Berliner-Mauer's provocation or challenge is to flatten the ontological hierarchy which places humans at the top, animals further down, then flora, and finally the rest of "dead matter" (whether these be rocks, bones or old cars). Despite voicing a preference for objects, she is essentially proposing an erotic democracy of all things that are.

And not any objects, but *constructed* objects, which suggest that human intervention is just part of the libidinal equation. Eklöf-Berliner-Mauer's compulsion to remake these walls, bridges and fences points to an appreciation of the technical genesis of such objects; the fact that they are more than a pile of bricks, but a "standing reserve" in Heidegger's sense of the built environment.[4]

There is certainly increasing evidence that the wider culture is recognizing the

claim of existential rights for entities previously dismissed as mere objects. Take, for instance, the para-legal category of "racquet abuse" in professional tennis tournaments; whereby the perpetrator can be fined for smashing a racquet on the ground, no matter what their status or reputation. In a different register, but located on the same continuum, NASA's Mars Rover probe "Spirit" was recently reported to be in "good health" by the space agency.[5] Similarly, the Pentagon felt obliged to personify the elements themselves during the Second Gulf War, claiming: "At this point in time the weather isn't co-operating with our forces." Even fabrics are now described as "distressed," and materials are "sensitive," just as the movie *American Beauty* featured as its signature scene the reified-sublime sequence of a plastic bag tossed in the wind.[6]

But this does not account for love. Eklöf-Berliner-Mauer explains that

> the feeling of love is always the same – it is the object for that love that may be different, but the FEELING itself is still the same. In my case I am in love with The Berlin-Wall. WHY I love exactly The Berlin-Wall, and find other constructions attractive, has to do with their way of looking, their construction and what they really are. That I can only speculate in, I do not know exactly why The Berlin-Wall.

Surely one need only be an architect or similar breed of aesthete to appreciate the erotic attraction of constructions. Indeed, a friend once confessed to me – not coincidentally an art critic – that during an unexpected moment she had an orgasm just looking at the Twin Towers of New York's World Trade Centers. (Parallel structures which are now and forever seen through the overdetermined lenses of politics, mourning, trauma, and the so-called "war against terror.")

J.G. Ballard's important novel *Crash* is essentially a meditation on what happens to desire when we factor the environment into the equation (which is, of course, something we should do in the age of machinic assemblages). For instance, after his initial car crash, the narrator soon becomes overwhelmed with the polymorphous eroticism of his hospital, whose "elegant aluminized air-vents in the walls of the x-ray department beckoned as invitingly as the warmest orifice."[7]

In his most recent novel, *Super-Cannes*, Ballard paints a portrait of

> The Polish whores in the bars outside RAF Mülheim ... scarcely women at all but furies from Aeschylus who intensely loathed their clients. They were obsessed with the Turkish pimps and their children boarded with reluctant sisters, and any show of feeling disgusted them. Warmth and emotion were the true depravity. They wanted to be used like appliances rented out for the hour, offering any part of themselves to the crudest fantasies of the men who paid them.[8]

Such an interpretation of reified relations under capitalism (itself congealed into "war-time," perhaps capital's most pure form), sets the scene – if not the tone – for those whimsical best-sellers such as Oliver Sacks' *The Man Who Mistook His Wife for a Hat*, and the various spin-offs of this phenomenon.[9] Such cultural symptoms are themselves signs of the unease we feel in sharing "our" world with those uncanny objects which elicit both fascination and repulsion.

2.

In his exemplary study *Stanzas*, Giorgio Agamben turns his attention to "the will to transform into an object of amorous embrace what should have remained only an object of contemplation."[10] In tracing his particular theory of the object, Agamben highlights the essential role of melancholia and fetishism in Eros's attempt to "find its own place between Narcissus and Pygmalion."[11] Such a third space would incorporate the attempt of humans to inhabit an erotic ecology increasingly populated by libidinized objects: objects magically transformed by a DNA-altering injection of exchange-value during the 19th century.

But this change in relations – a breakdown of the apartheid between people and things – had consequences for "both sides." As Rilke so eloquently put it, "relations of men and things have created confusion in the latter," suggesting a non-human confusion of roles in things that had once been *either* useful *or* sacralized, but never both. (A collapse baptized by Duchamp but anticipated by Bosch, Baudelaire and Brummel.) This identity crisis of the object had an effect on those who depended on them, and fashioned themselves through their presence. On the one hand, the intimacy and aura of objects which shared their lives silently with us, like respectful servants, began to drift from us "emotionally," through the logic of the simulacra documented so famously by Walter Benjamin. Yet on the other hand, Jean Baudrillard's "precession of the simulacra" gave these objects an uncanny potential to suddenly spring to life, like the broomsticks in Disney's *Fantasia*, refusing to submit a day longer to the realm of utility and use-value. More than the fear of human obsolescence as the hands (or rather "claws") or machinery, was the unsettling sense that "we" were no longer the protagonists of the story.

Hence the twin strategy of melancholia and fetishism to reterritorialize the object's attempt to "humanize" itself (defined by humans in their infinite arrogance as the will-to-intelligence). Melancholy, the first strategy, "would be not so much the regressive reaction to the loss of the love object as the imaginative capacity to make an unobtainable object appear as if lost."[12] That is, "in melan-

cholia the object is neither appropriated nor lost, but both possessed and lost at the same time."[13]

In an insight which returns us to Eklöf-Berliner-Mauer's compulsion to build model walls, fences and bridges, Agamben notes that:

> Precisely because the fetish is a negation and the sign of an absence, it is not an unrepeatable unique object; on the contrary, it is something infinitely capable of substitution, without any of its successive incarnations ever succeeding in exhausting the nullity of which it is the symbol. However much the fetishist multiplies proofs of its presence and accumulates harems of objects, the fetish will inevitably remain elusive and celebrate, in each of its apparitions, always and only its own mystical phantasmagoria.[14]

Fetishism – whether defined by Marx as the belief in a supernatural power of objects, or by Freud as libidinal transference – alters our relationship with the world of objects, and by extension, each other. Objects bear the burden of our all too human will; particularly the degraded will-to-power which has financial wealth as its "object." In an alienated-reified age where "the owner of a commodity will never be able to enjoy it simultaneously as both useful object and as value," the reflected nature of subjectivity begins to stretch into grotesque shapes and sizes in the funhouse mirrors of the marketplace.

Witnessing the full effect of this hyper-commodification, Baudrillard begins to build a critique of Marx based, on the one hand, on a more primal mode of symbolic exchange (Mauss, Bataille) lurking within advanced capitalism; and on the other, the de-materialization or "implosion" of the commodity with the sign (Calvin Klein, Tommy Hilfiger). Baudrillard's fatal strategy to counter the historical alienation of the subject is to shed such an auto-interpellation and "become-object." Such a strategy is not·to be confused with a will-to-objectivity in relation to reality, as with positivist science, but is rather an expression of the desire to escape the delusions of an ontological orientation which has notorious difficulty in processing the Real, and its own role in relation to it.

For Baudrillard then – and perhaps for Eklöf-Berliner-Mauer as well – the objectum is intrinsically bound up with a form of seduction unsullied by the logics of accumulation (whether this be of wealth or knowledge):

> Is it seducing, or being seduced, that is seductive? Yet being seduced is still the best way of seducing. It is an endless strophe. There is no active or passive in seduction, no subject or object, or even interior or exterior: it plays on both sides of the border with no border separating the sides. No one can seduce another if they have not been seduced themselves.[15]

3.

But we have merely postponed the question of "why love?" One answer may lie in the primary school *rite-de-passage* of being herded into the gym to watch Albert Lamorisse's *The Red Balloon*, in which children learn to diligently exercise their fledgling sympathies not only for each other, and the young protagonist of the movie, but also for the red balloon itself.[16] Watching this film, and others much like it (such as, say, John Carpenter's *Christine*) is in effect a virtual initiation into an affective relationship with the object. Children usually have no trouble with integrating this into their own experience, having grown up with various security objects; whether these be a blanket, a teddy bear, a thumb, or a breast.[17]

And let us not forget that in the Freudian universe, before our Fall into the post-Lapsarian world of the commodity, we can barely distinguish between the Self and the Mother, the Breast and the World: a confusion which persists in the syndromes and symptoms under discussion. Beginning from this rather orthodox perspective, we can reverse the usual assumption that we merely project human sentiments *onto* objects which act as avatars or scapegoats for our surplus affects. Indeed, perhaps it is only our advanced anthropocentrism that assumes the cotton-reel of the famous *fort-da* game is a metaphor for the mother, rather than the cognitive trigger for thinking through the more fundamental drama of simply Being and Non-Being *tout court*.

Similarly, we could consider the notion that it is the unsettling *presence* of objects which disturbs our underlying categories of Being, categories which are more cultural-historical than ontological. Like those landowners in the American South, who could never quite shake off the unpleasant recognition and proximity of their slaves (that is, their *property*), we laugh uncomfortably at puppets and scarecrows and other mimics of self-posited subjectivity. And we do this to silence their ontological and ethical imperative.[18]

But once again, we see evidence of humans responding to this call. Take for instance, this court transcription from day 131 of the Australian government's Royal Commission's inquiry into the collapse of insurance company HIH. Wayne Martin QC is examining the disgraced executive Raymond Reginald Williams:

> Martin: "Could you tell us please if, on your frequent first-class trips to London, you booked the seat next to you for your briefcase?"

> Williams: "I don't recall specifically. But that may have been the case, on some occasions."

Martin: "That your briefcase was also travelling first class?"

Williams: "That may have been the case."

Martin: "Did you express the view to Qantas that this briefcase should be eligible for frequent flier points?"

Williams: "I can't recall that."

Martin: "And were you subsequently informed that said briefcase would not be eligible for such points on the grounds that it was not, in fact, a person?"

Williams: "That may have been the airline's position on that issue."

Martin: "Was that briefcase, from that point on, booked under the name of Casey Williams?"

Williams: "Casey Reginald Williams, AM."[19]

Of course it is flippant to employ such an example in the services of reappraising the Great Chain of Being in the 21st century, but the mere fact that such a surreal conversation took place in the official and public discourse of State business – at the highest level of the law – says something about the increasingly animated role of objects in our everyday lives.

4.

One of the centerpieces of Jean-Paul Sartre's ontology is a large section of *Being and Nothingness* entitled "Concrete Relations with Others." This detailed treatise on intersubjectivity is probably the longest ever answer to the aggressively phrased question, "what are *you* looking at?!" By rephrasing this title to "Relations with Concrete Others," we hope to make up for some of the more subject-centered assertions of Sartre's system.

For instance, Sartre defines the world as "the totality of beings as they exist within the compass of the circuit of selfness."[20] To be sure, these beings are involved in the elaborate waltz of the "transcending" and the "transcended," however there is little doubt that this choreography is for the benefit of "human reality." In the case of sexual possession, Sartre's scheme depends on capturing or

appropriating the freedom of the other; for the lover (always gendered as male) "does not want to possess an automaton."[21] And why? Because "[t]his captivity must be a resignation that is both free and yet chained in our hands."[22]

Clearly making love to walls and fences falls beyond the boundaries of such an inter-*subjective* system. This is in itself nothing remarkable – indeed, it would be quite scandalous for Jean-Paul to anticipate objectum-sexuality within his *magnum opus*. And yet Sartre's ontology constantly refers to the objectification of the other, up to and including the point where the beloved "consents to be an object."[23] But in this inter-folding complexity, the object is not simply an inert thing to be used and abused, but "the object in which the Other consents to find his being and his *raison d'être* as his second facticity – the object-limit of transcendence."[24] Perhaps here we have the beginnings of a post-humanist libidinal economy.

He continues:

> If the other tries to seduce me by means of his object-state, then seduction can bestow upon the Other only the character of a precious object "to be possessed." Seduction will perhaps determine me to risk much to conquer the Other-as-object, but this desire to appropriate an object in the midst of the world should not be confused with love.[25]

One wonders what Eklöf-Berliner-Mauer would make of such a statement (or indeed The Berlin Wall, if it were still with us).

In Sartre's "game of mirrors," to recognize the subjectivity of the other is to realize the objectivity of the self *for that very same subjectivity*. Hence the speed with which erotic relations can slip into either sadistic or masochistic modes, in order to break this agonistic solipsistic-paranoid circuit (given the echoes of Hegel's master-and-slave dialectic between Sartre's words).[26]

For Sartre, and no doubt 99.9% of the world's human population, to experience oneself as an object is bound up with a profound sense of shame. Moreover, this ontological shame of (the) naked being (perhaps related to Agamben's notion of "bare life"), is a symptom of our own anthropocentrism. "I desire a human being, not an insect or a mollusk, and I desire him (or her)[27] as he is and as I am in situation in the world."[28] Such a statement betrays a stark lack of imagination, ignoring – amongst many other things – those Futurist parlour games in which men morphed into trains, battle-planes and aliens, while women transformed themselves into heavily-symbolized tropical foliage, geodisic domes, or screeching birds of paradise.

In our own avant-garde texts, the human protagonist of William Gibson's

novel *Idoru* blushes when he looks into the eyes of the holographically produced virtual pop star Rei Toei. What does this mean for a world only beginning to include digital beings in its own psychic census of the planet's population? Emerging versions of artificial intelligence are sure to both complicate and enhance the limits we place on our own erotic kingdom ...

... which is not to promote some kind of orgiastic response to the world of objects (ravishing toaster ovens and so forth), in which we might merely extend our terrestrial conquest by sexual means. Rather, it is to attune ourselves to those "vibrations" – in Heidegger's sense of an intra-mediated ontological (id)entity – of those existents with whom we share space and time. (After all, from the perspective of micro-physics there simply is no difference between people and things; and as a consequence, it is indeed a faith in animism that sustains the self-identification of humans *as* humans.)[29]

Despite Sartre's dismissal of Heidegger's system as "asexual," both share an emphasis of the *in situ* essence of encounter. We may become distracted and obsessed with the flesh of the other – Clare's knee, for example – but Sartre insists that "we do not desire the body as a purely material object," simply because "a purely material object is not *in situation.*"[30] Such a highly-tuned observation can fortunately be refuted by the all-purpose retort: "Says who?" Since here Sartre falls back on the legacy of Descartes, the ascendancy of "consciousness" and something he calls "organic totality" (as if objects were automatically somehow artificial or synthetic).

By contrast, Heidegger insists that any "point of departure from an initially given *ego* and subject totally fails to see the phenomenal content of *Da-sein.*"[31] Where for Sartre the pure being-there of *l'autrui* is "like a yeasty tumescence of fact,"[32] for Heidegger it is less a brutal opacity – or bad case of thrush – than a challenge to be accepted. Beginning with a critique of Descartes' definition of the *subjectum* as *res extensa*, *Being and Time* moves through – amongst many other considerations – a contextualization of Being in its originary relation to "thingliness." Taking the example of a hammer, Heidegger argues that objects and their objective presence reveal themselves by way of reference, specifically handiness or unhandiness. Useful things do not warrant our ontological attention, since they are bound up with the "total relevance" of the utilitarian situation. However, when a hammer becomes dysfunctional, it suddenly reveals its object(ive) presence to us: "When we come upon something unhandy, our missing it in this way again discovers what is at hand in a certain kind of mere objective presence."[33] The unhandy object becomes obtrusive, and thus *intrudes* on the ontic continuity of everyday life (a distinction which continues to drive the desire to produce art and

48

related aesthetic objects).[34] The unhandy object suddenly becomes conspicuous; a term which should also alert us to the modes of consumption that draw attention to the status of those who collect unhandy objects (known in the hip-hop community as "bling bling").[35]

But, asks Heidegger, what does this "modified way of encountering what is at hand" actually mean in terms of our comprehension of the world? The answer lies behind the phenomenon just mentioned; that is, the total relevance of circular reference through which the world makes itself known. The hammer connects to the nail, which connects to the beam, which connects to the roof, which connects to the facility of shelter, which connects to the nurturing of *Da-sein*, which connects back to the hammer. Only where there is a breach or break in this holistic continuity is this virtual totality *actually* revealed to us (suggesting a deeper functionality which lies at the heart of dysfunction). Via this process, "the surrounding world makes itself known"[36] – a world populated by objective presences: including (other) beings.

And these are the conditions for the Cartesian-Freudian ego to relinquish center-stage, and begin to acknowledge the constitutional power of what had previously been considered "mere props." Through the recognition that "we" in fact are part of a wider milieu (a machinic assemblage, if you will), objective presence is seen as something saturating the subject. Heidegger writes: "[Beings] are relevant *together with* something else ... To be relevant means to let something be together with something else."[37]

If we return to Eklöf-Berliner-Mauer for a moment, we can appreciate that she does feel the need to isolate different objects from their specific context:

> I "divide" all objects according this:
> 1. The construction (the object itself).
> 2. The purpose of the object.
> 3. The time period the construction is/was used in.
> This way I get the object free-standing from the rest. I have always done like this.

In an interesting rhetorical move (made explicit by the presence of the quotation marks), Eklöf-Berliner-Mauer uses the object's genesis, purpose and historical context to isolate it from those very same elements. The "free-standing" object is achieved in order to disrupt the referential continuity of Heidegger's system, so that it can better be the object of affection. After all, something must first be isolated before it can be loved.[38]

5.

In Stanley Kubrick's *2001: A Space Odyssey*, a mysterious monolith, which looks and behaves like a slab from an extra-terrestrial wall, beckons the massive "heedful adjustment" required to release ourselves from evolutionary stagnation. Merging the agendas of Arthur C. Clarke, Wagner and Nietzsche, the apes and astronauts respond to the intense objective presence of something which cannot be confidently assumed to be "alive," and yet which clearly communicates *something* to those who come into contact with it. (Again, in concert with the ideal incarnation of *Art* – if "in-carnation" did not already conflate "presence" with "flesh.")

A few years later, Led Zeppelin released an album simply called *Presence*, the cover of which featured an enigmatic black object, utilized in different ways by different groups of people in different social situations. The joke was that this object seemed both handy in its all-purposeness, and completely bewildering in its actual function. However, we would be hard-pressed to find a better illustration of the "symbolic object" as described by Pierre Lévy.[39]

Lévy takes his inspiration from Michel Serres, who in *Le Parasite* constructs a theory of the "quasi-object," which, simply by circulating, creates the community through the vector of movement.[40] One example is the football, which can galvanize an entire stadium of spectators into what Lévy (perhaps too hastily) calls "collective intelligence." Other examples abound, from the shells which move from hand to hand in a strictly regulated pattern around the Trobriand Islands, to the underground mix-tapes which foster and reproduce fanatical cells of musical subcultures.

From a humanist perspective, the objects are quite contingent aspects of the age-old need for community in all its forms; however, from the emergent posthuman perspective, the object is the very catalyst which calls community forth in order to complete its own Being. (And here we can recall Marshall McLuhan's provocative assertion that humans are merely the "sex organs of the machine world.") When viewed from such an angle, so-called "human constructions" in fact *use* humans as unknowing midwives for their own existence. When we build a wall, it is less the apotheosis of the molar need for shelter, than the whisper of the scattered, virtual bricks to become-wall.[41] (Such a process or logic can be found in artistic attestations to feeling more like an instrument for some greater design, than the master and author of an artifact.)

For Lévy, the dialectical interplay between object and subject first became palpable (and, no doubt, pulpable) with the advent of writing on papyrus; that

being, the semi-objectification of internal mental tensions. And thus begins the moebius process of cultural creativity:

> An emotion that has been verbalized or sketched on paper can more easily be shared. What was internal and private becomes external and public. But this is also true in the opposite sense: When we listen to music, look at a painting, or read a poem, we internalize or personalize a public item. As soon as we begin talking, we begin to externalize, objectivize, and exchange primarily subjective entities such as complex emotions, understanding, and concepts, which travel from place to place, time to time, and from one mind to another.[42]

Through the topology of the torus, we never completely absorb or excrete, but dwell around and within the simultaneity of both. And since "the shared object dialectically engenders a collective subject",[43] the historical development of "hominization" leads from papyrus to those "hypertext mechanisms [which] represent an objectification, exteriorization, and virtualization of the reading process."[44]

Lévy claims a special status for the Internet, which in its dynamic and constructed nature, he considers to be the "shared object" *par excellence*.[45] And as both the "distributed transcendence" *and* immanence of collective activity, the World Wide Web prompts him to wax lyrical about "the vertiginous sensation of plugging into the communal brain that explains the current enthusiasm for the Internet."[46] Lévy's vision of a digital "republic of minds" may be worrying enough, but when combined with claims that the Internet enables "the transition from collective intelligence to intelligent community,"[47] we can only wonder what other kinds of objects Lévy has been relying on to churn out so many books on such topics, with such naïve optimism.

But despite these all-too frequent lapses into liberal teleology, Lévy is correct on at least three accounts. The first is that the cadaver lies at the origin of thinking on the ontological fractures between subject and object, and the virtual-temporal overlap between the living and the dead.[48] The second is the insight that our subjectivity is "exposed to the play of the shared objects that weave, in a single symmetric and complicated gesture, individual intelligence and collective intelligence, like two sides of the same cloth, embroidering on each surface the indelible and flagrant figure of the other."[49] And finally, it is difficult to refute the assertion that "communities possess no more intelligence than is contained in their objects."[50]

6.

In the late late late capitalist era, the desire to become-object is culturally tangible, and usually masquerades under the designation of the "post-human." From Andy Warhol's wish to become a motorbike, to Baudrillard's fatal strategies and objective seductions, to Stelarc's attempts to "become dry, hard, and hollow," people are both consciously and unconsciously reassessing the constitutive role objects play in their so-called subjectivities. Of course we could dismiss this as a purely masculinist fantasy – the body-loathing legacy of the Futurists, but this would be too hasty and too easy; ignoring the polygendered intimacy of objects. (After all, this essay was inspired by Eklöf-Berliner-Mauer, and her love for the Berlin Wall. And to this example we could add Björk's schizo-sexual videoclip for "All is Full of Love," as well as the universe of onto-erotic possibilities opened up in Rachel P. Maine's history of the vibrator, entitled *The Technologies of Orgasm*.)[51]

To quote Agamben once more: "the redemption of objects is impossible except by virtue of becoming an object. As the work of art must destroy and alienate itself to become an absolute commodity, so the dandy-artist must become a living corpse, constantly tending toward an *other*, a creature essentially nonhuman and antihuman."[52] In the twenty-first century, there are fewer cultural barriers between the local garbage man and the "dandy-artist," so that the human mechanisms designed to quarantine subject(ivity) from object(ivity) are crumbling like the Berlin Wall itself. (Although it is perhaps too early to make equivalences between subject and objects, West and East Germans, and the possibility of "reunification.")

Eklöf-Berliner-Mauer has even inspired one Brian Cotts to post a manifesto on the Web not only defending her right to have sexual relations with objects, but to see in such behavior the future of the species:

> We have to prepare ourselves for a world of objectum-sexuality. This is a logical extension of technology, of our society. Why shouldn't someone fall in love with the Berlin Wall? Why isn't this natural? Just because we're human does not mean we have to restrict ourselves to "loving" the merely human. Or the animate. Or the anthropomorphic. Or the organic.
>
> And who cares if the Wall can't love Eija-Riitta Eklöf-Berliner-Mauer in return? There have been countless – countless – examples of human beings falling in love with other human beings who do not return even the slightest fraction of love. This is not uncommon. So how is this any different than being in love with a wall?

What's more, "the Berlin Wall will never want to 'just be friends...'"

Epilogue 1

Things are not outside of us ... rather, they open to us the original place solely from which the experience of measurable external space becomes possible.
GIORGIO AGAMBEN[53]

When we were undergraduate university students in 1990, a fellow student impressed an entire room of people by producing a shoe box full of rubble, salvaged during the celebrations in Berlin the year before. For a group of Australians, this box seemed to contain a literal piece of history: illuminated within by the aura of European authenticity. It would certainly be difficult to claim that those present were sexually excited, as we passed the chunks of concrete from hand to hand, like a sacred relic, the paint flakes from graffiti still visible on one side. But we *can* say that the contents of this shoe box constituted an object-bond for that evening, and perhaps a little longer.

Looking back on this moment now, having made the virtual acquaintance of Eklöf-Berliner-Mauer, we feel a pang of sadness, for at no point on her website does she make mention of being a widow. (Indeed, were it not for the inevitable political complications, it would be tempting to run the film of history backwards, as the Lumière brothers did in 1896, so that the film *Demolition of a Wall* miraculously rebuilds itself.) She shares with us a picture of the wedding ceremony itself, back in 1979, before the Cold War had thawed into different global conflicts (and – perhaps only coincidentally – the year Pink Floyd released their mega-selling double album *The Wall*).[54] The quality of the photograph is poor, and we only see a shadowy figure clinging to a corner of the wall itself: just one of a million melancholy punctums floating around the world from modem to modem.

Epilogue 2

But where is the object? What is the grain of sand which has violated the solitude of the oyster-consciousness?
RENÉ GIRARD[55]

In his *Ethics*, Spinoza claims that, "There are as many kinds of pleasure, of pain, of desire, and of every emotion compounded of these, such as vacillations of spirit, or derived from these, such as love, hatred, hope, fear, &c., as there are kinds of objects whereby we are affected" (Prop. LVI). However, at the beginning of this article we heard Eklöf-Berliner-Mauer insist that "the feeling of love is always the same – it is the object for that love that may be different, but the *feeling* itself is still the same." What to make of such irreconcilable positions? Is love something that grows "within" and must be cathected onto others like Spiderman's sticky-web or Wonder Woman's golden lasso? Or are we the ones who become entangled in the affective tendrils of a global libido: the rhizomatic erotics of a radicle epoch?

Perhaps at this stage in our ontological awareness, answers are not as important as recognizing the stakes involved in the questions. For it is not only the status of the object that is ambiguous, but also the definition. And as long as "the object" of an action is simultaneously the agent, subject (as in "subject" under discussion/research), purpose, and goal ("our *object* is to complete these findings"), then we will have little to base even our most humble epistemological assumptions on. (Which is, of course, the first building block of any "we" to begin with.)[56]

Perhaps we were too hasty in dismissing Sartre above as too mired in humanistic models of interaction. Further on in his discussion of concrete relations he actually confronts the problem of concrete itself; as something more than the metaphorical counter-point to the abstract. "[I]t is as a reference to my flesh that I apprehend the objects in the world. This means that I make myself passive in relation to them and that they are revealed to me from the point of view of this passivity ... Objects then become the transcendent ensemble which reveals my incarnation to me."[57] Further:

> ... to perceive an object when I am in the desiring attitude is to caress myself with it. Thus I am sensitive not so much to the form of the object and to its instrumentality, as to its matter (gritty, smooth, tepid, greasy, rough, etc.). In my desiring perception I discover something like a flesh of objects. My shirt rubs against my skin, and I feel it. What is ordinarily for me an object most remote becomes the immediately sensible; the warmth of air, the breath of wind, the rays of sunshine, etc.; all are present to me in a certain way, as posited upon me without distance and revealing my flesh by means of their flesh. From this point of view desire if not only the clogging of consciousness by its facticity; it is correlatively the ensnarement of a body by the world. The world is made ensnaring; consciousness is engulfed in a body which is engulfed in the world.[58]

54

Within this extract we can see Sartre's genuine desire to connect with what might be dubbed "the wider world;" however, he cannot envisage this other than an engulfment, a suffocation, a negative external constraint, and ultimately death. Sartre's everyman is ultimately appalled by what he calls "the coefficient of adversity in things," and the unbearable cacophony of their harsh rudeness.[59] What could be more human? Indeed, what could be more masculine?

But we need not look too far for alternative ways of interacting with "the environment" as something more than background for human action. Orthodox Jews congregating at the Western or "wailing" wall clearly treat this object as something transcending mere objectivity, as a medium to divinity.[60] The same could be said for the stockbrokers on Wall Street, devoutly yelling their esoteric prayers to the almighty dollar. Indeed, as we write this, scientists at Lausanne's Federal Institute of Technology – inspired by biology and genomics, as much as computer engineering – have built *The Biowall*: a six square-metre concave wall and processing unit resembling a living organism. "Essentially, what we've done is to create electronic stem-cells and an electronic genome," explains Gianluca Tempesti, one of the scientists who worked on the project. "As in our bodies, the Biowall contains a collection of cells. Each contains all the information necessary to keep the system alive. Crucially, there is a supply of back-up cells, which are activated only when a fault is detected."

Such techno-organic developments can only encourage a new generation of objectum sexualities. Perhaps it is not straying too far from the realms of possibility to imagine a Mrs Eklöf-Biowall, whispering her erotic secrets into the flesh-plasma of her beloved; just as in the final scene of Wong Kar Wai's *In the Mood for Love*, whereby the unrequited lover whispers the intimate details of his tormented desires into the walls of Angkor Watt. This latter scene is as moving as it is bewildering, and it would be succumbing to either human habit or hubris to try to "solve the mystery," or file it under "sublime – don't bother." As Baudrillard states:

> We can only remember that seduction lies in not reconciling with the Other and in salvaging the strangeness of the Other. We must not be reconciled with our own bodies or with our selves. We must not be reconciled with the Other. We must not be reconciled with nature. We must not be reconciled with femininity (and that goes for women too). The secret to a strange attraction lies here.[61]

Better than hollow calls for reconciliation is to hear the flexible wisdom contained in another film, namely Lars von Trier's unprecedented musical, *Dancer in the Dark*. Selma's would-be lover is worried about her refusal to attend to her own failing

eyesight: a sacrifice she is willing to make in order to secure the same necessary operation for her son. To his question, sung in a shaky voice: "What about China, have you seen the Great Wall?" Selma replies: "All walls are great, if the roof doesn't fall."

The Elusive Object

"Look at the Bunny": The Rabbit as Virtual Totem (or, What Roger Rabbit Can Teach Us About the Second Gulf War)

"Myxomatosis"
Caught in the centre of a soundless field
While hot inexplicable hours go by
What trap is this? Where were its teeth concealed?

You seem to ask. I make a sharp reply,
Then clean my stick. I'm glad I can't explain
Just in what jaws you were to suppurate:
You may have thought things would come right again
If you could only keep quite still and wait.
PHILIP LARKIN

1. Follow the White Rabbit

This chapter begins with a decoy question: why bunny rabbits?

Certainly, the bunny rabbit looms large in the Anglo-American imaginary as a virtual totem for ontological uncertainty; and it is this thematic consistency of the role played by rabbits in cultural texts and discourses which interests us here. For while an analytical map of any given animal could yield interesting hermeneutic patterns, the rabbit has proven itself to be a catalytic object for dialectical questions of presence and absence, as well as metaphysical explorations of madness, sanity, and those existential forms of psychic liminality which lie between these relative poles.

To begin with, consider the prototypical magic act: pulling a rabbit out of a hat. This prestidigital standard has amazed and delighted children for many generations, since the hat seems to work as a kind of cosmic portal from which rabbits manifest themselves "as if from nowhere." Indeed, if pressed, the children may say that the hat serves as a kind of burrow leading to a parallel universe populated by bunny rabbits; suggesting that the particular bunny on stage is a kind of tourist in our own dimension. There may or may not be a puff of smoke, helping the bunny make the remarkable transition from *not-there* to *there* – a transition which subliminally initiates the children into the basic philosophical question: "Why is there something and not nothing?"

Doubtless, once again, a hamster or a dove could serve the same function as the rabbit, but for some mysterious reason the latter is the creature endowed with the greatest symbolic weight. So while our decoy question may be "why rabbits?", we are actually using this question as a portal to understand the psychosocial subtext of a particular genealogy involving rabbits as ontologically unstable, *virtual* creatures. Creatures which sometimes help, and at other times hinder, our comprehension of what it means "to be" and/or "to become" in different media-historical contexts. As with *Alice in Wonderland* and *The Matrix*, we will try our best to follow the white rabbit, enlisting various bunnies drawn from films like *Harvey* (Henry Koster, 1950), *Who Framed Roger Rabbit?* (Robert Zemeckis, 1988), and *Donnie Darko* (Richard Kelly, 2001) – as well as books like Richard Adams' *Watership Down* and John Steinbeck's *Of Mice and Men* – in order to see just how unfamiliar and unsettling these "familiars" can be.

All the while another, altogether different, question attempts to pull itself out of the hat, drawing our methodological focus in the opposite direction. This alternative question reflects on the way in which "looking at the bunny" has become a relatively common term for the process of being distracted from more important events unfolding nearby, denoting a very deliberate form of diversion. What is it, then, we ask, that we are *not* seeing – as a culture in general – when we become too entranced by the antics of real or imagined bunny rabbits?

2. Shadow Puppets

You have shown me a strange image, and they are strange prisoners.
GLAUCON, IN PLATO'S *REPUBLIC*[1]

Much has been made of the perceived link between the shadows flickering on the walls of Plato's cave, and the various distractions of the contemporary spectacle; whether this latter is figured as the identifiable simulacra of "the media," or the even more all-englobing consensual hallucination of "the Matrix." Plato himself is not too specific about the form or content of these shadows, making reference to "all sorts of vessels, and statues and figures of animals."[2] (Certainly, if everyday experience is anything to go by, the rabbit is one of the most popular shadow puppets due to the recognizable pointy ears; so we could perhaps presume that these "strange prisoners" were watching bunnies ... but this is to indulge in pure conjecture.)

What concerns us here, however, is the homologous role of the shadows – no matter what they represent – with the function of the bunny rabbit in the mod-

ern phrase: "look at the bunny." For while the origin of this phrase is quite obscure, it extends all the way back to the Platonic process of distraction. Hence we have the situation where a man manages to escape from the cave, but is dazzled by his new surroundings, with the result that he continues to believe that "the shadows which he formerly saw are truer than the objects which are now shown to him."[3] And so when we say "look at the bunny" to a child who is about to receive a painful doctor's injection (perhaps employing a hand puppet provided for just this procedure), we form part of a conspiracy with far-reaching implications. Elements such as the operator (doctor), operation (inoculation), *telos* (health), subject (child), and decoy (parent-bunny complex) thus constitute a paradigmatic assemblage for much cultural activity.

For, on the one hand, we have the metaphysical distraction of Plato's cave – a fetish of shadows rather than the objects which lie at their source. And on the other we have the more strategic, "political" distraction of using one object to draw the attention away from another: the logic of the decoy. The question at the heart of many studies linking Plato's cave with the wider social media concerns the extent to which we can separate these two forms of distraction, and whether or not they are in fact interdependent, even in the original text. The critique of capitalism, given a fresh boost in the academy by the deployment of the term *Empire* by Hardt and Negri, sees little difference between a philosophical project of compromised vision in relation to concepts such as "the good," "the unthought," "pure form" etc., and the political project hostile to those advertising companies which churn out shadows on a daily basis, for projection on the walls of our own personal, IKEA-decorated caves.

Interestingly, the proleptic powers of Plato extend as far into the future as the Academy Awards, as witnessed in the section which reads: "And if they were in the habit of conferring honors among themselves on those who were quickest to observe the passing shadows and to remark which of them went before, and which followed after, and which were together; and who were therefore best able to draw conclusions as to the future, do you think that he [i.e., the enlightened-Keanu-Reeves-Jim-Carey-type figure who has escaped the Cave-Matrix-Seahaven] would care for such honors and glories, or envy the possessor of them?"[4] Thus those figures who refuse to accept their Oscar statuette, like Marlon Brando and George C. Scott, subconsciously play the role of the Platonic character who has escaped the seductive irrelevance of the shadows; to become the exceptional person who refuses to "look at the bunny."

But what is it that has the power to break the hypnotic power of these flickering images, especially in the modern context? Well, ironically enough, the bunny rabbit figure itself. For just as Alice follows the march-hare down the rabbit hole

leading to Wonderland, Neo (Keanu Reeves) is inspired by the tattoo of a rabbit to execute the series of events which will short-circuit his slavish access to the Matrix. In these two symptomatic bookends of the twentieth century – which in a certain sense traced an arc from Lewis Carroll to the Wachowski Brothers – the bunny is a slippery figure which may or may not be in the service of cognitive (re)orientation.

3. Surfing God's Channel to ToonTown

For some time now I have used the metaphor of the rabbit and the hat in connection with a certain way of making something appear from analytical discourse that isn't there. I might almost say that on this occasion I have put you to the test of eating raw rabbits. You can relax now. Take a lesson from the boa constrictor. Have a little nap and the whole thing will pass through.
JACQUES LACAN[5]

Richard Kelly's debut film *Donnie Darko* is a rather ragged attempt to wed David Lynch's surreal suburban Gothic enigmas, with the angst-ridden search for existential answers posed by the average Marilyn Manson fan. It does, however, continue the proud tradition of featuring a rabbit with dubious ontological credentials (albeit a rabbit with a pronounced insectoid-skull mutation). Donnie himself is a high school senior with "emotional problems," who sees daylight hallucinations of Frank the Giant Bunny Rabbit, even when taking his medication.

Two details are worth noting: the first being that Donnie is definitely aware that the rabbit is "not real." For when his psychiatrist asks if Frank is real or imaginary, he answers the latter. The second point is that Frank is not so much a bunny rabbit, as a person wearing a bunny rabbit suit.[6] These details intertwine as the film develops, along with its obsession with virtuality, time travel and predestination. At one point, Donnie can see the virtual path of people's movements before they happen, visualized by a "vessel" or "vector" or "sphere" that extends out from the chest. In following this vector (which looks like a horizontal tornado),[7] Donnie can *see* what is going to happen before it happens; as if the universe is predestined by God, and one need only this form of second sight to anticipate the next move. Indeed, he explains this process to his psychiatrist in similar terms: "Every living thing follows a set path," and thus follows "God's channel." Moreover, the central problematic of the film pits this statement against the possibility of altering fate – a tension which unfolds under the knowledge that "every living creature on Earth dies alone."

Freudian resonances are, as always, present, but should perhaps be considered red herrings. Donnie asks his friends: "What's the point of living if you don't have a dick?" and also confesses to his shrink that he follows the bunny into his parent's bedroom. "What did you find?" she asks. "Nothing," he says, in blank denial.[8] From this perspective, the self-destructive time loop (signalled by the skeleton suit that Donnie wears during his Halloween party: a form of virtual iconography or "premediation"[9]), forms the circular arc of the death drive, leading from the womb via the tomb back to the womb again.

The significance of these "time portals" or "wormholes" should not be reduced to the psychodrama of the traumatized ego, but extended out to link-up with other intertexts. As already mentioned, bunnies seem to be the guardians of portals into parallel universes; acting as guides through the looking glass, often teasingly leading people towards the Brigadoon of human happiness.[10] At one point Donnie talks to Frank the Rabbit through a liquid mirror, recalling the genealogy linking Alice to more recent wonderlands. In fact, this reference to Alice should not be underestimated in this or other contexts, especially – and this may at first seem surprising – as it invokes the recurring theme of paedophilia. For if the "wonderland" trope is traced from its origin to those texts inspired by the Alice mythology, bunnies emerge as a decoy for more disturbing urges and activities. Even without alluding to Michael Jackson's *Neverland* fantasy project, we can appreciate the split symbolism of "innocence" which is both created and violated by the modern "invention of childhood." Bunny rabbits play a key role in this discursive development, as witnessed by the constant presence of "space-bunnies" in the BBC's *Teletubbies*, whose "sex(uality) ... seems at once over-explicit and unspecified."[11]

The troubling ambiguity of Alice's erotic ambience has only increased with each published biography of Charles Dodgson's (i.e., Lewis Carroll's) hobby of photographing young children with loving attention. From a certain perspective, this hobby could be seen as a symptom of a creative mind responding to the dawn of the age of mechanical reproduction, and the ways in which technologies circulate within the libidinal economy of virtuality itself (that is, the way minors/mirrors begin to function as signifiers of purely potential sexuality). Jan Svankmajer, in his semi-animated version of *Alice*, was not shy about emphasizing this aspect of Carroll's story. Furthermore, in that *other* 1988 film blending animated with "real" actors – *Who Framed Roger Rabbit?* – eagle-eyed viewers will spot the graffiti, "For a good time, call Allyson Wonderland" (a strange joke for a kid's movie).

In fact, the shift from copy to simulacra, effected during Carroll's lifetime, could be described as a change in paradigm from Plato's cave to Alice's looking-glass. J.G. Ballard's novel *Super-Cannes*, in some ways the ultimate statement of late postmodern globalization, reserves a special role for Alice, since the intrigue

revolves around a library stacked with multiple copies of Carroll's book, each one representing an orphaned girl available for abuse by successful, corrupt corporate types. (Just as the prepubescent dance group "sparkle motion" is exploited for similar purposes in *Donnie Darko*.)

However, it is possible that the cultural matrix of *Alice-liminality-sexuality-bunny rabbit* is simply related to the child's capacity to imagine things which are not strictly "there." While training for his part in *Roger Rabbit*, Bob Hoskins watched his young daughter to learn how to act with imaginary characters. In an interview with *Starlog* magazine, not long after the film premiere, Hoskins explained how she

> was three at the time, and she had all these invisible friends whom she talks to
> – Geoffrey and Elliott. And I realized that, as we get older, our imagination goes
> further and further to the back of our head. When we're a kid, we can actually
> take it out and look at it. I mean, we can see it. As we get older, senility comes
> in, and the imagination comes to the forefront again, and takes over. So, I just
> concentrated on an immature imagination – forcing it back to the front so I
> could actually take it out and look at it. And I managed to actually see them,
> which was all right, but you do it for sixteen hours a day for five months! I start-
> ed to lose control and hallucinate in all kinds of embarrassing places. Some of
> it's quite rude, but there's not much you can talk about. At one point, it was
> quite frightening, weasels and all sorts of things turning up.[12]

Thus, in an uncanny reverberation of both *Harvey* and *Donnie Darko*, Hoskins starts hallucinating "actual" bunny rabbits. (Indeed, speaking on the *Parkinson* talk show a few years later, Hoskins was still clearly haunted by the experience, despite using it as the basis for jokes).

The 2003 "featurette" *Behind the Ears*, filmed for inclusion with the DVD special edition of *Who Framed Roger Rabbit?*, features a wealth of observations by the production team on the "blurry line" between the cartoon world and what they call the "live-action" world. In fact, the experience of making the film seems to have served the function of one of those ACME "portable portals"[13] that saves Eddie Valiant's life at one crucial point in the story, allowing them a glimpse of another parallel universe. (Indeed, all the animators have the same protruding eyes, which suggests that they have all been staring at "the other side" for quite a while now.)

Charles Fleischer, the actor who provided the voice for Roger Rabbit himself, is also clearly a little crazy; at least according to his co-stars. From his decision to wear a rabbit suit from day one of shooting, despite engaging in strictly "off-cam-

era acting," to his exposition of "trans-projectional acting," Fleischer is clearly a graduate of the F. Murray Abraham school of delusional thespianism. Seeing him talk so earnestly about the process, however, dressed as a two-bit, flea-bitten rabbit, is yet another revealing glimpse of the bunny-as-totem. (Indeed, it is not a stretch of the imagination to see the same character in *Donnie Darko*.) Which is not to isolate Hoskins or Fleischer as psychic victims of "this monster," but to emphasize the fact that the very production process of the contemporary spectacle leads to the point described by Ed Jones, the optical photography supervisor: "All of us were loony tunes by the end of it."

However, if we get diegetic for a moment, we can see how the same tropes are transported inside the frame of the film. In the opening scene, which is 100% animated, Roger is warned to behave by the mother of the house, or else he's "going back to the science lab" (a clear and perverse reference to the less-than-cute fate reserved for most bunny rabbits). The main story which follows, unfolds in Hollywood 1947, focusing on private investigator Eddie Valiant (Bob Hoskins), who refuses to "work ToonTown" since a Toon killed his brother with a falling piano. From the beginning, it is clear that Toons are second-class citizens, flagged by the disparaging way Valiant dismisses "toons" (as in "coons"), and the fact that many of them – Dumbo in particular – "works for peanuts."

Being the alcoholic, broke, film-noir cliché that he is, Valiant takes a job involving Toons, despite his bitter reservations, noting in a prophetic meta-comment (given Hoskins' gruellingly surreal onset experience), "the job's ridiculous." During this job Eddie warms to these creatures from the wrong side of the tracks, and attempts to foil not only a vast real-estate swindle, but full-blown genocide of Toons by a renegade Toon-turned-humanesque character, Judge Doom.[14]

Anticipating chapter 6 somewhat, dedicated to the trope of public transport, we can point to the fact that Judge Doom's foiled evil plot centers on the dismantling of Los Angeles' tram system (ironically "the best public transportation system in the world," back in 1947), in order to clear the way for today's dystopia of freeways, billboards and roadhouses. In a thinly-disguised reference to the ethnically coded survival (whether it be the "safe haven" of Israel, also "created" in 1947, or the many metropolitan struggles against gentrification), ToonTown is eventually saved from these diabolical plans. And so, the equation between joy, enchantment and public transport is made explicit; along with the key role of a rabbit that is, and is not, *real*.

4. The Private Life of the Rabbit

We have already identified the *illicit* subtexts of rabbit-related sexuality, but we need not dwell on this alone, for there are many instances of a more socially-visible form: namely, *adult*-bunny-sexuality. The most obvious, of course, is the Playboy empire, founded on the famous logo of the eponymous bunny. But while we have traced an outline of the bunny-trope, we have made little progress in explaining the *sexual* association, or even appeal, of the rabbit. It seems altogether too far-fetched to suggest that the girls in the employ of Hugh Hefner, wearing cotton tails and bunny ears, incarnate some kind of sublimated curiosity in bestiality (despite Donna Haraway's enthusiastic promotion of the practice in her cyborg manifesto). Rather, it seems more related to their symbolic role as the mascot of procreation; that is, as creatures which .. well ... breed like rabbits.[15]

Picking up on the bunny-bombshell motif, *Who Framed Roger Rabbit?* introduces the now iconic Jessica Rabbit, who has since become something of a standard figure in the tattoo and cartoon fan world. Indeed, Jessica (who is not a rabbit, per se, but a human Toon *married* to a rabbit), was so successful as a sex symbol, that certain scenes had to be reanimated in order to ensure anxious parents that she is wearing underwear. The voice for Jessica was provided by Kathleen Turner; however, Betsy Brantley, a virtually unknown starlet, served as the body model. (A process which seems to have reached its apotheosis with the new CGI characters such as Lara Croft and S1m0ne, both of whom have an originary-isomorphic relationship with flesh-and-blood women.)

A quasi-structuralist reading of the film would no doubt emphasise how crucial Jessica is to the narrative: she mediates between the "real" world of filmed humans and the "artificial" world of Toons, being at once human and Toon. Moreover, she can be a legitimate object of desire for humans insofar as she is doubly inaccessible: both Toon *and* married to one. "Rabbit" becomes at once proper noun, married name, and patronym — and absolutely improper insofar as it derives from something that's neither really real nor really a rabbit. And because Jessica is married to such a hysterical, clearly "feminized" cartoon rabbit, it's just as "clear" that her relationship with Roger *cannot* be a sexual one. "He makes me laugh," she finally explains to Eddie (no doubt giving the audience another chance to dream of impossible cartoon sex).[16]

Such digitally-created characters suggest that we may be moving closer to an age where we may indeed interact with virtual characters in a culturally-acceptable form of "daylight hallucination." For while we are expected to be polite to (an underpaid guy dressed as) Bugs Bunny when we encounter him in Warner Bros Movie World, we are not yet prepared to psychosocially assimilate holographic

versions going door-to-door (first deployed, no doubt, in the services of marketing). Spokespeople for the "imagineering" industry tell us that it is only a matter of time before the avatars found in video games and contemporary cinema step out of the screen and into what we now simply refer to as RL (Real Life). In which case, ToonTown will indeed be a place where the animate and the animated rub shoulders in a strange kind of ontological co-existence.[17]

As usual, science fiction has anticipated just such a scenario. In William Gibson's 1996 novel *Idoru*, the human protagonist, Laney, blushes when he finally finds himself face-to-face with the virtual pop star Rei Toei, whose bodily presence is in fact projected by a sophisticated hologram device: "He looked into her eyes. What sort of computing power did it take to create something like this, something that looked back at you?"[18] The fact that Rei's gaze prompts a flush to his cheeks suggests that she is not simply a hallucination; but that some kind of unprecedented intersubjective encounter is taking place – despite the humanistic logic which would affirm that this is not possible.

Moreover, today's digital technologies are allowing increasingly believable on-screen interactivity between advanced "Toons" and humans; something the overworked, hand-painting animators of *Roger Rabbit* could only dream about. The CGI character Gollum in Peter Jackson's *Lord of the Rings: The Two Towers* (2002) is one such generation of Idoruesque credibility, despite being more convincing in close-up than when placed beside human actors – and, in close-up, perhaps more convincing than many of the humans themselves. Unfortunately, there is no opportunity here to further explore the link between this coded virtual creature and the claymation Golem of Jewish legend (especially as treated by Derrida). However, it is worth mentioning that the genesis of the biological and the digital are not so different as they may initially appear, since the animators of *Shrek* tell us that one small glitch in the code can lead to a strange "explosion" of the molar character, as happens with DNA glitches during the cloning process. Does this point to a deeper connection between digital information and biological information? And if so, what does this analogous relationship tell us about the process of emergence, or life, or intelligence?

Thus while we have strayed a little from the realm of rabbits, we are still close to the elusive line which separates the virtual from the actual, and the subject from the object, since both Bob Hoskins and the viewer experience the same uncanny connection as Laney and the Idoru, when face-to-face with Jessica Rabbit.[19]

But we have yet to address two of the most influential texts on invisible rabbits: John Steinbeck's novella *Of Mice and Men*, and Henry Koster's 1950 film *Harvey*.

In the former, we can see the treatment of themes already explored in our analysis. The large simpleton Lennie Small is forced to hit the road with his smarter side-kick George, after refusing to let go of a little girl's red dress, and being subsequently chased out of town. (That is, after the girl "rabbits in an' tells the law she been raped.")[20] The book is at pains to make clear, however, that Lennie has the intellect and spirit of a child, and therefore this attraction had little to do with a predatory instinct, but is rather the expression of his innocent desire to stroke pretty things, on a purely sensual level. Nevertheless, this desire seems to have a habit of spiralling out of control, since he accidentally kills a puppy with his crude attentions: a prelude to doing the same with a young woman simply called "Curly's wife" (described as "jail bait," despite being old enough to be married).

This rather tragic canonical tale is perhaps most famous for the now popular refrain: "tell me 'bout the rabbits." This phrase, itself following the plague vector of bunny rabbits around the world, was promoted by Robin Williams during his early career as a stand-up comic; and has since become something of a catchphrase to be used whenever someone needs solace or motivation. For this is, of course, how the phrase is used in the book. George is forever being prompted by Lennie to *tell him 'bout the rabbits*, in order to take his mind away from the brutal, menial, vagabond life which has befallen them. His friend George uses the image of a peaceful life, tending rabbits, to soothe the simple fellow to sleep, only to threaten its withdrawal to make him behave. Thus the image of rabbits – their virtual presence in Lennie's life, as it were – functions like a carrot dangling in front of a donkey; goading him forward, and keeping him on course.

Lennie's monomania is often exasperating to the man whose voice has the power to constantly evoke these rabbits into life: "The hell with the rabbits. That's all you ever can remember is them rabbits."[21] As Lennie drifts into sleep, his imagination paints the scene in hallucinatory shades: "Let's have different color rabbits, George." To which the latter replies, "Sure we will .. Red and blue and green rabbits, Lennie. Millions of 'em."[22] However, when George decides to threaten the rabbits with premature extinction, Lennie becomes defensive, stating the counterthreat that he "can jus' as well go away ... an' live in a cave."[23] (An interesting choice of retreat, given the Platonic genealogy of distraction.)

Steinbeck is well aware that these rabbits serve a virtual function for Lennie; to the extent that he prompts this character to threaten any "future cats which might dare to disturb the future rabbits."[24] The object, in this case, constitutes one of those "incalculables" that Heidegger refers to in his "Age of the World Picture" – immaterial, unquantifiable phenomena which, in contrast to Plato's cave, casts an *in*visible shadow over the world. According to the argument of this same treatise, Lennie is trapped within the representational limits of the world-picture, for

where a Hellenic subject awaits the coming-to-presence within *fantasia*, the modern man "as representing subject ... 'fantasizes', i.e., he moves in *imaginatio*, in that his representing imagines, pictures forth, whatever is, as the objective, into the world as picture."[25] And so, Lennie is not the only person who navigates the world through a visualization of the future (a visualization which in facts contributes to the *construction* of any such future; much like the vessel-vectors in *Donnie Darko*). George and another character, Candy, both buy into the fantasy of freedom, private land and unalienated labour: Lennie just makes it more obvious by constantly vocalizing the utopia ahead of him.[26]

The stress of unintentional murder, and the swift retribution that is bound to follow, provokes a breakdown in Lennie's mind, so that these virtual rabbits combine into one megabunny, which leaps out of his head and into the world. At first this vision looks uncannily like his stern Aunt Clara, but then she soon morphs back into a gigantic rabbit which happens to speak in Lennie's own voice: "Tend rabbits," it says scornfully. "You crazy bastard. You ain't fit to lick the boots of no rabbit. You'd forget 'em and let 'em go hungry. That's what you'd do."[27] As with *Donnie Darko*, the central fear seems to be loneliness and abandonment, for the rabbit taunts him with the mantra: "He gonna leave you, ya crazy bastard. He gonna leave ya all alone" – meaning, of course, his only friend George. When the latter finally finds him, a few minutes ahead of a lynch-mob, the rabbit scuttles back into Lennie's brain, only to be blown to smithereens in an act of tragic compassion. Again, as with *Donnie Darko*, the disturbing hallucinations are only "cured" through death. Hardly the message we usually associate with cute, cuddly bunnies.

5. Nobody Here But Us Rabbits

Dr. Sanderson: "Trauma ... It means shock. There's nothing unusual about it. There's the birth trauma – the shock of being born." Elwood P. Dowd: "That's the one we never get over."
HENRY KOSTER'S *HARVEY*

Psychoanalysis plays a large role in *Harvey*; an increasingly forgotten film adapted from the Pulitzer Prize winning play by Mary Chase. The protagonist, Elwood P. Dowd (James Stewart) continuously disturbs his family and the town in general by insisting on always introducing his good friend Harvey. The disturbing aspect concerns the fact that Harvey is a 6 foot 3 inch white rabbit, which nobody else can see. Elwood's aged sister Veta is fed up with the resulting social stigma, and

decides to commit him to a sanitarium, whereupon – in the lingo of the business – "hijinx ensue."

Veta makes the mistake of admitting in her exasperation to the resident psychiatrist that every once in a while, she even sees this rabbit herself. The psychiatrist, Dr. Sanderson, realizes that this woman is somewhat "jumpy" and – after confirming a bout of depression following the death of her mother – commits her instead; at least until the mix-up is straightened out. As the story unfolds, however, the viewer is given certain clues as to the actual existence of Harvey, beginning with the discovery of a hat with two holes cut in the crown (presumably for rabbit ears to fit through). The second clue comes when the sanitarium's strongman, Mr. Wilson, turns to the encyclopaedia to look up the unfamiliar word "pooka." He reads aloud, for the benefit of the viewer:

> "Pooka ... from old Celtic mythology. A faery spirit in animal form – always very large. The pooka appears here and there, now and then, to this one and that one. A benign but mischievous creature. Very fond of rumpots, crackpots, and how are you Mr. Wilson?"

Mr. Wilson pauses in surprise, before repeating: "How are you Mr. Wilson? *Who in the Encyclopedia wants to know?*"

Another key scene occurs when the head of the sanitarium, Dr. Chumley, goes to Veta's house in order to both smooth-out the potentially litigious confusion, and to bring Elwood back to the clinic for treatment. A painting on the wall, recently put in pride of place by its subject, depicts Elwood with Harvey himself, the only visual representation afforded the viewer of the pooka-rabbit.[28] Before noticing the actual painting, Veta gives Dr. Chumley a lecture on art in the age of mechanical reproduction:

> "I took a class last winter. I learned the difference between a fine oil painting and a mechanical thing, like a photograph. The photograph shows only the reality. The painting shows not only the reality, but the dream behind it. It's our dreams, doctor, that carry us on – they separate us from the beasts. I wouldn't want to go on living if I thought it was all just eating and sleeping and taking my clothes off ... I mean putting them on."

In contrast to his sister, Elwood ("the screwball with the rabbit") seems to have discovered the secret of living in a world largely comprised of the banal, the quotidian and the disenchanted. Despite the fact that his best friend is a giant invisible rabbit, and drinks martinis almost constantly, Elwood seems to be one of the

most down-to-earth people in town. Unlike the other characters, driven by social vanities and other "flyspecks" of daily distraction, Elwood harbours no prejudice or discrimination between people, places and situations. Straddling the line between saint and sociopath, he seems to have no recognition of class and its importance, despite his wealth, so that hardly a scene goes by without him handing out his card to taxi drivers, nurses, jailbirds, gatekeepers, etc. What's more, this isn't a business card, but simply a calling card: a token of the willingness to expose one-self to another human being, prior to any judgment on social purpose or personal compatibility.

And yet, despite the increasing number of clues as to Harvey's actual exis-tence – to which the viewer, by the end of the film, is not left in any doubt – Elwood is re-committed to the sanitarium in order to have an injection designed to cure his "third degree hallucinations."[29] This despite the fact that the head of the facility, Dr. Chumley, has seen the rabbit, and is convinced of its supernatural powers. The film thus emphasizes the limitations – indeed the dangers – of the sci-entific perspective on paranormal phenomena; habitually dragging it within the diagnostic realm of mental health, and the attendant modes of curing and con-taining "madness."[30] (A process famously described and denounced by Foucault.) And so, only minutes before rolling up his sleeve to receive the prescribed injec-tion, Elwood is talking privately to Dr. Chumley about the magical powers of Harvey, subtextually reinforcing the film's critique of the impoverished system of psychoanalysis, which seeks to rationally explain the supernatural, the unex-plained, the uncanny and the bizarre.

One of Harvey's gifts, anticipating the rabbit in *Donnie Darko*, is prophecy, for he can reliably predict the future. Another, even more impressive power, is the capacity to create a *fermata* by arresting the flow of time:

> Elwood: "Did I tell you he could stop clocks?"
> Dr. Chumley: "To what purpose?"
> Elwood: "Well ... You can go anywhere you like, with anyone you like, and stay as long as you like, and when you get back, not one minute will have ticked by ... You see, science has overcome time and space,[31] but Harvey has not only overcome time and space, but any objections."

The key phrase here – "any objections" – is Hayes Code language for the social sanction of erotic fantasies (of which the good Dr. Chumley happily confesses).[32] The elusive object of Harvey himself thus authorizes the libidinal abandon that psychoanalysis sets up as both its object and objective (through socially-accept-able sublimation, etc.).

Elwood, however, perhaps liberated in a different direction by the *pooka*, has reached an almost Nietzschean affirmation of things the way they are, and is free from the fantasies which only encourage melancholy, and its attendant sense of lack. When Elwood is earlier encouraged to "face reality," he says that: "I wrestled reality for thirty-five years, doctor, and I'm happy to say that I finally won out over it." The implicit meaning here refers to social reality, since Elwood is anything but delusional, embracing the world exactly as it appears, rather than racing towards a dream-goal dangling in the future like a carrot on the end of a stick. And in this sense, he practically passes Nietzsche's test of the eternal return: "I'd almost be willing to live my life again."

Stepping outside the logic of the script for a moment, we can see how the figure of an extra-dimensional rabbit overlaps with all the other texts covered so far. As with *Donnie Darko*, the rabbit is considered by most people to be a hallucination, but in fact turns out to be an ontological messenger, intimately connected to the quantum mechanics of time. As with *Of Mice and Men*, the rabbit functions as the totem for a "simpleton" – although in *Harvey* this familiar underlines the importance of the present, rather than the (false) promise of the future. (Another significant difference is that Elwood is a very smart simpleton.) As with *Alice in Wonderland* and *The Matrix*, one need only follow the white rabbit to an alternative take on your own universe, and its associated assumptions.[33]

Some significant connections can also be traced to *Who Framed Roger Rabbit?*[34] In a taped interview with James Stewart in 1990, included on the video version, he admits that: "I have a special admiration and love for that big white rabbit ... He became a very close friend of mine. You can see it in the performance ... All of us, you can see all of us sort of accept the existence of this rabbit." Despite the qualifier "sort of," Stewart talks in terms similar to those who worked on *Roger Rabbit*, bearing witness to the phenomenon where a virtual object has actual effects – whether you choose to "believe" in it or not. And although Stewart's ability to focus on dead space does not rival Hoskins', certain paraphernalia associated with the production and the promotion of the film attest to the *presence* of Harvey as a pseudo-ontological being. One photographic still, for instance, behind the scenes, includes a cast member's folding-chair with the name Harvey. (Obviously we have no idea if he is sitting in the chair or not.) Similarly, the original poster for the film shows James Stewart sitting to one side, dominated by the shadow of the rabbit.

Without wishing to popularize Heidegger's rather more weighty concepts into the ether, this shadow is another instance of the "incalculable" introduced above:

Everyday opinion sees in the shadow only the lack of light, if not light's complete denial. In truth, however, the shadow is a manifest, though impenetrable, testimony to the concealed emitting of light. In keeping with this concept of shadow, we experience the incalculable as that which, withdrawn from representation, is nevertheless manifest in whatever is, pointing to Being, which remains concealed.[35]

The *Da-sein* (being-there) of Harvey – according to this positive gloss on shadows – is to be simultaneously there and not-there, according to the criteria of Being applied by humans. So while the thought of dying alone terrifies both Donnie Darko and Lennie Small, Elwood P. Dowd is more strictly "philosophical" about the being-toward-death which necessarily follows the birth trauma.

All of which brings us to the sardonic, throw-away line offered by Elwood's bartender, in answer to the question posed by Dr. Sanderson while anxiously looking for his escaped would-be-patient. "Is he alone?" asks the doctor, gesturing to Elwood sitting in a booth with two martinis. "Well," replies the bartender, "there are two schools of thought on that."

6. The Dubious Hospitality of the Shining Wire

Rabbits ... are like human beings in many ways. One of these is certainly their staunch ability to withstand disaster and to let the stream of their life carry them along, past reaches of terror and loss. They have a certain quality which it would not be accurate to describe as callousness or indifference. It is, rather, a blessedly circumscribed imagination and an intuitive feeling that Life is Now.
RICHARD ADAMS, *WATERSHIP DOWN*[36]

Hlessi – *A rabbit living above ground, without a regular hole or warren. A wandering rabbit, living in the open. (Plural,* **hlessil.***)*
"LAPINE GLOSSARY," IN *WATERSHIP DOWN*[37]

Richard Adams' enormously popular 1970's novel, *Watership Down*, informs us that: "It is true that young rabbits are great migrants and capable of journeying for miles, but they do not take to it readily."[38] Nevertheless, a group of bunny rabbits abandon the relative safety of their warren to become *hlessil* in search of a "high, dry place," prompted by the Aeschylan visions of horror, suffered by the rabbit Fiver. (Cassandra's visions are quoted in the first epigraph, providing a high-

culture precedent for Fiver's apocalyptic prophecy, "... it's coming – it's coming. Oh, Hazel, look! The field! It's covered with blood!"[39]). The journey and events that follow could be interpreted as an allegory of diaspora and exodus in general, but things are not as easily decoded into didactic types, as they are in George Orwell's *Animal Farm*, for instance.

The narrative does, however, resonate with the dilemma of the deracinated as figured through bunny rabbits (especially "outskirter" bunny rabbits, "thin-looking six-month-ers, with the strained, wary look of those who are only too well used to the thin end of the stick"[40]). Speaking of the mass movement of migrating animals, the narrator notes:

> anyone seeing this has seen at work the current that flows (among creatures who think of themselves primarily as part of a group and only secondarily, if at all, as individuals) to fuse them together and impel them into action without conscious thought or will: has seen at work the angel which drove the First Crusade into Antioch and drives the lemmings into the sea.[41]

What the book calls (in a phrase which would strike fear into the heart of any farmer) "that great, indestructible flood of Rabbitry,"[42] flows across the countryside and toward new and foreign warren systems. In a key Derridean chapter, entitled "Hospitality," the wandering rabbits are suspicious of the welcome that receives them, along with the pronounced lack of suspicion.

The host rabbits offer them food, shelter and entertainment, despite the protagonists' insistence that, "After all, you might be afraid that we were coming to take your does or turn you out of your holes."[43] The hosts do not seem to be prone to paranoia concerning the motives of visiting strangers, so that: "All over the burrow, both the newcomers and those who were at home were accustoming themselves to each other in their own way and their own time; getting to know what the strangers smelled like, how they moved, how they breathed, how they scratched, the feel of their rhythms and pulses."[44]

Indeed, one would be hard pressed to find a more naively poetic description of Levinasian deference to the Other, and Derridean hospitality, than the following:

> [and] so this gathering of rabbits in the dark, beginning with hesitant approaches, silences, pauses, movements, crouchings side by side and all manner of tentative appraisals, slowly moved, like a hemisphere of the world into summer, to a warmer, brighter region of mutual liking and approval, until all felt sure that they had nothing to fear.[45]

But as is often the case, a perceived utopia disguises more sinister designs. The visiting rabbits soon realize that a shining wire is subtracting their fellows one by one, until Hazel feels sure in announcing: "That warren's nothing but a death hole! The whole place is one foul elil's larder! It's snared – everywhere, everyday!"[46] The local bunny rabbits remain unaware of the horror at the heart of their lives, since they themselves have adopted the strategy at the heart of our study, namely, "look at the bunny." (Although, in this case it means not looking at the bunny – especially the disappearing bunnies). Hazel explains to his companions that the locals are distracted by "songs" and "shapes on the walls" which "passed the time and enabled them to tell themselves that they were splendid fellows, the very flower of Rabbitry."[47]

Hazel continues:

> And since they could not bear the truth, these singers, who might in some other place have been wise, were squeezed under the terrible weight of the warren's secret until they gulped out fine folly – about dignity and acquiescence, and anything else that could make believe that the rabbit loved the shining wire. But one strict rule they had; oh yes, the strictest. No one must ever ask where another rabbit was and anyone who asked "Where?" – except in a song or a poem – must be silenced. To say "Where?" was bad enough, but to speak openly of the wires – that was intolerable. For that they would scratch and kill.[48]

Indeed, the realization that the shining wire may itself constitute both the decoy and the object of destruction, simultaneously denied and executed, is one we would do well ourselves to learn in the age of hyper-cynical media manipulation. (That is, in an age in which Nike can use the phrase "100% slave-labor" as an official ad campaign, and the Pentagon can use the daily events of war to obscure the *motivation* of war in the first place.)

In other words, we have become so entranced by these kind of objects that their power to fascinate serves to camouflage their (usually destructive) purpose. That is, we are so amused that the Trojan Horse has the words "Trojan Horse" written across its side in bold, day-glo colours, that we let it in anyway (just to share the joke with others).

Which brings us almost full circle.

Since by now, we should not be surprised that *Watership Down* finishes with an epilogue introduced by Lewis Carroll's *Through the Looking-Glass*: "He was part of my dream, of course – but then I was part of his dream too." This feedback loop between the spectacle and the spectator, the bunny rabbit and the human, the

being and the yet-to-be, is the enigma of the age – acting like a carrot-on-a-stick for those who still believe there are lessons to be drawn from a media-environment seemingly far more concerned with producing noise than signal.

And yet, perhaps it is in the white noise (or the "white blindness," as Adams would put it), that we can conceive afresh the link between the cave and the looking-glass, via the white rabbit-hole.

7. Avatars of Otherness

> *Ought I to say: 'A Rabbit may look like a duck'? Would it be conceivable that someone who knows rabbits but not ducks should say: 'I can see the drawing as a rabbit and also in another way, although I have no word for the second aspect'? Later he gets to know ducks and says: 'That's what I saw the drawing at that time!' – Why is that not possible?*
> LUDWIG WITTGENSTEIN[49]

Joseph Jastrow's duck-rabbit image has since been made famous by Wittgenstein, who treated this visual conundrum more in the mode of early cognitive theory than the deconstructionist standby of "undecidability." Essentially, Wittgenstein ponders the process behind the perception of the image as either a duck or a rabbit – perhaps considered one and then the other, but never both simultaneously. Has the image changed, he asks, or has our attitude toward the image changed? Or has only our description of the image changed? Moreover, on what basis do we distinguish these allegedly autonomous processes?

What Wittgenstein calls "aspect-regarding" or "continuous aspect-perception" suggests that we see "the world" through a grid of pre-formed grid of cultural and personal expectations, assumptions, memories, and knowledges: meaning, we already see something *as some thing*... which is (to varying degrees) familiar. This particular spin on Husserl's notion of "structuring" obviously has profound political implications, for we tend to project our own patterns and meanings onto the things we see. So while the question of whether an image is a duck or a rabbit may seem purely hypothetical, the question of whether a man wearing a turban is a Sikh or a Moslem, a terrorist or a freedom-fighter, an enemy or an ally, is one of vital quotidian importance. This constitutive cultural-political aspect of phenomenological interpretation links the question of hallucinated rabbits directly to those "avatars of otherness" which have been persistently evoked by politicians and the media to mobilize certain rhetorics of domination and control. Moreover, this process has a viral, meme-like infection rate.[50]

Before enemies are flesh-and-blood targets[51], they are virtual figures who stalk the imagination as much as the world itself. (As the old Cold War posters warned: "Are there Reds under the bed?") Thus, during the so-called "fall of Baghdad," we hear an American citizen proudly stating that: "If they strike us, we strike them." The *they* in this case is not so much the abstract "they" of Heidegger or Sartre, but the stigmatized, explicitly delineated, *they* of political paranoia. Structurally, it follows a hallucinatory logic, which like *Donnie Darko* and *Of Mice and Men* can only end in the expedition of death.

And so whatever answer we give to the question, "why rabbits?" – whether it be a simple case of literary tradition (Lewis Carroll-John Steinbeck) cross-breeding with folklorish symbolization ("breeding like rabbits"-Bugs Bunny) – it is still a matter of responding to a decoy. Presuming that the twenty-first century will continue to unfurl itself under the signs of both Plato's cave and Alice's wonderland, then "the object of fear" will always already be a virtual one: and yet no less dangerous for that.

As cultural critic Mark Dery reminds us:

> a P.R. firm, Hill & Knowlton ... orchestrated the congressional testimony of the distraught young Kuwaiti woman whose horror stories about babies ripped from incubators and left "on the cold floor to die" by Iraqi soldiers was highly effective in mobilizing public support for the [first Gulf] war. Her testimony was never substantiated, and her identity – she was the daughter of the Kuwaiti ambassador to the U.S. – was concealed, but why niggle over details? "Formulated like a World War II movie, the Gulf War even ended like a World War II movie," wrote Neal Gabler, "with the troops marching triumphantly down Broadway or Main Street, bathed in the gratitude of their fellow Americans while the final credits rolled." *(Culture Jamming)*

What is now referred to in some circles as the "military-industrial-entertainment complex" spends a great deal of its energy on producing spectacular bunnies for the citizen-consumer to become entranced by (another metaphor for Chomsky's "manufacturing consent").[52] As touched upon above, the difference from the distraction model offered thus far in our account, is that the *inoculation itself* has now become the distraction as well. The operation and the decoy have fused in the millennial media, so that the *coverage* of war effectively does just that – it *covers* and conceals the events "on the ground" as well as "behind closed doors."[53]

In the case of the Second Gulf War in March and April 2003, the alibi for invading Iraq was the disavowed presence of weapons of mass destruction. The fact that few if any were actually unearthed afterwards did nothing to hinder the

rhetoric coming from the Pentagon, The White House and Number 10, Downing Street. Mimicking the representational logic of cognitive scientists, the Anglo-American Easter bunny found what it had simply put there in the first place (both epistemologically and historically speaking). One would have as much chance convincing that smug trickster-figure Bugs Bunny himself of desisting his "wascally" ways as persuading the Bush-Cheney-Rumsfeld-Blair hydra to desist from implementing the frightening recommendations of the Project for the New American Century. ("What's up doc?" ask the administrators, deaf to advice from academics who do not already speak the language of world-historical nihilism.)

One of the more disturbing images broadcast on news channels during the Second Gulf War was not the gruesome footage of murdered and injured Iraqi civilians, but the seemingly playful scenes of an American GI, standing on a stationary tank, and introducing a gathering of Iraqi children to the game of Hoky Poky.[54] One initial reaction to this surreal lull in battle is to make comparisons with the infamous football match between the English and the German army in the First World War. However, this would be to misread the general pattern of events. The remarkable fact of the latter case was the genuine playful spirit which can emerge at liminal moments such as Christmas time, affording a brief break in the relentless momentum of killing and hatred. The former, however, is more cynical, even if it is not experienced as such by any of the participants.

A dancing GI is a clear case of "look at the bunny," in a kind of punishing Energizer logic of endurance inflicted on the soldiers by Rumsfeld and other engineers of the war. In twenty-first century conflict, civilians are a major element in the battle plan, and must be "distracted" from options such as resistance, protest and subterfuge by things like food aid, water, promises, strange Western summer camp games, and other modes of symbolic support. And thus the warm glow which should accompany a GI dancing with a group of Iraqi children (given the alternatives), is actually just as chilling, given the Platonic economy in which it is involved. For all we know, the kids are being distracted from the fact that their parents are being rounded up for brutal interrogation, or worse. Thus the Hellenic concern with shadows merges with the Roman priority of bread-and-circuses, in a millennial empire that has mastered philosophical and political discourse. (Or at least recognized the artificial basis for any border between the two.) A radical politics therefore begins by asking who is the bunny? What brand of battery powers the bunny's frenetic drumming? Who owns that brand, and what are its other interests? Who benefits most from the operational procedures involving doctor, parent, child, syringe, and finger puppet? And – most sinister of all – what if the bunny is not only a decoy, but the object itself?

Such a complex of questions exposes the fundamental violence supporting the ethical edifice of who has the power to acknowledge, and who is (or is not) acknowledged. These are the stakes of relationality itself – the politically loaded premise of interactivity (a preferable term to "intersubjectivity," given this latter term's prejudice toward the subject). Thus, to give only one of a multitude of examples, the decision to refuse refugees the right of entry in to Australia lies on the same continuum as the instinct to deny that James Stewart has a large invisible rabbit for a friend. It is an expression of certain assumptions regarding ontological status; as well as the sovereign power of bequeathing or denying such status. Looking at the bunny (and then away from the bunny, and then back again), affords a glimpse of the complex processes assembled and operated by institutions which manufacture and maintain the precious right to be.

That is, to be *before* having to be any *thing* in particular.

The Media(ted) Object

From September 11 to the 7-11: Popular Propaganda and the Internet's War on Terrorism

If you happened to be browsing the Internet's Newsgroups in October 2001, you would soon get the feeling that Osama Bin Laden is one unpopular guy. No matter which group you happened to be perusing, whether it be dedicated to model trains, stamp collecting or foot fetishism, a picture of Bin Laden was bound to have been posted by someone, somewhere. Nine out of ten of these pictures were hostile, and pretty much all of them were, at the very least, unflattering. In this chapter we look at a sample of these pictures – usually doctored photographs or crude homemade animations – in order to see the confluence between relatively new technologies (i.e., the Internet, imaging and editing software, etc.) and relatively old ideologies (i.e., racist stereotyping, propaganda, jingoism, etc.). These pictures are symptoms of an extremely grave global diagnosis, and we can see the accompanying exponential anxieties in their most "naked" form. American shock, anger, grief, and resulting cross-cultural resentments are expressed in literally pornographic terms, and this in itself reveals a great deal about the current apocalyptic condition.

Newsgroups are the most popular features of the Internet, which is comprised of more cyberspaces than the most visible World Wide Web. Along with ICQ, MUDS, MOOS, chat rooms and bulletin boards, Newsgroups allow people all over the planet to gather in a virtual space and share common interests. Much of the digital traffic is innocuous enough: advice on how to swap 1950's baseball cards, fanatical questions regarding the latest *Star Trek* episode, sound files recorded during coffee-shop poetry evenings, and the like. The mass of information, however, and the relative difficulty of monitoring such a large amount of Internet traffic, means that Newsgroups are also the notorious hubs of child pornography, amateur sleaze, bestiality, voyeurism, and other less-than-savoury hobbies. Newsgroups are thus considered the celebration of online community for the civil libertarians, and the very playground of Satan for the moral crusaders.

While much of the data traffic on Newsgroups is simply text (recipes, chess games, hacking advice, etc.), a great deal is also binary information, which when decoded with the correct program, reveals a digital picture. Thousands upon thousands of specialist groups have sprung up in the last six or seven years, some surviving through popularity, and others disappearing after only a matter of days due to global indifference. After the September 11 attacks on New York and Washington, no matter which group you happened to be browsing, a picture of Osama Bin Laden would almost certainly appear (due to the all-too-common practice of "spamming," that is, posting non-relevant or commercial material).

When we put the dissident leader's name into a Newsgroup search engine, it came up with about two hundred pictures, which had scattered themselves throughout all the different groups like anthrax spores. Understandably, *alt.binaries.pictures.celebrities.fake* featured quite a few, as did *rec.binaries.pictures.cartoons.humor.* (Less clear, however, were the reasons why several also appeared in *alt.binaries.pictures.celebrity.female.megryan.*) These pictures can loosely be grouped into four categories: orthodox propaganda, humorously obscene, aggressively obscene, and just plain surreal (although there are many overlaps, as we shall see). All categories also exploit cultural difference to make a point; usually inciting racism.

In the days immediately following the attacks, the sense of outrage manifested itself in such pictures as "World Trade Center Rebuilt," whereby five towers of varying height replace the former Twin Towers. After a moment of confusion, the viewer notices that these building actually comprise a hand, giving the finger (presumably towards the East). Another shows a digital face looking at the walls of missing photographs which were quickly plastered all over Manhattan. A tear rolls down his or her face (the gender is ambiguous), and the World Trade Center in flames is reflected in the tear drop. Plainly, this speaks of a terrible grief and genuine "early mourning system." The effect, however, is too close to kitsch to do justice to the emotions it attempts to represent. Nevertheless, this digital tear provides enough water to nourish the seeds of the next round of propaganda, of the more hostile variety, which emerged a week or so later.

Just before this, however, came the early wave of defiant doctorings. In these, King Kong suddenly appears on the Twin Towers instead of the Empire State Building, and, judging by the aerial carnage, the Great Ape is far more successful at swatting planes than in the original film. (Presumably we are supposed to endorse the sacrifice of the plane's unsuspecting passengers rather than the WTC office workers.) Another more light-hearted offering is titled "In a Perfect World," which shows an animated hijacked plane approaching the WTC, while the buildings sud-

denly spring apart, as if made of rubber, to let it pass harmlessly through. The effect is vaguely humorous when divorced from its historical and political context, but when these are taken into account, its goofy counter-historical optimism only heightens the tragedy it wishfully seeks to avoid.

The most infamous posting, however, was a file commonly labelled "missing," which became so popular that it leaped out of the Newgroups and into the email inboxes of the world's home and office computers. This picture claimed to be a photograph rescued from a camera dug up from the rubble, and showed a tourist standing on the World Trade Center viewing deck, posing, while a 767 airplane approaches behind his shoulder. It was soon exposed as a fake (the plane was "Photoshopped"[1] into a perfectly banal tourist photo), although the initial "impact" of the photo was still a large factor in its global dissemination. Later versions show Bin Laden himself in the place of the anonymous tourist. The caption reads: "I know I told them to meet me here at 8:45. Where are they?" Again, the role of wish-fulfilment is clear.

In mid-to-late September, however, by far the most common posting was a picture of Osama Bin Laden sodomizing George Bush. This was actually one of the

first files to appear after the attacks, and first had the name "Can't We All Just Get Along." The same picture was soon reposted as "Make Love Not War," suggesting that – at least for some – the initial shock of the attacks had not yet moved towards anger, but was simply groping towards a possible reconciliation. It suggested a benign denial that such horrible events had even occurred. As these picture spread virally from group to group, the intent behind those who reposted it became clear in the file names and descriptions. One version animates the scene, so that George Bush releases a huge explosion out of his anus, incinerating his bed-partner. Another version swaps the heads so that George Bush is now sodomizing Osama Bin Laden, the file name appropriately changed to "revenge," in the same week the American forces began bombing Afghanistan. Thus we have what is fundamentally the same picture standing for completely opposed political positions.

Indeed, signs of what Freud calls "anal aggression" appear consistently through the archive of these pictures. One particularly low-tech attempt pastes the Al-Qaida leader's head onto somebody's bare behind and calls itself "Osama Butt Laden." Another depicts him being sodomized by the Empire State Building, with the by-line "So You Like Skyscrapers, huh Bitch?" Another picture shows a dog with an American flag tied around its neck, defecating on a picture of Bin Laden, while encouraging the viewer to "Do Your Patriotic Duty." Yet another shows an astonishingly obese woman squatting over Bin Laden's head, titled "They Caught Him," while a picture called "The Osama Miracle" presents a picture of his head in the contents of a used nappy. And finally, we have a young soldier brandishing a short-range missile with the caption: "Bin Laden Suppositories."[2]

This theme is extended to bestiality, which is the moment an overtly racist resonance emerges, as opposed to simply being the expression of hostility towards an

individual allegedly behind the terrorist attacks. Here we see Bin Laden sodomiz-ing a sheep while riding a motorcycle. Other versions show him having sex with either a donkey, a goat, or a camel. Hence we see how the worst stereotypes of Middle-Eastern behaviour are evoked through the use of computer manipulation in a kind of mass revenge fantasy by those who feel impotent in the face of danger.

And the *face* is the most important aspect here. Even two months after the initial attacks on the United States, the American authorities still had not provid-ed definitive evidence that Osama Bin Laden orchestrated the attacks, although there is no doubt that he applauded them. (Even if the FBI eventually provides such evidence, the popular trial has already occurred in the media, kitchens and bars of the West.) This "first war of the twenty-first century" distinguishes itself by the fact that America no longer has a palpable enemy: a rogue State with a leader who personifies that State, as was the case with Saddam Hussein and Iraq. Terrorism is terrifying because it has no face. But rather than pause for a moment, and really think what it means to be at war with a global network, linked by religion or polit-ical orientations rather than nationality, the people (at least the people who cre-ated and posted these pictures) simply decided to go the default route of demo-nizing the most convenient face on offer. In order to contain and profile the threat, they find solace in seeing a "scapegoat" sodomizing a creature of similar species.

One of the most remarkable things about these new technologies is the way in which they have made the State's propaganda machine almost irrelevant. Or rather, to be more accurate, the way in which it has *extended* the propaganda machine into the wider community itself. Adobe Photoshop© and other image manipulation programs allow the production of propaganda by the traditional *consumers* of propaganda, that is, "the people." Rather than *responding* to an Uncle Sam poster, Johnny Websurfer now *creates* an Uncle Sam poster, in the comfort of his own home: a development which speaks of the efficiency of the Internet in spreading ideological memes such as hostile patriotism during war time.[3]

The *New York Times* reports that the current Bush State Department appointee in charge of the propaganda effort is a CEO from Madison Avenue. In an age where 80% of proposals to venture capitalists include the term "viral mar-keting" – and out-of-work New York actors are surreptitiously employed to rec-ommend products to trusting strangers in restaurants and on subways – we can appreciate the momentum that such strategies have when turned toward politics rather than products (although the two can often be hard to distinguish).[4] Columnist Frank Rich points out that the White House's chief propagandist was chosen "not for her expertise in policy or politics but for her salesmanship on behalf of domestic products like *Head & Shoulders* shampoo. If we can't effective-

ly fight anthrax, I guess it's reassuring to know we can always win the war on dandruff."[5]

The smooth vectors of late capitalism, ironically enough, allow the terrorists to attack the same system more effectively. Through the Internet, the postal system, and networked financial transfers, the Al-Qaida networks effectively promote, fund and wage their own campaign against the godless media of the West.[6] On the other hand, this techno-democratic structure allows those in the grip of fear and mourning to express their anger and pain in the knee-jerk forms of jingoism.

Which leads us to some examples of more "orthodox" propaganda: an eagle eating the battered and bloody head of Bin Laden. A doctored photograph of Bin Laden with horns and red eyes, the word "Satan" across his brow. A split frame juxtaposing the soldiers of Iwo Jima with the firemen of New York, simply titled "American Heroes." A picture of a blonde, buff, red-blooded American woman in a star-spangled bikini brandishing a machine gun: "Osama This, Mother Fucker!" Or, alternatively, a cartoon of an old Yankee grandma waving a flag and saying, "Hey Osama Yo Mama. Kiss my red, white and blue star-spangled tushy!" – which combines orthodox propaganda with a withered attempt at humour.

Several pictures betray both an anxiety concerning the strength of the Taliban, and an overconfidence regarding Afghan military vulnerabilities. We downloaded several versions of an American jet fighter in hot pursuit of Bin Laden riding a magic carpet. Some featured talk bubbles, some were animated, while others simply left the scene to eloquently speak for itself; especially in terms of the assumption regarding different technological levels and strengths. One picture titled "Closer Than It Looks," shows a car's wing mirror with a military helicopter bearing down on its target. A road sign stating "Kubul [sic] 35km" leaves little doubt as to who is stalking whom in this revenge scenario.

The systematic simplification of the situation, which is essential for the American authorities to justify launching an attack on Afghanistan, is captured in one picture which features a generic Arabic building (perhaps even a Mosque), with "Taliban HQ" written on the wall. The wish-fulfilment fantasy revolves around the need for a stable and identifiable target; the pathos-inducing belief in a 21st century HQ. If Pentagon officials have learned one thing recently, it is the anachronistic vulnerability of "power centers." To this category of posting, we could also add "Osama go bye bye" (a straightforward picture of a desert explosion), and "Osama's House After Renovations" (an equally straightforward picture of a vast desert crater). In addition to these, we could include the numerous examples of "Bin Laden in Target Site" theme, "Wanted: Dead or Alive" posters (in honour of George W. Bush's explicit, yet inexplicable, Old West rhetoric) and "Who Wants To Bomb a Millionaire."

One of the most sophisticated postings, at least in terms of concept and execution, is titled "In Hell with Osama." As the name suggests, this is a mock-up screen-capture from a video game of Bin Laden in Hell, where the viewer can shoot the subject in the style made so familiar by computer games such as Doom, Quake and Duke Nuke 'em. The caption reads: "Shoot him or force feed him pork products or simply push him through the gates of Hell where Satan will be waiting for him. It's sadistic fun for the whole family." Goats make another appearance, this time in Satanic form, while on-screen information icons tell us that we still have four "force feed" spam tins spare, and five "bitch power" credits (symbolized by veiled women, presumably Afghans).[7]

Spelling mistakes feature highly in these digital artifacts, as do misunderstandings of Satanic numerology (why 6666 rather than 666?). We are told that this particular picture was doctored in the USA or "mabey Mexico." Elsewhere, cartoons make reference to "the great god Alla." Which only proves that those creating these files are more literate in computer imaging technologies than in English, and that those with a college education are turning to different forms and forums to express their opinions in the wake of the attacks.

Finally, we turn to the humorously obscene, and plain surreal, category of postings. These include pictures of Bert from Sesame Street fame, acting in cahoots with the Saudi dissident. (A legacy of a long-running cameo campaign of this character by Internet copyright dissidents themselves.) We also have "Mini Bin," in reference to the character Mini Me, in *Austin Powers 2*, and a "Mr. Bean Laden" referring to Rowan Atkinson's popular buffoon. One photo features an extremely Arabic looking 1980s heavy-metal band: "Anthrax: Coming to a City Near You." And finally, "I See Dead People," which depicts a scene from *The Sixth Sense*, but now the little boy imagines the face of Bin Laden.

To this list we can add the picture, "Jihad For Dummies," which lampoons the popular How-To series and claims that Bin Laden is a "mass murderer and twister of Allah's words." Although this picture makes a tokenistic attempt to separate the alleged deeds of Bin Laden with the entire Moslem world, it cannot resist making a connection between Islam and impotence. Similarly, "the civilized world," is evoked in contrast to the Eastern heathen. Another picture, "Osama Found," shows him working behind the counter of a 7-11: an unsettling joke which prefigures the stigmatizing of Arabs who live and work in the USA.

Such swipes only become more grotesque, as the catalogue of pictures spirals back into the explicitly sexual. "Tail-O-Bang" satirizes the cover of a porn movie, featuring the "All-Gayda Gang" in "hot all male non-infidel action." It also claims to put the "fun" and "men" back into fundamentalism. This is only the latest piece in over a century's worth of propaganda to marry vulgar innuendo with homophobia and racism, and any residual traces of humour evaporate when we see that this production was brought to us by "deadarab.com."

Admittedly, to believe that wartime can be free from jingoism and racial stigmatizing is to be as naïve and optimistic as the author of the animated Twin Towers, springing free from harm like rubber legs. On one level, these pictures represent a global *charivari* against an only too genuine social and cultural threat.[8] But like all *charivaris*, they are conducted on the level of the popular and the traditional, and are thus tied to conservative agendas: something which will only exacerbate the current confusing conflict (specifically because it is *not* traditional, despite the neo-crusader rhetoric).

Newsgroups are the planet's Id, at least those parts of the planet who have access to it. The obscene nature of most of these photographs attests to the obscenity of the Real which was unleashed onto a culture which specializes in

quarantining the Real behind glass screens. Sex and death both begin and end with the body, and photographic representations focus on partial objects, just as the New York rescue teams were scooping partial objects into body bags. We do not want to come to terms with these things – stare them in the face – because, as we have said repeatedly, there is no face. There is only flesh and blood.

The reasons why apocalyptic moments are filtered through libidinal economies are too complex to explore in this chapter.[9] What the home-grown propaganda effort proves, through its racially inflected sexual aggression, is a nation suddenly, and doubly, traumatized by duel castration. Rather than screwing the enemy in attempted revenge, with bombs and images of hatred, America and its allies should be addressing the historical logic behind the attacks. Much ink has been spilt in an effort to describe "the power of images." But what these rather pathetic pictures prove is the accompanying *powerlessness* of images, since they are reminiscent of a hung-over giant who awakes to the startling realization that he too is naked and open to attack. To resort to Freud's categories of "acting out" and "working through," Newsgroups probably helped a lot of people deal with the stress of September 11. But unless we want to add a whole host of other dreadful dates to our "perpetual calendar of human anxiety" (Focillon), then we should spend less time demonizing the enemy, and more time Photoshopping a future we can all actually live in.

The Shared Object

Abandoned Commonplaces:
Some Belated Thoughts on *Big Brother*

COLLABORATOR. Historical situations, always new, unveil man's constant possibilities and allow us to name them. Thus, in the course of the war against Nazism, the word "collaboration" took on a new meaning: putting oneself voluntarily at the service of a vile power. What a fundamental notion! However did humanity do without it until 1944? Now that the word has been found, we realize more and more that man's activity is by nature a collaboration.[1]
MILAN KUNDERA

1. Ill-communication

As the social theorist Niklas Luhmann once remarked, "today will be yesterday tomorrow". Logically irrefutable, this little aphorism also effectively summons up and summarizes those uncanny aspects of postmodern life – "insecure security", "uncertain certainty" and "unsafe safety" – that beset everyone. Wherever you are, you hear new news every day, of war, terrorism, unemployment, earthquakes and typhoons, murders, more murders, fluctuating exchange- and interest-rates, low-tech genocide, global instability in the economic system, the resilient fragility of the environment, secret state organizations, and the banning of smoking from establishments where food is sold. Decisions concerning the future are made elsewhere, by others, most probably malignant toward, or, at the very least, indifferent to, your continued existence, whose values and knowledges and interests and powers and whatever are absolutely beyond your personal control (and probably beyond theirs as well). It's no wonder that, statistically speaking, you're more than likely to be depressed, enraged, panicked or fearful. Postmodern life is hard on the psyche.

But it's tempting to overstate the novelty of the present: after all, a sense of impending catastrophe has always been a temptation for human beings. As Robert Burton wrote almost four hundred years ago, positioned on the threshold of modernity, and at the center of a radical media explosion:

I hear new news every day, and those ordinary rumours of war, plagues, fires, inundations, thefts, murders, massacres, meteors, comets, spectrums, prodigies, apparitions, of towns taken, cities besieged in France, Germany, Turkey, Persia, Poland, etc., daily musters and preparations, and such-like, which these tempes-

tuous times afford, battles fought, so many men slain, monomachies, ship-wrecks, piracies, and sea-fights, peace, leagues, stratagems, and fresh alarums. A vast confusion of vows, wishes, actions, edicts, petitions, lawsuits, pleas, laws, proclamations, complaints, grievances are daily brought to our ears. New books every day, pamphlets, currantoes, stories, whole catalogues of volumes of all sorts, new paradoxes, opinions, schisms, heresies, controversies in philosophy, religion, etc. ...[2]

Barraged yet still afloat upon this irresistible tsunami of confused messages, Burton can happily and prolixly confess that he will *steal* his way through; there's nothing you can do but thieve the words, thoughts, or reports of others to support yourself – so be proud of it.

But it wouldn't do, either, to simply take Burton at his word, nor to minimize the effect of the info-shocks that the present era inflicts on its subjects. It is not only that we are witnesses to very different hazards – the decline of the nation-state as the major site of policy analysis and activity, the concomitant vitiation of the principles of parliamentary democracy, a globalized information economy, new forms of capital investment, the rise of multinationals, and so on. There is now a globalization of hazards (notably environmental), a blurring of boundaries between work and non-work and "the integration of mass unemployment into the occupation system in new forms of *pluralized under*employment."[3]

The philosopher Immanuel Kant's famous trinity of questions – what can I know? what ought I do? what can I hope for? – is now answered for you: not much; whatever; don't bother. After all, as the experts tend to agree, the emblematic contemporary subject is not a person who has accomplished or accomplishes acts, admirable or otherwise: rather, the subject is enacted as pure, privatised potentiality. That is, the subject has become a peculiar kind of second-order passivity: rootless, fragmentary, deprived of any stable identity or ends. Worse still, this peculiar passivity bears all the characteristics of frenzied, unstoppable activity. As Zygmunt Bauman puts it: "The ethical paradox of the postmodern condition is that it restores to agents the fullness of moral choice and responsibility while simultaneously depriving them of the comfort of the universal guidance that modern self-confidence once promised."[4] This deprivation of guidance can only be (momentarily) occluded by acts of commodity selection and presentation, which stand in for the want of any stable ethical markers. And if the consumer, overwhelmed by the stupefying choice in brands of toilet paper, experiences any difficulty in consuming, there is always a battery of experts on hand to proffer their qualifications and advice: psychiatrists, dieticians, new-age therapists, academics, film reviewers, etc. In postmodernity, there is only really a single categorical imperative that counts: "Ill-communicate!" (with thanks to the Beastie Boys).

2. Abandoned Commonplaces

The historical conditions under which human life is so structured are those to which Guy Debord once famously referred as the "Society of the Spectacle" or Jean Baudrillard refers to as the "epoch of simulation"; that is, life lived under the massive dominance of information technologies, in which human experience is rendered *always already virtual.* As Manuel Castells remarks:

> What is then a communication system that, in contrast to earlier historical experience, generates real virtuality? *It is a system in which reality itself (that is, people's material/symbolic existence) is entirely captured, fully immersed in a virtual image setting, in the world of make believe, in which appearances are not just on the screen through which experience is communicated, but they become the experience.*[5]

Given this telegraphic invocation of the current hegemonic status of communications technology, almost every contemporary thinker would assent to the proposition that there is no private language: communication, whatever it is, is necessarily a public affair, which comes from others and from elsewhere. Communication is commonplace, in which one shares commonplaces. But what *is* a commonplace?

Once a translation from the Latin *locus communis,* itself a translation from the Greek *koinos topos,* the word *commonplace* is now a thoroughly naturalised English term, most often used to denominate the trite and ordinary, the unremarkable. What is remarkable about this meaning is that it inverts the original value of the term. For centuries, it was usual for all sorts of persons – not just scholars and intellectuals, but your average literate person as well – to keep so-called "commonplace books", diaries in which would be entered not the squalid and unedifying details of quotidian life, but authoritative phrases of moral or rhetorical interest, often grouped around themes: for example "Hope", "On the religious life", "On melancholy". For a commonplace was then precisely *not* something of local or specific interest, nor a hackneyed triviality, but a notable passage of general interest. Commonplace books grew out of the botanically redolent *florilegia* (Latin, literally "culled flowers"), compilations of ancient wisdom that emitted the fictive odours of a flourishing garden of knowledge.

Moreover, in the mnemotechnical tradition that was so important in a world in which materials and education were scarce and valuable commodities, commonplaces were the basis of memory-work. Children were taught by rote learning, unpopular today, but then considered necessary, to the point where it would routinely be enforced with a whip. Rote learning was "to lay a firm foundation for all

further education, not solely as "information" but as a series of mnemonically secure inventory "bins" into which additional matter could be stored and thence recovered."[6] One was expected to construct one's memory *architecturally*, each person painstakingly imagining a palace, a cloister, a garden inside their head; once this imaginative construction is fully complete and perfect in every detail, the work of furnishing the rooms with objects will begin: "The words *topos, sedes,* and *locus,* used in writings on logic and rhetoric as well as on mnemonics, refer fundamentally to physical locations in the brain."[7] Hence the role of bestiaries, to provide affective material that would be susceptible to coding up information provided by *florilegia* as mnemonic content, and then disposed forever in these nearly-infinite internal spaces. Such furnishings are not simply speech, nor writing, nor image; though *phantasmata,* they are at least as substantial as anything in the so-called material world.

The anonymous monks who copied and collated the classics, subordinating their individuality to the domination of erudition and to the universal glory of a God-given Memory, eventually gave way to writers who would publish their own commonplace books as original works in their own right. Early seventeenth-century England witnessed some notable examples of such publications: "Guided by a genius, the pages of a commonplace book could be transformed into an original and continuously argued text as Ben Jonson did with *Discoveries* – a form which [Robert] Burton's *Anatomy* sometimes resembles though it never mimics."[8] Not only do such gatherings of quotations display the author's erudition and generosity, judiciousness and powers of judgement, but they also become indices of an admirable and singular subjectivity – a subjectivity formed from the residues of others, which then transubstantiates into something new. Authority has somehow been transferred from the quotations themselves to the figure who gathers those quotations into a fabulous bouquet.

As the fabulous Burton puts it:

> that which I have is stolen from others, *Dicitque mihi mea pagina, fur es* [my page cries out to me, You are a thief]. If that severe doom of Synesius be true, "It is a greater offence to steal dead men's labours than their clothes", what shall become of most writers? I hold up my hand at the bar among others, and am guilty of felony in this kind, *habes confitentem reum* [the defendant pleads guilty], I am content to be pressed with the rest. 'Tis most true, *tenet insanabile multos scribendi cacoethes,* and "there is no end of writing of books", as the wise man found of old, in this scribbling age especially, wherein "the number of books is without number" (as a worthy man saith), "presses be oppressed", and out of an itching humour that every man hath to show himself ... As apothe-

caries we make new mixtures every day, pour out of one vessel into another; and as those old Romans robbed all the cities of the world to set out their bad-sited Rome, we skim off the cream of other men's wits, pick the choice flowers of their tilled gardens to set out our own sterile plots. *Castrant alios ut libros suos per se graciles alieno adipe suffarciant* (so Jovius inveighs): they lard their lean books with the fat of others' work ...[9]

This is writing as vampirism and cannibalism. Burton's lack of embarrassment – indeed, his delight – about this peremptory and necrophiliac skimming-off of the fat of the dead, derives not only from the lack of any copyright laws, but also from the sense that reading is as sovereign a pursuit as writing, and that the re-presentation of one's reading can also be an exemplary and authoritative presentation of the self – even to others who are familiar with *exactly* the same readings. What Burton's prose betrays is the historical discovery that the commonplace is a utopia, *insofar* as it is a delocalised fragment, a ruin, cut off from its original context. It is, moreover, likely to be a corrupted fragment – transformed through an error (inadvertent or deliberate) of transcription. Due to objective factors (similarity of sounds and letters, the fading or obscurity of the text due to wear-and-tear, bookworms or barbarians) or to subjective determinants (tiredness, malice, incompetence, psychogenic visual disorders), the mutilated narcissi blossom in the fertile soil of a fantasy that presents itself as real. Grafted onto other plants, in a foreign soil, deposited in arrangements and according to taxonomies that their original authors would have found puzzling if not incomprehensible, these ruined flowers cannot but forget the Eden of their original Creation – at the moment they are praised as its legitimate destiny. The commonplace dissimulates oblivion.

About one hundred and fifty years later, and reacting to this realisation, the great Romantic authors developed their written works as finished ruins: utopian because constitutively mutilated, or, as Marcel Duchamp would much later declare about his *Large Glass*, "definitively unfinished." William Wordsworth writes ceaselessly of ruined churches or incomplete aristocratic follies; Percy Shelley of the desert remains of Ozymandias; and *Kubla Khan*, one of Coleridge's most famous poems, is itself a fragment. As Phillipe Lacoue-Labarthe and Jean-Luc Nancy have it: "Ruin and fragment conjoin the functions of the monument and of evocation; what is thereby both remembered as lost and presented in a sort of sketch (or blueprint) is always the living unity of a great individuality, author, or work."[10] Romantic fragments are allegorical of utopia because, in their very incompletion, they allude to a possibility of completion that they know can never be achieved; it is no longer possible to quote *verbatim* due to anxieties about plagiarism and copyright (the modern forms of which date from the mid-eighteenth century), and

the commonplaces go at once unmentioned – for one can, at a stretch, presume they are known by all – *and* are tampered with, inverted, perverted, or otherwise deformed. The commonplaces are rendered ghostly, silent but everywhere presupposed, whereas the singular and idiomatic – by definition, the uncommon, the unfrequented – is painstakingly and lengthily propounded. The Romantics, furthermore, separate and transform two of the elements evident in the quotations from Burton: the happy admission of plagiarism in happily plagiarised words, and the enthusiasm for the exponential publication of books. The first, the Romantics *disavow*; that is, they acknowledge the exhaustion of the present, the fact that everything has been said – better, before –, yet they still attempt to twist the oxidized traces of these old letters into new wreaths. The second, the Romantics *sublimate*; that is, they turn the vertiginous empirical infinity of letters into a fact that at once overwhelms the insignificance of the self, and permits its tranquil recovery at another level. It is for such reasons that the Romantics are one of the first generations to insist absolutely on the priority of the author's *name* (rather than the author's *substance* or *position*). The artist is a harnesser of ghosts; only the supernatural barrier of an artist's name can guard against those spirits' loss *or* return. And it is precisely for this reason that the Romantics also experimented with anonymous, pseudonymous and heteronymous texts, heading for that threshold at which the artist becomes his own ghost.

But this melancholic Romantic sense of the becoming-spectral of commonplaces is further exacerbated by the greatest of all twentieth-century commonplace books, Walter Benjamin's monumental and unfinished *Passagen-Werk*. This book, nominally dedicated to a new architectural phenomenon of the 1820s and 30s, the Paris Arcades, is in fact a labyrinth about labyrinths, the secret and elusive correspondences that can be discerned behind the material phantasmagoria unleashed by industrial capitalism. But the book is also an enormous fragment of fragments, anonymous and hazardous: much of the text is composed of what Benjamin's editor, Rolf Tiedemann, has called "oppressive chunks of quotations."[11] But this slightly demeaning comment misses the point of Benjamin's overt attempt to write a book composed entirely of quotations. Such a project was intended to render writing contemporary with film and radio, on the one hand, and, on the other, to simulate the work of the connoisseur, who brings together diverse objects in a single cabinet, united only by the interfering selectiveness of chance and taste. For Benjamin, commonplaces are no longer the ghostly residues that they were for Romanticism, but are rather absolutely and irrevocably absent – not lost, lacking. For Benjamin, the fragmentary quotations one deposits in notebooks may illuminate, through the chance that brings the disparate together in a single cabinet or on a single page, a network of hitherto secret affinities. But these affini-

ties, evanescent and mystical, trace only the revolutionary lineaments of what does not exist – that is, *ou-topia*.

Exaggerated Benjaminians, we live in a time and place where every commonplace is experienced as at once defunct and absolute. Defunct, because we are confronted everyday with our inability to communicate even the simplest thoughts, in a world where even a nominally single language is patently traversed by all sorts of concepts, words, phrases, intonations and accents that are foreign to any particular speaker – to the point where ill-communication is the only certainty. Cultures are now clearly incapable of understanding *themselves*, let alone any other. Absolute, because there is no question that all the commonplaces of every language are stored somewhere in an archive: dated, labelled, ratified and, in principle, eminently retrievable. Mixing memory and oblivion, the absolutely common and the irreducibly idiomatic, the contemporary commonplace is at once ubiquitous yet idiotic, universal yet incommunicable; a missing fragment of a missing fragment. And, most probably, electronic to boot (given the recent exponential explosion of blogs).

The previous epochs of commonplaces – of impersonal ethical mnemotechnics, of transubstantiating authority, of allusive incompletion, of messianic anonymity – have given way to a fifth epoch, an absolute indifference of the commonplace, in the face of which there are only competing and irresolvable differences. Everything is enmired in immanence. Benjamin noted the "heightened graphicness" of nineteenth-century life, which became more and more palpable as it became more phantasmagoric; now everything is as equally material as everything else – and for that very reason, equally virtual.

This is to outline, in a dangerously etiolated fashion, how different times have dealt with the problem of the commonplace, what has been bequeathed by "the pastime of past time" (James Joyce). In each of the eras, and in the work of each author discussed, there is a different understanding of the relation between the individual and the group, between past and present, between memory and forgetting, between materiality and the ideal, between communication and the architecture of its archives. If it is now often felt that these relations seem to have dissolved altogether, it would be wrong to see the contemporary world as having simply suffered a loss of the commonplace. For the commonplaces of previous epochs were common only to that tiny fraction of the populace who were educated persons – and so the contemporary sense of loss of commonplaces is perhaps only an unexpected by-product of mass education itself. It is not ignorance, but multimedia literacy that leads so many today to feel the necessity for a recomposition of the loss of what never existed.

3. Big Brother Number One

Confronted with the postmodern virtualisation of the world and the commonplace experience of the pulverisation of commonplaces, it is no wonder that literate people scrabble helplessly – and sometimes dangerously – to recompose those ideals of community that never really existed. So-called "fundamentalist" movements are an example of such a reaction. Critics such as Jean Baudrillard, Zygmunt Bauman, and Umberto Eco have concluded that "fundamentalism" cannot simply be considered the terrifying revivification of archaic or traditional passions. On the contrary, such phenomena (and we can include neo-tribalism and racial fantasies under such a rubric) are an absolutely postmodern response to the technological, political and economic exigencies of globalization – as up-to-the-minute in their own ways as the "politics of desire" and cyber-hype. Postmodern civilisation seems to have perfected a remarkable political technique, unique to its form of life: turning its crises and malcontents into factors for its own reproduction. Terrorism and stock market crashes, far from derailing the contemporary world, are now the very events off which it lives. Since globalized capitalism does not require us to assent to its values – or, more precisely, its total un-founding of all possible values other than those of the market – we are now perfectly free to criticise as much as we like. But this freedom is either neutralised in advance or becomes just another commodity to be retailed like any other. The market thus exercises a much more effective censorship over cultural production than the modern state ever could.[12]

One of the reasons the reality game show *Big Brother* – in which a group of strangers are incarcerated in a house under the unblinking eyes of TV cameras – has proven so popular is that it starkly stages a new way to deal with these issues.[13] As Bauman acerbically writes: "In the postmodern habitat of diffuse offers and free choices, public attention is the scarcest of all commodities (one can say that the political economy of postmodernity is concerned mostly with the production and distribution of public attention)."[14] In the strange world of *Big Brother*, the incarcerated "contestants" must simultaneously attempt to make themselves as appealing as possible to the others in the house *and* to the unknowable audiences watching at home. Every week, one contestant from a short-list of three contestants selected by the house-mates themselves is "voted" out of the house by the viewers. The last remaining contestant literally has a "winning personality."

Unlike the classic "interview situation" in which two people exchange questions and answers for the benefit, not of each other, but of their auditors, *Big Brother* offers neither explicit questions, nor information, nor a clearly structured format. Rather, the focus is upon group interaction, a structured process of dou-

ble-selection on the basis of game performance. At last, a *game* show in which the value of your identity is at stake, in which you literally *play* at making a spectacle of yourself. One could underline certain features that *Big Brother* shares with other reality and chat-shows: an undoubtedly watertight legal framework (psychological pretesting of the contestants, release forms, contractual incarceration); the essential indistinction it enforces between fiction and documentary, between social experiment, life, work, and leisure (as spin-off and supplementary programmes proliferate); mythic narratives of salvation through rebirth (here, as "celebrity"); the micro-discrimination of merchandising, immediate audience feedback mechanisms dependent on new communication technologies (email, mobile phone text messaging, letters, etc.).

If, as Marxists have consistently suggested, it is always a better policy to predict people's behaviour on the basis of an analysis of their *interests* rather than of their *personalities*, *Big Brother* directs itself towards bringing out personality by ensuring a commonality of interest. Precisely because the processes and goal of the show are open, transparent, objectively set – the last person standing gets the money – it is the tactics of personality that *Big Brother* is calibrated to reveal. But "personality" is no longer the "personality" of even relatively recent media hegemonies. This "personality" is not that of professional performers who still conform to minimal conditions of media acceptability (the contestants have little to do with "talent," "form" or "formation"), and even beyond those celebrities "famous merely for being famous" (the contestants are famous precisely for *not* being famous). *Big Brother* is concerned, rather, with im-personalities and de-personalisation (of which more below).

What makes it all possible is the contemporary version of Josephine Baker's projected house-with-transparent-walls: an entirely artificial and transitory construction in which surveillance systems are the expressed *sine qua non* of its existence, and in which there is absolutely no place to hide.[15] Surveillance entertainment is its condition and its justification. If Foucauldian genealogical accounts have typically focused on architectures that, while being organised according to the diagram of "discipline and punish" (prisons, schools, workhouses, hospitals, asylums, factories, etc.), *openly dissimulated* or disavowed this logic, contemporary architectures tend to effect a triple manoeuvre: 1) the logic of surveillance or, better, monitoring is explicitly affirmed; 2) this logic explicitly appears as a contingent "construction," an "assemblage," detached from other institutions and not reassembled under an overarching law; 3) this logic is put to the ends of entertainment, not to simple economic exploitation. *Big Brother* is not interested in *formation* but, at best, in *deformations*, in producing and highlighting *divagations without norm*. It certainly does not work to optimise its human resources accord-

ing to time-motion efficiencies. It's presumably for reasons such as these – explicit affirmation of surveillance, routines-without-law, and entertainment-as-work – that Deleuze suggests that the discipline-and-punish model no longer functions as a model of our times. Instead, we are in a new era of "control": "if the stupidest TV game shows are so successful, it's because they're a perfect reflection of the way businesses are run."[16]

At the viewer's end of the deal, something similar is at work. It's well known that the internal organization of private homes has been completely transformed by the TV, the new hearth of privatised mediatized living. The TV is typically at the actual and symbolic center of the house, where the design of furniture (couches, coffee-tables, etc.), food (and not just the famous "TV-dinners"), decorations, clothes and physical comportment have been irreparably altered by television. The convergence, whereby even mobile phones now permit all sorts of radio, TV, internet, video connections, constitutes an extension and intensification of this post-WW II phenomenon. The refractive, refractory abysses of contemporary media are the matter and manner of *Big Brother*.

In such a situation, any creatures who can interpose themselves between the viewers and the viewed are freighted with a great deal of enjoyment and anxiety. As the security guards themselves are not usually in evidence, it is the various gatekeepers who bear the brunt of such attention. In Australia, the malevolent Gretel Killeen (sic) was perfect for the role, mediating between the house's interior and the exterior of the studio audience. "Gatekeepers," incidentally, is a word that has social pertinence only in a context where administrative routines have become absolutely and manifestly rationalised. For it is in such a context that everyone appears not for what they are but as part of a short-term team composed on the basis of formal tactical requirements (a certain mix of people, of certain ages, looks). Pure position is what counts, not being. Yet precisely since it is no longer ability (good looks, winning smile, brains, athletic ability) but the simple occupation of a site that guarantees status, then it is impossible to avoid questions as to the nature of the forces that maintain a person there: chance or malevolent forces? Where being and position are short-circuited in such a way, the gap of law – which is, in an integral sense, nothing other than an irreducible non-coincidence between being and position, existence and localisation – unleashes demons as it snaps shut. And since the contestants are the only place where these "forces" materialise before the gaze of the audience (who are themselves one of these forces), we end up with a re-personalisation of the de-personalisations effected by supposed transparency. Contestants have agreed to throw themselves on the mercy of the whims of each other and their audience.

For the contestants, an experimental double address is necessary, entailing a

constant self-monitoring and production of self in accordance with the social question: "what must I do to make myself attractive to those *here* and those *there*, even though I don't really know who is either here or there, or even if they want the same thing?" What the *Big Brother* audience watches are "ordinary people" struggling in the traumatic bind of this double injunction, where each contestant has to experiment with how to perform being him- or herself beneath the innumerable eyes of divided Others (see appendix). To watch *Big Brother* is to watch people who have agreed to be deprived of the means of concealing the production of their own subjectivity. In a peculiar identificatory twist, these "ordinary" people become, in an elliptical or disavowed fashion, the audience, *ourselves*.

Such a situation changes the conditions for what counts as a *significant event*. Since there are no existing rules for how to behave or what is acceptable, the smallest, most minuscule occurrence – a raised eyebrow, an almost-imperceptible stutter, a grubby T-shirt, a stumble – can take on the weight of a catastrophe or an epiphany. In the *Big Brother* house, any action is irreducibly ambivalent and can have radically disproportionate effects; or, more precisely, there is an *unmooring of proportion*, there no longer being any established procedures or standards of measurement. Moreover, such actions are significant only to the extent that they are significant *for the others* or, at least, to the extent that you *suspect* that they are significant for the others. Even more unnervingly, significance cannot be assigned once and for all, as the episodic, serial nature of reruns and sound bites defers significance indefinitely; the possibility of illimitable repetition, moreover, changes the meaning of each action with each actual repetition. Psychological mechanisms of projection and introjection are thereby revealed as both insufficient and unavoidable: you cannot help but recognise that you have to think that the others are acting in a particular way for particular ends but that – even if they are – this is as much a result of your actions, as of any alleged "identity" on their part. You cannot help but know *they may not really be that*, or that *they're doing all this just for you*. But what *are* they doing? Jean-Paul Sartre thought that hell was other people, the demonic force of the other irremediably staining the vacant mirror of the self.

The situation is, to put it another way, *positively objectively paranoid*, your identity being a nebula of dust in the eyes of the other. In the blinding mist of this identity-dust, shame, aggression, fear, resentment and ecstasy blossom and radiate like new constellations. But this objective paranoia (Big Brother really *is* watching you) is as much a medium of distraction and enjoyment as one of tension and humiliation. After all, Big Brother doesn't really exist, even if everyone likes to pretend that he does. Having said that, of course, people are clearly prepared to do a lot for things that don't exist – to the extent of going to immense

lengths to prove their existence. The longer the show went on, the more relaxed *and* the more fraught the contestants became, and the closer they came to perfecting their own *personae*. By the end, it's as if they really *were* the selves that they had been playing, usurped by their own collaborative fictions. The eighteenth-century philosopher George Berkeley once announced that "to be is either to perceive or be perceived." If he were alive today, Big Berkeley might have added: to be is to be perceived as another-that's-not-fully-there, that is, as a *process of improvised dis-appearing to a variety of unknown others*. The contestants on *Big Brother* developed into genuine artists of the spectacle, a fate verified by the fact that they became more famous the more they were watched successfully playing the selves that they were not quite. The self oscillates between *wannabe* and *has-been* and back again, endlessly, besporting itself in the larval regime of voluntary servitude.[17]

But *Big Brother* is also for that reason a utopian show: it presents people trying to overcome and transfigure the realm of (paranoid) necessity. In the current socio-political situation in which communication technologies are so powerful, *fame* – perhaps even more than money – is the event of grace that unlocks the holy gates of a this-worldly *civitas dei*. Celebrity is an open passport to all the lands of the earth. This is more than simply metaphorical. If there will always be newspaper editorials to be written denouncing those who are famous-simply-for-being-famous, the bearer having no discernible individual talents, one would have to say that this condition of celebrity-on-the-basis-of-nothing in fact has a profound ontological and political significance. As Hannah Arendt has put it: "Only fame will eventually answer the repeated complaint of refugees of all social strata that 'nobody here knows who I am'; and it is true that the chances of the famous refugee are improved just as a dog with a name has a better chance to survive than a stray dog who is just a dog in general."[18] Watching *Big Brother* was a participatory exercise in the production of survivalist fame; in an inadvertent act of unconscious reflexivity, the audience were literally watching the characters growing famous before their eyes – and in this sense were also watching their own invisible and unrecognised *powers of watching*. Entertainment becomes a second-order voyeurism of Being. We are all Big Brother – at least to the extent that we are in a position to desire to bring the other into being by forcing it to mis-perform what it mistakenly thinks we think we want ...

Identity *is* collaboration.

At the heart of the Big Brother system are the catastrophic residues of what Eric Santner has called "symbolic investiture":

the calls of "official" power and authority...are largely calls to order, rites and procedures of *symbolic investiture*, whereby an individual is endowed with a new social status, is filled with a symbolic mandate that henceforth informs his or her identity in the community. The social and political stability of a society as well as the psychological "health" of its members would appear to be correlated to the efficacy of these symbolic operations – to what we might call their *performative magic* – whereby individuals "become who they are", assume the social essence assigned to them by way of names, titles, degrees, posts, honours, and the like. We cross the threshold of modernity when the attenuation of these performatively effectuated social bonds becomes chronic, when they are no longer capable of seizing the subject in his or her self-understanding.[19]

So the fact that an identity always only comes from others becomes absolutely evident at the moment those others are revealed to be incapable of providing consistent and satisfying support for that identity. Yet there is nothing and nobody else; in truth, there never has been. Santner, using a juridical term drawn from the language of political crisis, speaks of such a situation as "a state of emergency"; we have called it the "Big Brother System". The Orwellian overtones of "Big Brother" should not, however, imply that our Big Brother is omnipotent and omniscient. On the contrary, it's a joke. What is so terrifying about such a system is that Big Brother (that is, the various others on whom we try to force such a function) is clearly impotent, lacking, incapable of sustaining the social mandate. Clearly, the best way to deal with the problem is to turn it into entertainment.

The tacky little logos and icons that multiply throughout contemporary culture are reminiscent of Sigmund Freud's remark about castration: whenever you encounter the proliferation of *phalloi*, you can be certain that you are being presented with the evidence of irremediable, desperate failure. What this means, among other things, is that you are confronted at every moment with the impossibility of ever finalising an identity, spun as it is out of the hazards and paradoxes of its own relentless dis-appearances. The participants in *Big Brother*, like those of fundamentalist cults, are genuinely attempting to recompose and stabilise new commonplaces amidst the seething simulacra of the virtual world.

Appendix

It is necessary to add here that, despite all the attempts to render the franchise *Big Brother* the most *apparently democratic* of shows, this can nevertheless only be sustained on the basis of exclusions that often have a particular local signifi-

cance. In the Australian context, for instance, it is interesting to ask why there were *no* Aboriginal contestants on the first series of the show (although there was clearly some attempt to affirm the "multicultural" constitution of society, by including an "obvious" "Jew", an "Islander", etc.). The clear answer – that such a person would have been immediately voted off, thereby demonstrating the abiding racism of Australian society – may well be correct, but is not the whole story. The important nuance is that such an expulsion would *repeat the foundational act that established Australian democracy itself* – the dispossession of Aborigines from any political stake in their own land. In an attempt to allay the *suspicion* that the "Australian public" was racist, the show's organisers thereby *proved* it by ensuring that such an act would remain *impossible* within the TV frame of the show itself. What is rendered "impossible" in a particular situation is often the very truth of that situation. Moreover, one could harbour the suspicion that such a "racism" has very little to do with *race* per se; all discourses about Australian "racism", whether "for" or "against", are insufficient insofar as they fail to recognise that "Aboriginality" has a political freighting in the Australian context that is *not* shared by, say, North American discourses about "Afro-Americans" or the indigenous peoples of the Americas. Such situations and differences are all the more corrupt and imposing to the extent that they necessarily remain invisible and unspeakable; one can point to the fact as much as one likes, but its existence – for the aforementioned reasons – will never be able to be proved, as a maths problem or a forensic solution is "proved". Yet it remains determining for all that this chapter, as every other activity in contemporary Australia, is marked by the insistent persistence of indigenous dispossession.

The Moveable Object

Public Transport: Jaunting from the Spaceship *Nomad* to the *HSS Tampa*

1. All Aboard

Allow us to begin with an extended quotation – a complete fragment from the notebooks of Franz Kafka:

> I stand on the end platform of the tram and am completely unsure of my footing in this world, in this town, in my family. Not even casually could I indicate any claims that I might rightly advance in any direction. I have not even any defense to offer for standing on this platform, holding on to this strap, letting myself be carried along by this tram, nor for the people who give way to the tram or walk quietly along or stand gazing into shop windows. Nobody asks me to put up a defense, indeed, but that is irrelevant.
>
> The tram approaches a stopping place and a girl takes up her position near the step, ready to alight. She is as distinct to me as if I had run my hands over her. She is dressed in black, the pleats of her skirt hang almost still, her blouse is tight and has a collar of white fine-meshed lace, her left hand is braced flat against the side of the tram, the umbrella in her right hand rests on the second top step. Her face is brown, her nose, slightly pinched at the sides, has a broad round tip. She has a lot of brown hair and stray little tendrils on the right temple. Her small ear is close-set, but since I am near her I can see the whole ridge of the whorl of her right ear and the shadow at the root of it.
>
> At that point I ask myself: How is it that she is not amazed at herself, that she keeps her lips closed and makes no such remark?[1]

Such are the thoughts of an early twentieth-century commuter. And yet, however atomized and existentially confused our allegorical author-narrator-protagonist may feel in this piece, he is not alone in finding the liminal space of public trans-

port conducive to questions of collectivity, affect and "amazement." Indeed, there is a proud history of thinkers and writers enjoying epiphanies – whether figured positively or negatively – while riding the train or the tram.

Of course, Freud famously identified the train as a steaming furnace of libidinal energies, with cultural effects eloquently documented by Wolfgang Schivelbusch in his study of the *Railway Journey*. In fact, the train-as-phallus equation has become a staple of pop culture as popular psychology (as witnessed in *The Simpsons*, when Principal Skinner's quick-tempered mother says, "I don't like you driving through tunnels, Seymour. You *know* what that symbolizes"). Our intention on this occasion, however, is to steer clear of psychoanalytic assumptions as much as possible, in order to illuminate the moments where the seemingly separate tropes of the "public" and of "transport" intersect in specific political and ontologically revealing ways. Jaunting between the timetables and transport routes of the twentieth and twenty-fifth centuries – that is, between the mobile ruminations of Jean-Paul Sartre and Martin Heidegger, as well as the science-fictional teleportation of Alfred Bester's *The Stars My Destination* – we shall shed new light on the vexed question of who can travel where, and why, in the age of (highly-restricted) globalization. Telescoping times and texts in this way, we plan to arrive at the geo-historical co-ordinates of the political furor over the fate of the *HSS Tampa*, whose cargo of refugees was left floating in extra-legal limbo for several weeks, forcing the Australian government's severely compromised immigration policy into an international consciousness. As with all travel plans dependent on public transport, however, we can never be sure when we shall arrive at our scheduled destination. Nor, indeed, can we be entirely confident of completing the journey, given public transport's vulnerability to hijackings, accidents, strikes, cancellations, and bankruptcy (as well as other less probable scenarios *actually covered* by insurance companies). Nevertheless, we shall begin our journey in good faith, and with high spirits (and perhaps a packed lunch in case the dining car is closed).

2. Who Puts the "Public" in Public Transport?

People are herded along highways, piled on top of one another in boats, pushed and shoved in airports. Others, more numerous still, the true immigrants of subjectivity, are forced to wander within. How can we respond to this situation?
 PIERRE LÉVY[2]

Every priority is noiselessly squashed.
MARTIN HEIDEGGER[3]

The trope of "transportation," introduced without obvious historical and cultural context, is so vast and multivalent as to be practically useless. Nevertheless, the ontological discussion of public transport in twentieth-century continental philosophy provides a useful frame of reference for more explicit political readings of such a trope. For instance, in *Being and Time*, Heidegger identifies the "utilizing of public transportation" along with "the use of information services such as the newspaper" as two quintessential modes of modern existence; modes which generate a sense of collectivity and belonging.[4] Indeed, the hustle-and-bustle of public transport encourages the kind of epiphany one is bound to have sooner or later, namely that one's personal problems and individual joys are but a drop in the seething ocean of humanity. Whether one finds this realization a kind of spiritual comfort, or, in contrast, the catalyst for an identity crisis, is less important for our purposes than the political space cleared by this initial epiphany itself. For in this case "public transport" is not only the banal method of getting to and from work, but "the transport of the public," in a more transcendent register: that is, in the sense that one is *transported* by music or literature, as well as by buses and trains.

Heidegger goes on to discuss this "being-with-one-another" which has the effect of erasing distinguishing features and individual characteristics, with the result that one is more likely to feel surrounded by the indistinct "mass." Rubbing shoulders with strangers, while your knuckles turn white with the effort of holding the strap and keeping your balance, encourages a complex identification with "the they" of society in general: that abstract category which "is nothing definite and which all are" (although, importantly, "not as a sum"). For Heidegger, "publicness" is a kind of self-deployed common denominator which "initially controls every way in which the world and Da-sein are interpreted." In doing so, however, publicness forms an obstacle to authentic thought and existence, since it is "insensitive to every difference of level and genuineness ... [and] obscures everything, and then claims that what has been thus covered over is what is familiar and accessible to everybody."[5]

Thus the common "experience" (a loaded term, of course, in Heidegger's discourse) of public transport is an exemplary site for the central complex of his project, especially the attempt to authenticate the dynamic feedback loops between the *mitsein* of an originary plurality, and the red-herrings of habitual subjectivism. On the peak-hour train, we could say with Heidegger that, "Everyone is the other, and no one is himself."[6]

Sartre, in part responding to the challenge of rethinking intersubjectivity in

Being and Time, offers his own version of public transport. The conductor's mantra of "tickets please" seems to be the catalyst for the aforementioned identity crisis, in which one is not only asked to prove the purchase of a valid fare, but also to metaphysically justify one's very existence. Indeed, the shame of being caught without a ticket is not so much experienced in ratio to the financial penalty involved, but more indexically attached to a kind of exponential logic of authority, in which the conductor is an agent or avatar of God. For while the conductor is indeed a "pure function" for Sartre, this very purity only serves to emphasize "my very comprehension of the world and of my being in the world."[7]

Another extended extract may be useful at this point in clarifying the issue:

> [T]he manufactured object makes me known to myself as "they"; that is, it refers to me the image of my transcendence as that of any transcendence whatsoever. And if I allow my possibilities to be channeled by the instrument thus constituted, I experience myself as any transcendence: to go from the subway station at "Trôcadéro" to "Sèvres-Babylon," "They" change at "La Motte-Picquet." This change is foreseen, indicated on maps, etc.; if I change routes at La Motte Picquet, I am the "They" who change. To be sure, I differentiate myself by each use of the subway as much by the individual upsurge of my being as by the distant ends which I pursue. But these final ends are only on the horizon of my act. My immediate ends are the ends of the "They," and I apprehend myself as interchangeable with any one of my neighbours. In this sense we lose our individuality, for the project which we are is precisely the project which others are. In this subway corridor there is only one and the same project.[8]

Interestingly, Sartre doesn't feel the same way when alone in his room and opening a "bottle of preserves with the proper bottle opener." The private sphere functions as a membrane – one of Sloterdijk's "symbolic immune systems," perhaps – protecting oneself (at least to a degree) from the They.[9] Heidegger uses a great deal of ink explaining why the hammer, or (in this case) the bottle opener – virtually incorporates a form of ontological memory, and Sartre also emphasizes the "hypothetical imperative" of the material object. However (and not without irony), it is not until one literalizes the *mitsein* in the public sphere that the implications of public transport "hit home."

This chain of associations between public transport, public communication and the manufactured object, thus leads to a "common transcendence" (what we have been calling an epiphany), which ultimately threatens to call into question the complacency and conceit of the seemingly autonomous individual (and by extension, the autonomous nation-state).[10] Whereas for Proust, the gentle train

ride back to Combray unveiled a chain of station names reinforcing and reconstituting a singular identity (Bayeux, Vitré, Lamballe, Coutances, Lannion, Questambert, Pontorson, Benodet, Pont-Aven, Quimperlé)[11], Sartre realizes he is but an "ephemeral particularization," dissolving in "the great human stream" which flows incessantly between "La Motte-Picquet-Grenelle."[12] (And it is this realization which tips the balance between the We-Object and the We-Subject.)

The slippages between the public and the private sphere can be most visible in the schism between these different modes of transport.[13] Advocates of trams, buses and trains promote not only their environmentally-friendly effects, but also the sense of community they can foster. J.G. Ballard's infamous novel *Crash* is in many ways a depiction of a world which has surrendered itself to the private mode, whose inhabitants must therefore literally initiate car "accidents" simply in order to meet other people. While this vision of the situation may seem extreme to many, the city of New York takes the situation seriously enough in 2002 to have commissioned a special subway route, dubbed the "love train initiative," in order to encourage people to regain a sense of intimacy with their fellow passengers. (For as we all know, simply travelling in the same compartment as other people does not necessarily lead to conversation, let alone community.)

But whereas Kafka, Heidegger and Sartre see something fundamental going on within the spaces of public transport, other thinkers take Ballard's lead and transcribe this "something" into the private sphere. Niklas Luhmann, for instance, pronounces that: "Marriages are made in heaven and fall apart in the automobile."[14]

3. Riding the Metron

Where are we?
 MARTIN HEIDEGGER[15]

Presumably Heidegger would have been unimpressed with the geo-specific accuracy of today's satellite-enabled Global Positioning System. For while this technology would allow the Great Man to go hiking in the mountains between writing sessions, and always locate his whereabouts with an error-margin of a matter of metres, he would no doubt only see such alleged "accuracy" as an expression of a specific and impoverished form of measurement.

Heidegger's remarkable essay, "The Age of the World Picture," paints a grand narrative linking three Western epochs – Hellenic, Medieval and Modern. He argues that to treat any difference in these ages as merely a difference of "world

view" is to misread the significance of the modern invention and insistence that the world be an object to be viewed by a centralized, Copernican subject. Tying this epistemic shift to the development of science, technology, aesthetics, "culture" and secularization, Heidegger nonetheless strives to avoid the notion of historical progress, advancing along a time line.[16] The increasing hegemony of the scientific method(ology) since the eighteenth century develops a "ground plan" for observation and explanation, through which a "sphere of objects comes into representation."[17] In other words, a map for navigating *that which is* (defined as such by the criteria of the ground plan itself). Hence, "Every science is, as research, grounded upon the projection of a circumscribed object-sphere," and therefore a species of specialization.

Significantly, this new type of thinker (designated by Heidegger as the "research man" in contrast to "the scholar"), is "constantly on the move." What's more, "He negotiates at meetings and collects information at congresses. He contracts for commissions with publishers. The latter now determine along with him which books must be written."[18] The consequence of all this is nothing less that the creation of world-*as*-view, and not simply a *new kind* of view. "Nature and history become the objects of a representing that explains,"[19] of which the map is the meta-object *par excellence*. And so, the "world picture does not change from an earlier medieval one into a modern one, but rather the fact that the world becomes a picture at all is what distinguishes the essence of the modern age."[20]

"Man" thus becomes a "relational center," simultaneously projecting and recording *that-which-is* in a vast, flexible, arrogant, centripetal and centrifugal accountancy operation. Research thus becomes an inventory of ontological validity; first turning certain "things" into manifest objects, and then only counting these representable objects as legitimate. What this system misses is "the incalculable," which casts an "invisible shadow" over the world. It is biased toward a particular rendering of actuality. (How would one measure "peer pressure" for instance, without recourse to the virtual?) Only the objective world receives "the seal of Being."[21]

It may seem that we have "moved" somewhat from the topic of public transport, but these later writings of Heidegger link directly to the section of *Being and Time* quoted earlier. Modern representing (as distinct from Greek "apprehending" or Medieval cosmological "correspondences") both presumes and creates subjectivism and individualism. And yet: "it remains just as certain that no age before this one has produced a comparable objectivism and that in no age before this has the non-individual, in the form of the collective, come to acceptance as having worth."[22] Furthermore, the "reciprocal conditioning" between subject(ivism) and object(ivism) is exposed as not only decisive, but also the poles of a transductive

relationship (i.e., a relationship which *creates* the elements of which it is composed, rather than being simply the *combination* of pre-existing elements).

In other words, the *all-seeing-I* is produced in a kind of non-Hegelian dialectic with *the they*; which itself produces the We-subject and We-object of Sartre's system. These latter then collude in the project already described, turning the globe and its inhabitants into a problem of measurement, accountancy, and other questions with preattached bureaucratic answers. The proverbial "inch-worm," busy measuring the marigolds, is thus exposed as a projection of bad-faith and humanistic megalomania, since Man reserves the sole right to measure the universe (and thus to place himself as the standard of such measurements). This "fundamental event of the modern age" is explicitly described by Heidegger under the logic of conquest, and thus cannot be decoupled from colonialism and the imperial project (either as the British Empire or Hardt and Negri's updated definition of the term). In the twentieth century, Man rushed into the phone booth of modernity and emerged as *Metron*, an anti-Nietzschean supersubject able to measure tall buildings in a single bound. And yet, for a species obsessed with improved performance and technologies of advancement, we can only dream about larger leaps into the Infinite.

4. Nomadology

> – *I can't make out why the corporation doesn't run a tramline from the parkgate to the quays, Mr Bloom said. All those animals could be taken in trucks down to the boats.*
> – *Instead of blocking up the thoroughfare, Martin Cunningham said. Quite right. They ought to.*
> – *Yes, Mr Bloom said, and another thing I often thought, is to have municipal funeral trams like they have in Milan, you know. Run the line out to the cemetery gates and have special trams, hearse and carriage and all. Don't you see what I mean?*
> JAMES JOYCE, *ULYSSES*[23]

The title of Alfred Bester's novel, *The Stars My Destination* (1956),[24] already implies travel and navigation. Indeed, the book revolves around an ingenious narrative-device called "jaunting" – a form of routine teleportation which allows the plot to cover an intergalactic amount of space in a limited amount of time. Jaunting is enabled by a focused tapping of hitherto unexplored psychic forces: "*Cogito ergo jaunteo*. I think, therefore I jaunte."[25] The distance is reasonably lim-

ited, although "public jaunte stages" have been set up for convenience and cross-country relay journeys:

> On three planets and eight satellites, social, legal, and economic structures crashed while the new customs and laws demanded by universal jaunting mushroomed in their place. There were land riots as the jaunting poor deserted slums to squat in plains and forests, raiding the livestock and wildlife. There was a revolution in home and office building: labyrinths and masking devices had to be introduced to prevent unlawful entry by jaunting.[26] There were crashes and panics and strikes and famines as pre-jaunte industries failed.
>
> Plagues and pandemics raged as jaunting vagrants carried disease and vermin into defenceless countries. Malaria, elephantiasis, and the breakbone fever came north to Greenland; rabies returned to England after an absence of three hundred years. The Japanese beetle, the citrus scale, the chestnut blight, and the elm borer spread to every corner of the world, and from one forgotten pesthole in Borneo, leprosy, long imagined extinct, reappeared.
>
> Crime waves swept the planets and satellites as their underworlds took to jaunting with the night around the clock, and there were brutalities as the police fought them without quarter. There came a hideous return to the worst prudery of Victorianism as society fought the sexual and moral dangers of jaunting with protocol and taboo.[27]

Significantly, this cultural (r)evolution was not considered a metaphysical miracle, but more of a development in public transport. (As with the Robert Zemeckis–Carl Sagan movie *Contact*, events essentially revolve around an intergalactic "transit system.") Bester's narrator tells us that "[t]he old Bureau of Motor Vehicles took over the new job and regularly tested and classed jaunte applicants, and the old American Automobile Association changed its initials to AJA."[28]

While the notion of convenient personal-teleportation would be seen by many as a godsend, in Bester's twenty-fifth century, it is considered by the wealthy and the powerful to be a somewhat gauche way to travel. For "[i]n an age when communication systems were virtually extinct – when it was far easier to jaunte directly to a man's office for a discussion than to telephone or telegraph," any man with a modicum of prestige "still maintained an antique telephone switchboard with an operator in his study."[29] Of course, this scenario of accelerated global movement has far-reaching cultural effects. The novel tells us that "[m]ore than a century of jaunting had so mingled the many populations of the world that racial types were disappearing,"[30] despite the fact that certain characters are clearly identified as black, white or Asian.[31]

The protagonist's name is Gully Foyle, a pure Deleuzian force who tears through the book like a personification of the line-of-flight, intent on wreaking violent revenge on the crew members of the spaceship *Vorga*, who left him for dead in the wreck of the starship *Nomad*. As if to reinforce this proto-Deleuzian logic, combining the concepts of becoming-animal, faciality and nomadology, Gully Foyle is tattooed with the tiger stripes of "a Maori mask," and the word *Nomad* emblazoned across his forehead. Jaunting between the Outer Planets and the Gouffre Martel in France, New York City, Rome, and even Canberra and Jervis Bay in Australia, Foyle traces each member of the *Vorga* crew in order to torture a confession from them – specifically, the reason why they ignored his distress flare, and abandoned him to icy isolation in space.[32]

Each crew member, however, has been chemically and genetically altered to "self-destruct" when tempted to tell the awful truth, thereby only increasing Foyle's fury and thirst for revenge. Eventually, however, Foyle comes face to face with his real nemesis, the man who ordered the ship to continue its journey without responding to the rescue-call. The truth is even more sickening than he ever anticipated:

> "You were running refugees from Callisto?"
> [...]
> "We were scuttling the reffs."
> "What!" Foyle cried.
> "Overboard....all of them...six hundred...Stripped 'em....took their clothes, money, jewels, baggage...Put 'em through the airlock in batches. Christ! The clothes all over the ship...The shrieking and the – Jesus! If I could only forget! The naked women...blue...busting wide open...spinning behind us...The clothes all over the ship...Six hundred....Scuttled!"[33]

What perhaps most dates Foyle and his interlocutor's horrified responses is that their responses are just that – horrified. Such affects are clearly foreign to the rationalised, entrepreneurial business of so-called "people-smuggling": cash for illegal sea-transportation of refugees from one locale to another, supposedly more welcoming. Judging from the global media event generated by the Australian government's handling of the Tampa Crisis in August/September 2001, what we will call *R-affects* are today more likely to be generated – not by the scuttling of refugees but by the *failure to scuttle refugees*. An R-affect is an affect-out-of-place, one that suddenly arises with and supports rationalities of (border) control; the extremity and nature of the affect accompanies and justifies extra-legal attempts at the reimposition of security. An R-affect involves a visceral, desperate

panic-disgust, undoubtedly in the realm of what Julia Kristeva calls "abjection" or the disgust that Pierre Bourdieu isolates as the underlining of Kantian aesthetics.[34] But it also involves its apparent negation: a coldness, an affectlessness in judgment.

There are other notable features of contemporary R-affects. The R-affect is not simply one species of a genre of responses to abjection, nor the arbitrary response of an individual to a public event. If all the key players in such affairs may no doubt prefer to be veiled in an impenetrable secrecy, it seems that publicity does not curb the excesses of affect, but exacerbates such excesses. Whereas it might seem that the vitriolic denunciation of refugees, while one continues to inflict upon them all sorts of torments and injustices, contradicts every humanitarian principle – and would therefore be something *shameful*, to be hidden or denied – the R-affect permits the public transubstantiation and redirection of shame for political ends. If R-affects are effectively deployed, shamelessness becomes a predicate of powerlessness, of the victims; the very torments and injustices perpetrated upon them become, by an unexpected twist, *what they are doing to us. We* are the true humanitarians; the refugees are viciously taking advantage of our goodwill; it is therefore necessary to incarcerate and torture them so we can retain our elevated humanitarian standpoint.

What Slavoj Žižek has denominated "the double blackmail" of contemporary geopolitics is evident here, reminiscent of that "old Israeli complaint against the Arabs: 'We will pardon you for what you did to us, but we will never pardon you for forcing us to do the horrible things we had to do in order to defend ourselves!'"[35] What gives the Australian situation its peculiarity is its rigorously oxymoronic character: "How can we forgive you for making us do horrible things to you just to ensure that we wouldn't have to do horrible things to you?" Or, to rephrase this as a syllogism of the pre-emptive futurism popular today: "How could you ever be so thoughtless as to presume that we would treat you well? If we did so we would only be encouraging others to do so; if others did so, then we couldn't treat them as well as we had you because treating you well would expend our resources; so we don't have to treat these others badly, we will make sure they don't come by treating you badly; doing so is simply the best solution for everyone."

This is not a simple case of "blaming the victim," precisely because the force of the R-affect permits the *affective occupation of the place of the victim itself*. In the supposed absence of any ascertainable civic, ethnic or national identity, refugees no longer even have a right to their own affects: *Affects 'R' Us*. This, moreover, seems a step beyond the still-Aristotelian logic of pity and terror that Philippe Lacoue-Labarthe has identified as emblematic of modern politics: "Pity

refers to what the modern age, under the name of compassion, thinks of as the social bond ... terror refers to the risk of the dissolution of the social bond, and the pre-eminent place of that first social bond which is the relation with the other."[36]

R-affects, rather, seem symptoms of a situation in which pity and terror have become indistinguishable and unassignable without, for all that, losing their power. This has an experiential dimension: one cannot feel pity for the other without suspecting that one has thereby already succumbed to terror. The media dissemination that organises contemporary institutional processes conditions such eruptions of intense, primitive affects (acephalic rage, for instance) not amongst those who are "primitive," "childlike," "uneducated" or the like, but amongst the highly educated dwellers of the technological first world. Contemporary media politics involves the routing, canalization of such affects by producing objects which can function as the triggers for such affects. If the Law of Empathy has functioned in modern liberal societies as a central repository or "container" of such affects – that which purportedly binds and sustains diversity in its very inability to sustain its claims – what binds media communities are the free-floating and murderous passions of post-tragic politics. Yet such passions are also, as we have noted, coldly cynical, operatory, apathetic.

So an R-affect is an affect of a sovereign group, the emphasis here being both on *sovereign* and on *group*. It is not the affect of a single subject, but of a group-subject forged and sustained by means of such affects which, thereby, and in a reflexive fashion, function as *indices of belonging*. One shows oneself publicly in the grip of such an affect, and such self-showing – beyond the dichotomies of conscious and unconscious – is manifestation of and testimony to its bearer's sovereignty.

Jacques Derrida, explicating Hannah Arendt's theories of the fate of the lie in "our political, techno-mediatic, testimonial modernity," notes that:

> Because the image-substitute no longer refers to an original, not even to a flattering representation of an original, but replaces it advantageously, thereby trading its status of representative for that of replacement, the process of the modern lie is no longer a dissimulation that comes along to veil the truth. Rather, argues Arendt, it is the destruction of reality or of the original archive.[37]

We have suggested that R-affects permit a sovereign group to experience itself, to *show-itself-experiencing-itself*, as a victim and as sovereign, celebrating self-sovereignty in the fiction of its breach. If Arendt's contemporary lie simultaneously *destroys* and *replaces* a reality which everyone already knows well, we could say that the R-affect voids the legitimacy of the experience of the other by taking it

as one's own. Given that "desperation" is a term that arises with extraordinary frequency in media descriptions and depictions of the individuals prosecuting Australia's border-protection policy, the R-affect is thus, quite literally and in all senses of the phrase, a form of *public transport* in the age of mass multimedia.[38]

Australia's recent "refugee crisis" is exemplary in this regard. Refusing all the canons of humanitarian good will and international law, the ruling right-wing Liberal Party, guided by the hand of the Prime Minister John Howard – a man once ironically denominated "Honest John" for misleading Parliament about the state of the economy when he was Treasurer – and Philip Ruddock, then Minister for Immigration, prosecuted an aggressive "Border Protection" policy. This policy involves the indefinite mandatory incarceration of asylum seekers in camps run, not by the state itself, but by a large private American corporation, Wackenhut. "People-smuggling" boats are to be turned back to their port of destination by the Australian Navy; while refugees are to be denounced in the mass media as "queue jumpers" – an astonishing act of historical denial and arbitrary line-drawing, considering the fact that all post-1788 Australians are in a very literal sense "boat-people."[39] The dark side of these transit systems, including the public "transportation" of English convicts to Australia, as well as the Atlantic slave trade, is thus conveniently repressed as a chapter somehow closed; unconnected to each successive "wave" of refugees.

Nevertheless, as part of this policy, the Liberals eventually came up with the hallucinatory "Pacific Solution," which involved paying small Pacific islands like Nauru, Tuvalu and PNG millions of dollars to have the refugees interned on their soil.[40] No one seems to have cared about the overtones, undoubtedly sinister to European and North American ears, of the phrase "Pacific Solution."

The crisis came to a head in late August 2001.[41] On 23 August, over four hundred (mostly Afghani) refugees fleeing Taliban persecution, left the tiny Indonesian port of Pantau on a boat named the *Palapa*, bound for the Australian territory of Christmas Island. Sinking, unable to get help from Indonesia, Australia or passing ships, the refugees were eventually picked up by Arne Rinnan, Master of the Norwegian vessel *Tampa*. Given confusing and contradictory messages by Australia and Indonesian authorities, he finally decided to head for Christmas Island with his boat full of sick refugees.

At that point, the entire machinery of the Australian political apparatus turned against him. Although advised by the Wilhelmsen Line's Sydney lawyer to keep going, a battery of politicians, bureaucrats and private entrepreneurs directed their attentions to keeping the Tampa out. The directive came from the very top – "The decision to stop the *Tampa* was taken by John Howard"[42] – but was administered by a veritably Pynchonian cast of operators and functionaries. After protracted vacillations, Rinnan finally took his boat into Christmas Island.

Instead of permitting the ship to land, a military team of SAS was sent to the *Tampa* to make a "medical assessment." Immediately afterwards, Howard denied the gravity of the situation in parliament. Additionally, he introduced a retroactive *Bill for an Act to provide for the removal of ships from the territorial sea of Australia* backdated to half an hour before the *Tampa's* Mayday. The Bill – worthy of the *Vorga's* Captain in Bester's novel – was rejected by Kim Beazley and his opposition Labour Party. (Beazley's rejection of this Bill was an undeniable factor in his election loss later that year.) A letter from an asylum seeker on the boat, handed to soldiers, reached high Canberra bureaucrats; under the Refugee Convention, that should have got them off the boat.

There are a number of issues: that the Australian Government was also close to perpetrating an act of piracy (taking control of a privately-owned Norwegian ship) should have been evident to everybody; government agencies were also unlawfully monitoring private communications to and from the *Tampa*; and Australia was stitching up deals with New Zealand and Nauru to take a number of the asylum seekers while stitching up the *pro bono* legal case against the Government in court. As for the military command on the boat: "A soldier put a big pot of jam in the middle of the Tampa's deck as the asylum seekers were queuing for lunch. There was a mêlée ... The SAS videoed everything."[43] When a bout of food-poisoning struck, the SAS were still filming. (Remembering that political torturers have always been specialists in recording devices; such devices function as an integral aspect of the very tortures they apparently only document.)

While the asylum seekers – who went without adequate food and health provisions for over a week – were forced to live in a liquid slime of their own faeces and urine, representatives of Australia's political elite had acted desperately (shrieking, haranguing, lying) to not only their own subordinates, Arne Rinnan and other representatives of the Wilhelmsen Line, but also to diplomatic counterparts from Norway, Indonesia, New Zealand and the United Nations. Hannah Arendt's notorious diagnosis of the "banality of evil," of the consequences of an absolute administrative submission to duty, finds a distanced echo in Australia's civil response to the crisis. Not that legal, moral, philosophical or practical exigencies have proved any barrier to the government's continued political success.

The situation was given a further twist two days into the 2001 Federal Election campaign in which "Border Protection" was a key issue and the "War Against Terror" had ignited an extreme jingoistic and xenophobic fervour. The HMAS Adelaide intercepted a boat carrying hundreds of asylum seekers from Indonesia. This is the last universally-accepted fact of the encounter. What happened then probably runs like this: the boat sank, spilling the refugees into the waves. The crew of the Adelaide picked up the refugees and took them off to be

incarcerated in various locations under the government policy. To this day, Commander Banks of the Adelaide claims that he said that there seemed to be one man "threatening to throw a child overboard." This quickly became: *children had been thrown overboard*! How it became so does not seem to have been proved by the subsequent Senate Inquiry. Peter Reith, then Minister for Defence, Ruddock and Howard leapt into action. Reports, photographs and video footage were released allegedly showing this to be the case.

What was so striking was the inability of any public figure to talk any sense about the incident. First, there was no real evidence that children had actually been thrown overboard, let alone that that had been threatened. The photographs and footage in the media could have been taken anywhere and designated almost anything; a mother floating in the water with children. They were not incontrovertible proof of children being thrown overboard. Second, *even if they had been*, it would be plausible to suggest that the refugees had been attempting to *save* their children from being scuppered by a warship; for example, "Look! Help! There are children aboard!" Third, the refugees were mainly Afghans, fleeing Taliban persecution. Since the Australian government was then noisily aiding the US in its assault on Afghanistan, one might have thought that refugees from the Taliban-controlled state would be welcomed, as "enemies of our enemies." Not a chance. Fourth – and whatever the circumstances – humanitarian issues clearly dictate that the sinking refugees should have been saved without further questioning. Save first, ask questions later is not, however, a policy of the present Government.

The situation was rendered even more frenzied, as Beazley also supported a "strong" (one of the key signifiers in contemporary political discourse) policy on "Border Protection." Indeed, the Labour Party had been responsible for earlier versions of the mandatory detention policy. And, with the *Tampa* driving the situation, almost every member of the two major political parties went into paroxysms to denounce the scum who had sunk their own ship and thrown their children overboard. The Prime Minister went on TV to declaim: "I don't want in Australia anyone who would throw their children overboard ... It offends the natural instinct." Voices of dissent were extraordinarily muted.

As the media belatedly and weakly agreed, the Government lied. Reith, whose term in Parliament was marked by various scandals, has been exposed as a liar. An "honest liar," however, as Reith was clearly only out for the main chance; his actions seem to have been self-promotional routines for a lucrative post-political job in the corporate world. In April 2003, it was announced that he had been employed as head of the European Bank for Reconstruction. Ruddock's case is less clear-cut. Once considered a "wet" Liberal, the vampiric Ruddock has consistently refused to remove his Amnesty International Badge, and, as a committed Christian,

has been quoted as saying: "If Jesus had found 10,000 people by the side of the road, he would have had to make some tough decisions too." As for Howard, though incontrovertibly a liar, his political standing has only been enhanced by the Tampa crisis and its aftermath. As Marr and Wilkinson have shown, Howard's handling of the Tampa affair destroyed the Labour Party – which remains, years later, in disarray.

Refugees are clearly useful reminders to the citizens of a state about just how well off they are, despite political, economic and social inequality, and just how badly off they could be. So refugees must be treated with impunity by state and international powers, who make them the objects of military, incarceratory and public relations operations. That refugees can be locked up indefinitely without trial, by the very states that proclaim their support for human rights (indeed, can go to war on the back of such proclamations), suggests that refugees are a special case of those "sacred beings" which states produce and maintain on their own territories as unassimilable to the category of "citizen." (For more on this crucial political-ontological trope, see chapter 8.) It is suggestive that, in Australia itself, "illegal refugees" have been traditionally imprisoned in locales where the Aboriginal population were once imprisoned; it is also suggestive that the government has shown great alacrity in setting up and maintaining sites from which Australian law is subsequently withdrawn.

5. The New Apartheid

We need topographers to give us exact descriptions of the places where they have been. But because they have this advantage over us, that they have seen the Holy Land, they claim the additional privilege of telling us news about all the rest of the world. I would have everyone write about what he knows and no more than he knows, not only on this, but on all other subjects. One man may have some special knowledge at first-hand about the character of a river or a spring, who otherwise knows only what everyone else knows. Yet to give currency to this shred of information, he will undertake to write on the whole science of physics. From this fault many great troubles spring.
MONTAIGNE[44]

Today we live in an intercultural climate composed of such informational shreds. Indeed, we have little evidence to counter Montaigne's assertion concerning the source of our "many great troubles." Indeed, it is practically impossible to ignore

the sinister ring behind Heidegger's statement, noted half-a-century ago, that "[f]rom here it is only a step to making values into objects in themselves."[45] Clearly we have already taken such a step. That is, ethical principles have since become managed, administered and even exported (as in the much discussed "exporting" of democracy to other parts of the world), as if they were commodities – ontologically equivalent to furniture or coffee beans.[46] And thus, the logic of representation "drives everything together into the unity of that which is thus given the character of object,"[47] shepherded by "the fundamental certainty" of the rational subject-citizen.

Indeed, it is this fundamental certainty which allows the Australian government, as much as the White House, to treat refugees and other culturally-coded avatars of otherness, as objects of their will. ("Political football" was the term used in the 1970s.) The element linking the life of the prostitute, the cluster-bomb victim, and the refugee, is that their movements are controlled by the calculable; and they accordingly hover in a liminal zone between subject and object. That this liminal zone is less an abstract conceptual space than a ship full of faeces and vomit, or a jail full of despair and suicidal solutions, makes this profoundly philosophical dilemma all the more urgent.

Heidegger goes on to say that "nothing can elude this objectification that remains at the same time the decision concerning what must be allowed to count as an object."[48] Such a decision process leads to the two-tiered form of apartheid much of the world suffers from today. Firstly, one must show up on the radar of ontological presence. This is itself an achievement, given the self-made blinkers of scientific discourse. The second form is to show up on the radar of political presence; another achievement despite the fact that it is supposed to be an automated democratic right. (Non-human life appears, for instance, on the first radar, but not the second – as do most refugees.)

Put in the starkest terms, the bitter debate over mobile populations, as moveable objects, in the twenty-first century must look past the rhetoric of security and paranoia, to the underlying assumptions which make both of these registers possible. That is, the destructive political will of the Western project will only mutate into a less virulent strain when so-called man has "overcome himself as subject, and that means when he no longer represents that which is as object."[49]

Coda 1: Escape from Woomera

We quote the following news items with only minimal comment:

Ruddock fury over Woomera computer game
 BY SEAN NICHOLLS
 APRIL 30, 2003

It's a dose of virtual reality that the Immigration Minister could probably do without: a computer game in which players try to escape from Australian detention centers has received $25,000 in federal funding [from the Australia Council's New Media Arts Board]. The game, *Escape from Woomera*, will be modelled on four of the country's most contentious detention centers ... The game's creators plan to reproduce the exact conditions within centers at Baxter and Woomera in South Australia, Port Hedland in Western Australia and Villawood in Sydney. Television footage, the recollections of former detainees and employees, and newspaper and radio reports will be used to mimic the layout and daily life in the centers, right down to meal times, the way guards communicate with each other and "episodic violence." Players will be challenged to escape using the means at hand – refugee action groups, sympathetic lawyers, digging tunnels or scaling fences – all based on actual events.

Coda 2: The Scramble for Africa

Australian technique used to map the brain
 BY DAVID WROE
 MARCH 1, 2003

The brain's surface is an uncharted continent of mountains, valleys and geological strata. The Human Genome Project, which mapped our genes, is complete. The human "brainome" project has just begun. Five men and one woman have become the first living people to have a section of their brain surfaces mapped in detail, using a ground-breaking Australian scanning technique. Like its genomic predecessor, it is the start of a mammoth, decade-long task that will eventually provide an atlas of the cortex – the grey surface that looks like tightly bundled intestine, where higher functions such as reasoning and language are processed. The scientists, led by Gary Egan from Melbourne's Howard Florey Institute and John Watson and Nathan Walters from Sydney University, say such a map is essential to guide exploration of the last frontier of anatomy.

128

As well as helping to understand the causes of neural diseases, it could explain genius – Shakespeare's gift for language, Einstein's spatial brilliance or Aristotle's unparalleled skill with logic. The six Australian subjects had only a small part of their brain mapped – the region that deals with visual perception. But this would open a floodgate, Professor Egan said. "When the first genes were mapped ... people suddenly saw you could do this, and the race was on," he said. "I'm sure other labs now will race to produce the first total brain map." Their research will be published on Tuesday in the prestigious US journal, the *Proceedings of the National Academy of Sciences*. Scientists have known for decades roughly what function each part of the brain performs. The frontal lobes house problem solving, memory, personality and language. The occipital lobes handle visual perception and so on. But what makes one person a Wittgenstein and another person a Warney[50] has much to do with the microscopic structure of the six layers in the cortex. It is these fine, cortical layers that the Australian scientists have seen in living subjects for the first time. "It's like going from a regular microscope to an electron microscope," Professor Egan said. "We looked at the brain in it's [sic] entirety, now we're looking at individual layers." Previously, the only way to see these layers was to dissect a person's brain – a Catch-22 since you cannot study a dead person's thoughts. By superimposing knowledge of brain structure with brain function, we can begin to understand why people think uniquely and perhaps even explain the deepest human qualities such as consciousness, creativity or reasoning. Exploration is a handy analogy. At present, our knowledge of the geography of the brain is limited to basic outlines of the continents. The Australian team hopes to fill in the cities, towns, mountains and rivers. "Human brain mapping has got up to about the 18th century of real map-making," Professor Watson said. "We're somewhere between Captain Cook and Phillip actually rowing into Botany Bay and then sending his marines and convicts up the Hawkesbury. We're not Burke and Wills yet."

(Note: Robert Burke and William Wills died of exhaustion and thirst in 1861, while attempting to become the first Europeans to travel from the South coast of Australia to the North.)

The Foreign Object

The Floating Life of Fallen Angels:
Unsettled Communities and Hong Kong Cinema

1. Sans Seraph

Only the angel ... can undertake long journeys from the invisible No-where ... toward the interior temple of man, enter his darkness, and help him recover his proper Orient.
 MASSIMO CACCIARI, *THE NECESSARY ANGEL*[1]

We must not be so afraid of the purely animal life, nor consider if as the worst state into which we can fall. For it is still better to resemble a sheep than a fallen Angel.
 JEAN-JACQUES ROUSSEAU, *FINAL REPLY*[2]

Wong Kar-Wai's *Fallen Angels* (1995)[3] is one of the most arresting movies to emerge from the now internationally celebrated Hong Kong cinema. Initially appearing to be a cross between *Blade Runner, After Hours* and MTV, it soon manages to carve its own idiosyncratic space in both the viewer's psyche and the archive of Asian urban imagery. Following the dreamy movements of Hong Kong's *demimonde*, Wong's film captures the hyper-alienated cultural climate of a city which has been cut loose from its previous colonial moorings, and now floats uncannily between the political grids which link Chinese and British history.

In his book *Hong Kong: Culture and the Politics of Disappearance*, Ackbar Abbas points to this "floating identity" as an integral part of a fundamentally liminal community. He writes: "Hong Kong has up to quite recently been a city of transients. Much of the population was made up of refugees or expatriates who thought of Hong Kong as a temporary stop, no matter how long they stayed. The sense of the temporary is very strong, even if it can be entirely counterfactual."[4] Abbas goes on to trace the perceived shift from what he calls Hong Kong's "reverse

hallucination" – not seeing the obvious – to "a culture of disappearance."[5] Abbas thus argues that Hong Kong represents an unprecedented form of post-coloniality – a kind of profane limbo populated by terrestrial angels who can't quite locate themselves, and consequently suffer various postmodern strains of globalist symptoms. "Hong Kong is an example of a *postculture*," he asserts, because "it is a culture that has developed in a situation where the available models of culture no longer work."[6]

Wong Kar-Wai's movies – at least those made up to (but not including) *Fallen Angels* – are presented by Abbas as symbolic artifacts from Hong Kong's post-cultural, post-colonial position. Wong's "systematic irresolutions" are said to be an active reflection of this culture of disappearance; an attempt to self-consciously reinvent Hong Kong's identity within the very paradoxes which prevented it from doing so before 1989. This filmmaker's entire aesthetic, at least according to Abbas, stems from his attempt to invent "a form of visuality that problematizes the visual"[7] – an appropriate strategy for a "para-sitic" culture which emphasizes identity over subjectivity, emotions over affectivity, and voice over representation.[8]

Abbas's argument serves to identify Hong Kong as an example of what Ken Gelder and Jane Jacobs have described as "unsettled societies." As a major informational and economic node in the global network, Hong Kong is a particularly spectacular example of the diasporic, millennial metropolis. *Fallen Angels* is thus a particularly vivid depiction of the people who inhabit the spaces between Hong Kong's shifting identity – those who exist beyond the clichéd collision between tradition and modernity (and yet retain a secular connection to sacrality).

One striking scene in *Fallen Angels* focuses on a beautiful young woman masturbating alone in her business partner's apartment while he prowls the nocturnal street for his victims. One would be hard-pressed to find a more compelling portrait of the loneliness and sense of dislocation of a generation of people who presumably grew up in Hong Kong, and should therefore by rights call it home. These are Wong's exterminating angels – the flip side of Buñuel's – who leave their rooms all too easily, and are in fact exiled to the streets and beyond, as if a giant invisible hand has spun their world with a powerful centrifugal force. These tear-and-blood-stained drifters are a testament to the atomized experience of a creeping global horror.

This same unnamed woman frequents her "partner's" favourite bar, hoping in vain that their paths will cross. She listens to a Wurlitzer jukebox which plays a Laurie Anderson song:

Daddy Daddy, it's just like you said
Now that the living outnumber the dead
Where I came from it's a long thin thread
Across an ocean down a river of red ...
I'm one of many – speak my language

Wong thus constructs his own personal hymn to Hong Kong's seemingly eternal night, and the deadpan hysteria of those who populate it. "The night's full of weirdoes," observes He Qiwu (Takeshi Kaneshiro), a Taiwanese immigrant. The different characters interact, but rarely seem to become intimate: preferring to trace the absence of each other's frustrated desires. In one scene, the young woman's partner, Wong Chi Ming (Leon Lai) – a hired killer – cannot even remember one of his former girlfriends. She has now coloured her hair blonde to avoid such humiliation in the future. ("Let bygones be bygones. You like me now, that's fine." "I never said that," he replies.)

According to Wong's portrait of Hong Kong, proximity entails boredom and love is akin to break-and-enter. The rain-soaked streets and nicotine-heavy mahjong parlours are pregnant with the potential for random violence, and even sudden death. His characters massage pig-carcasses in a grotesque pantomime, and torture an inflatable doll in a stairwell. And yet within these interstitial and illicit spaces the possibility of human contact emerges. A family taken hostage in an ice cream truck seem to enjoy a spontaneous tour of the city, temporarily wrenched out of their domestic routine. A woman enjoys the numb warmth of riding pillion on a high-speed motorbike, just as He Qiwu smiles at his dead father (who spoke a Taiwanese dialect with a Russian accent) captured for posterity on videotape. All these fleeting, fuzzy moments seem to contradict another character's heartbroken conviction that "there are no miracles in this world."

Massimo Cacciari has stated that "the dimension of the Angel is ou-topic. Its place is the Land-of-no-where, the *mundus imaginalis*".[9] As a quintessentially European thinker (and former mayor of Venice, no less – Calvino's invisible city), Cacciari is concerned with the topology of a particularly Western angelology. Nevertheless, as the epigram to this section attests, his conclusions can be both productively – and problematically – applied to the "fallen" aspect of the angel, especially as it relates to exile. Like Wong's characters, the angel has no proper place; indeed, it is so weary, and "the vertigo of the fall so violent," that it has forgotten what it had to announce.[10] In a profane context, the angel becomes an unsettling and uncanny figure precisely by its banality: "Their own *tremendous* presence is a sign of distance, of separation. A metaphysical fracture intervenes in the angelological tra-

dition. Instead of being the guardians of a threshold, here Angels appear to be unsurpassable demons of the limit ... [This] means that every encounter will now have to begin by putting ourselves at risk."[11] Any relationship with the Other thus becomes a negotiation with the ontological miracle of presence, along with the subversive effects of absence: the broader culture of disappearance.

Cacciari reminds us that the angel represents a sacred form of lack, and that "incompleteness means metamorphosis, change of roles, ironic dissolution of the certainty of figures, of their 'ubi' [whereabouts]."[12] We need only recall the glazed gaze of Wong's assassin in order to evoke that angel who "transforms the gaze into the gaze of nowhere."[13] Looking backwards into the future, these avenging angels stalk the streets of a mythical city-space in which the familiar is always strange, and those who belong are already outcasts.

In his book *The Practice of Everyday Life*, Michel de Certeau sees little distinction between "a foreigner, a city-dweller, [and] a ghost."[14] Moreover, he sees all urban consumers as "immigrants in a system too vast to be their own, too tightly woven for them to escape from it."[15] In a passage which vividly evokes *Fallen Angels*, De Certeau notes that

> [t]he moving about that the city multiplies and concentrates makes the city itself an immense social experience of lacking a place – an experience that is, to be sure, broken up into countless tiny deportations (displacements and walks), compensated for by the relationships and intersections of these exoduses that intertwine and create an urban fabric, and placed under the sign of what ought to be, ultimately, the place but is only a name, the City. The identity furnished by this place ... is only a pullulation of passer-by, a network of residences temporarily appropriated by pedestrian traffic, a shuffling among pretenses of the proper, a universe of rented spaces haunted by a nowhere or by dreamed-of places.[16]

Wong's neon-lit angels are not only a hybrid of nations and races, but seem to be the illegitimate offspring of the union between cherub and ghost, even dyeing their hair blonde in order to closer resemble "the angels of perversity" (Remy de Gourmont). They themselves seem to be only "the effect of displacements and condensations."[17]

From Pythagoras to Pygar, the fallen angel has represented the limits of the Enlightenment project, especially the uneasy nihilistic mandate of scientific paradigms. The supposed death of God, in the era of accomplished nihilism, seems to have "accomplished" little other than an unleashing of angels and demons across

the contemporary cultural landscape, which has become a breeding ground for all sorts of odd apparitions. Accompanying the fatuous neoconservative multicultur-alism of "world music" is what we might call "world spiritualism," where vampires, monsters, aliens, fairies, half-men and zombies commingle promiscuously in an orgy of mediatic vacuity.

Hong Kong cinema has been particularly fond of depicting these supernatu-ral figures in a variety of genres according to a range of aesthetic perspectives and intentions. (Many of which, necessarily, represent a more localized and culturally-grounded response to this "world spiritualism" just mentioned.) The Kuomintang government, for instance, banned the making of paranormal movies in 1935 in order to counter what it saw as a celebration of superstition; however, the last couple of decades have seen an explosion of Hong Kong horror movies, from the comic, to the erotic, the spooky, the sublime and the ridiculous.[18]

Abbas offers Stanley Kwan's *Rouge* as an anti-spectacular meditation on Hong Kong identity, memory and desire through the figure of the ghost. One need not focus on an "actual" spectre, however, in order to bring a post-colonial narra-tive into the same uncanny tropological system. In Clara Law's *Floating Life*, for instance, the compounded estrangement of migration becomes the medium of a similar unsettlement in regard to temporal and spatial slippage. Here ghosts are indistinguishable from fallen angels, for they both embody the restless plight of the exile: a life to be endured both *avec et sans seraph*.

2. Terror Nullius

I agree that ghosts only come to sick people; but that only proves that ghosts cannot appear to anyone but sick people, not that they themselves don't exist.
SVIDRIGAILOV, *CRIME AND PUNISHMENT*[19]

Tradition is the illusion of permanence.
WOODY ALLEN, *DECONSTRUCTING HARRY*[20]

Clara Law's *Floating Life* (1996) is a fascinating counterpoint to Wong Kar-Wai's equally beautiful, but radically distinct film. While *Fallen Angels* employs an eclec-tic and erratic array of styles, techniques and film stocks to reflect the adrenalized exhaustion of its characters, Law's film is serene, stark and extremely nuanced in its depiction of a large Hong Kong family scattered across the globe between Germany, Australia and Hong Kong.

When most of the Chan family arrive in the Australian suburbs to be reunited with their second daughter, Bing (Annie Yip), she immediately gives them a long and neurotic list of warnings about their new home. The ozone layer has a hole in it and will give you skin cancer. People get burgled every few minutes. Watch out for killer wasps, redback spiders and pit-bull terriers. ("It isn't that scary, is it?" asks ma. "So many people killed in Australia," laments pa.)

As a result of these suburban horror stories, the newly arrived family cower inside the house, which, unlike the traditional haunted house, is Spartan, white, and flooded with harsh Australian light (in contrast to the soft pallor of the Hong Kong scenes). For a while the house resembles both bunker and boot camp, ruled over by the tyrannical Bing who insists that they assimilate into this new country, and yet terrifies them into such a state that they are incapable of leaving the relative safety of the thin wooden walls ("No incense! The house could burn down").

After becoming sick of midday TV soaps and listening to international radio broadcasts, the family decide to venture down the street in search of some Chinese tea while Bing is at work. They venture outside down a cul-de-sac which seems to be on the very edge of the city, and consequently the world.[21] They soon become terrified of a tiny barking dog and run home, leaving the more curious pa to soldier on. He comes face to face with a kangaroo, an almost mythical creature which only serves to accentuate the alterity of Australian space. Pa lifts up his fists in true Hong Kong action style, and the kangaroo skips off.

Later on in the film we are given a flashback of Bing's early days as an immigrant, working and living alone, waiting for her husband to save enough money to join her from Hong Kong. She takes a torch into the attic and is confronted by a more traditional image of Gothic horror – a dark and sinister room choked full of spider webs and eerily shifting shadows. The scene quickly cuts to Bing frantically taping up the roof access with gaffer tape, as she attempts to isolate the creeping symbolism of her psyche (which, of course, constitutes only a repression which shall inevitably return in the noirish eruption of her clinical depression).

De Certeau reminds us that "[t]here is no place that is not haunted by many different spirits hidden there in silence, spirits one can 'invoke' or not. Haunted places are the only ones people can live in."[22] According to such an observation, the Chan family house in Australia is terrifying due to the very *absence* of spectres and other supernatural tenants.

While waiting for the bus into town, pa says to ma, "Let's not buy incense. We have nowhere to burn it. *Follow the customs of the new village.* Actually we're so far away, even if we make an offering it won't reach them." Ma begins to cry, so pa reassures her that it's okay, because "it's all in the heart." The distress resulting

from not being able to relocate the family altar in the new house, however, seems to counter pa's stoic claim. Geographical distance in Law's film thus becomes an impediment to communing with the dead, just as the price of international phone calls prohibits any meaningful communication with the eldest daughter Yen (Annette Shun Wah) in Germany, or the first son Gar Ming (Anthony Wong) in Hong Kong.

In fact, geographical location seems to define what falls within the realm of the natural and the supernatural; what is ontologically present or absent. Yan – distressed by the unsettlement of her family – seems to blame her misfortunes on bad *feng shui*. Her German husband is initially sympathetic, and helps her to move the furniture around. As soon as the spiritual directions of interior direction become illogical to him, however, he reminds his wife that they need not feel bound by the laws of *feng shui*: "You're in Germany now."

At this point the slippage between house and home – a crucial one for the narrative – becomes painfully clear to Yan. In a tearful bedroom monologue, she explains her dilemma to her husband:

> I don't know where my home is. I don't even know if I should think of myself as Chinese. I was born in Hong Kong. I don't speak Mandarin. And soon Hong Kong won't be Hong Kong. The colour of my skin is yellow, not white. I speak German with an accent. I live in Germany, but I'm not really German ... Where is my home?

Yan answers her own question by initially deciding that her home lies wherever her family lives. In contrast, Gar Ming believes it to be Hong Kong, where he still resides, hesitant to make the move to Australia.

Indeed, Gar Ming has his own horror to cope with, having seen his mistress's aborted foetus throb for a moment, following his unusual request to see the aftermath of the operation. "Three seconds of pleasure produces three inches of flesh," he ponders gloomily. "It throbs only once in its entire life. Its whole life is just one second. In one second it experiences birth, aging, illness and death. Too short or too long? It's not a piece of flesh. It's my child."

This traumatic experience is exacerbated by his filial duty to collect the bones of his grandparents, due to the shortage of land space for burials in Hong Kong. He is instructed by the neo-Shakespearean gravedigger to make sure that the bones are arranged properly in a ceramic pot so that his ancestors do not have to endure eternity while kneeling.[23] Thus, for Gar Ming, the undead seem to have a particularly vivid currency in his thoughts concerning dislocation, deracination and expatriation, leading to an enigmatic epiphany concerning "the dead who are

supposed to have disappeared."[24] Ultimately, it seems that a faith in "spirituality" is little compensation for the permanence of death (especially the imminent passing of his parents, pa and ma).

McKenzie Wark has noted that "we no longer have roots, we have aerials." This may seem true in the case of the Chan family, as pa combs the airwaves with his shortwave radio in order to listen to Radio Free Russia and the BBC World Service. The resemblance to a cyborg, however, ends here. Yen, Gar Ming and Bing seem to suffer from phantom roots, which continue to ache like phantom limbs. The ghostly presence of these thirsty tendrils do nothing, however, to discredit Wong's and Abbas's representation of Hong Kong as being a place of *suspended emigration*, even "before the exit visas have been issued."[25]

Even at the very beginning of *Floating Life*, the bustling people of Hong Kong are shot out of focus and in slow motion, so that they recall a population of spectres. Pa discusses green tea with a restaurant owner who is waiting for his Canadian visa: "I say we've just been warming our arses over here and now we're off to somewhere else." The family drinks Coke and talk of duty-free Nikes, displaying an already endemic globalist identity and recalling Abbas's always already rootless Hong Kong residents.

Why then, given the floating life of the Chan family, is the transition to Australia so traumatic, even horrific ("This house stinks. It's full of AIDS ... You're here as migrants, not to enjoy life," shouts Bing)? The answer must be that we continue to have both roots *and* aerials.[26] Roots constantly seek filial nourishment, no matter where we are transplanted, and aerials receive the mysterious signals of our (sub)urban environments. Hence the crucial moment when ma reconstructs her ancestral altar in Bing's abandoned house in order to exorcise the demons from her daughter's troubled mind.

Home is thus figured by *Floating Life* as a form of utopia – a nowhere land glimpsed on the fringes of the banal everyday. Clara Law's film itself is symptomatic of this uncanny and ubiquitous cross-cultural liminality. An Australian film critic calls it "one of the most beautiful Australian films of the last few years,"[27] while the Hong Kong industry consider it merely an expatriate extension of their industry (just as John Woo and Jackie Chan will always be considered Hong Kong directors, no matter how many films they make in Los Angeles – the "city of Angels").

3. Australienation

Trees of our life, when is our winter?
We do not agree on this. We do not know,
as migratory birds know. Outpaced and tardy,
we force ourselves into unseasonable winds
before landing heavily on some indifferent pool.
RAINER MARIA RILKE, *THE DUINO ELEGIES*[28]

Don't they ever stop migrating?
ALFRED HITCHCOCK'S *THE BIRDS*[29]

Australia has traditionally been viewed by the northwestern hemisphere as "down under," or even upside-down. In commenting that everything is "back to front" in Australia, Ma Chan not only echoes a long legacy of culturally-coded compass points, but depicts the upside-down and uncertain perspective of Rilke's angel.

In a recent advertisement for Sprite soda, Fox Mulder (David Duchovny) of the famed *X Files* parodies his character's obsession with paranormal phenomena by tracing the elusive Big Foot to Australia, which turns out to be the hirsute cricket-player Merv Hughes. In the last shot, Mulder circles the syllable "alian" in the word "Australian" on his office blackboard. The truth of a certain species of Otherness – the ad suggests – seems to be "out there," in Australia.

Abbas has noted that the population of Hong Kong is "now faced with the uncomfortable possibility of an alien identity about to be imposed on it from China," and is consequently "experiencing a kind of last-minute collective search for a more definite identity."[30] Wong's pre-1997 fallen angels seem almost too amnesiacal to feel the full effects of this immanent alienation, embodying Baudrillard's thoughts on the anachronistic flavour of the very notion. How can such a moorless subjectivity experience the isolation of alienation?

When the Chan family move to Australia in *Floating Life*, everything seems particularly alien to their transplanted world view. The film's depiction of *actual* Australians (whatever such a fraught term may mean) is fleeting and peripheral, as if they themselves are ghostly apparitions haunting the fringes of the landscape. The overall effect is that the "natives" themselves become spectral and surreal, whereas the newly arrived immigrants are vivid and fully materialized in this new place.

No doubt, watching *Floating Life* is a radically different experience depending on whether you grew up in Australia or Hong Kong. As an example of the former, we couldn't help but recall Gelder and Jacob's notion of an uncanny form of

nationalism, intermingling with what we call the "anglo-grotesque." In his intro-duction to *Floating Life* for SBS television, Australian film critic David Stratton states that Law "makes Sydney a mysterious, at times rather threatening place, and the film was made before the ignorant bigotry of racism became a political factor in this country." Despite the astonishing naiveté of such a comment (as if the spectacular case of Pauline Hanson's One Nation party[31] was the only reser-voir of racism in the last two hundred years), Stratton pinpoints the almost atavis-tic tension surrounding multiculturalist discourses in contemporary Australia.

As we write, national politicians are already making references to the "spec-tre of One Nation" in one breath, while hystericizing the "influx" of illegal Chinese immigrants in the next, seemingly oblivious of the hypocrisy involved.[32] Indeed, Pauline Hanson herself contributed to the supernaturalizing of her status in the national imaginary by taping a "posthumous" videotape to be broadcast in the event of her assassination ("Fellow Australians, if you are watching me now it is because I have been murdered"). That her sacrifice was made in the ballot box, and not by a bullet, makes the event no less uncanny; in fact it makes the whole cha-rade appear even more grotesque.

Coincidentally enough, we are also writing during the third anniversary of the Port Arthur massacre, a partly racially-motivated attack on Asian tourists which soon became an indiscriminate slaughter. The layers of homicidal history on this very site compelled the authorities to demolish the blood-stained café in order to expunge the demons which had possessed this most recent structure (as if the entire area was not a ghoulish industry based on memorials of colonial horror).

As mentioned earlier, Gelder and Jacobs discuss the unsettlement which inherently lies within modern Australia's relationship to the Aboriginal sacred. Their study is concerned with mapping that political dynamic whereby disposses-sion (and the discourses which articulate it) provides "the very conditions for a renewed mode of possession to occur."[33] Moreover, "sacredness 'returns' to mod-ern Australia in the *context* of dispossession."[34]

The phantasmatic promised land of "reconciliation" both beckons and haunts the nation, sublime and unattainable. Gelder and Jacobs also emphasize the rela-tionship between the uncanny and the *unheimlich* (Freud's "unhomeliness") in order to "give unsettlement an activating function": a crucial strategy in this age of global dispossession.[35] Considering such a perspective, it isn't too far-fetched to see an affinity between the spectral Australians in Law's film, and the Chinese protagonists. "One is always (dis)possessed," write Gelder and Jacobs, "in the sense that neither possession nor dispossession is a fully realisable category."[36] Australian movies such as *Picnic at Hanging Rock* and *Summer Holiday* (both made in the self-conscious 1970s) symbolically trigger the European fear of trespassing

on sacred ground – the *terror nullius* of Aboriginality, exposing an asymptotic parallel with the dilemma of the Chan family. Do we really belong here? Where is "here" anyway? At what point can we call Australia – Peter Allen style – "home"?

4. The Horror, The Horror

[M]eaning is not in things but in-between.
 NORMAN O. BROWN, *LOVE'S BODY*[37]

To be unhomed is not to be homeless ...
 HOMI K. BHABHA, *THE LOCATION OF CULTURE*[38]

Decisive here is the idea of an inessential community, a solidarity that in no way concerns an essence. Taking-place, the communication of singularities in the attribute of extension, does not unite them in essence, but scatters them in existence.
 GIORGIO AGAMBEN, *THE COMING COMMUNITY*[39]

Neither *Fallen Angels* nor *Floating Life* is an obvious candidate to describe as horror film. Nevertheless, they do open a useful theoretical space in which to discuss the mutating forms of a prosaic, but no less devastating, condition of global horror. Both are infused with a particularly postmodern strain of homelessness. And isn't the powerful sense of unsettlement while in the bosom of the home the very essence of the Gothic? (We need only refer to Poe's *The Fall of the House of Usher*.) It is within this generic context that we should understand Bing's comments to her parents regarding her younger brothers ("They might even kill you for your life insurance"), as a Gothic expression of horror toward the dormant enemy within. In Baudrillard's age of transparent evil and all-too-visible obscenity, Reason produces monsters as much in its waking state as during sleep. Within such a context, the mundane (*mundus* – "earthly") angel and ghost become uncanny tropological figures through which we can rethink conceptions of identity, abandonment, alterity and belonging, in an age of unprecedented unsettlement.

Homi Bhabha has noted that during displacement "the borders between home and world become confused; and, uncannily, the private and the public become part of each other, forcing upon us a vision that is as divided as it is disorienting."[40] Translating the micro-sphere into the macro, Bhabha states that "the unhomely moment relates the traumatic ambivalences of a personal, psychic history to the wider disjunctions of political existence."[41] "Can the perplexity of the

unhomely, intrapersonal world," he asks, "lead to an international theme?"[42]

The answer in mid-1999 – when the contrast between suburban Sydney and "war-torn regions" could not be more striking – would have to be a resounding "yes." In scenes straight from an old B-Movie, the pro-Indonesian militia in East Timor drink goblets of each other's blood in a vampiric performance of fealty and hatred. What we are witnessing in the Balkans, East Timor, Rwanda, and other less reported places, are the global consequences of unsettlement. Dispossession – or the fear of dispossession – leads to scenes far more gruesome than in any cinema. When these atrocities are perpetrated in the name of sovereignty or state power, the United Nations and NATO begin to look something like an *Attack of the Killer Zombies*, as the husks of old power formations shuffle towards the market economy in order to reanimate themselves on the other side of the millennium.[43]

Ghosts, angels, and indeed zombies, are figures of irreconciliation – of being unable to lay the past to rest. As with Benjamin's over-cited Angel, history becomes merely the political momentum of an always unfolding catastrophe. Abbas has stated that Hong Kong has become a "mutant political entity,"[44] although he believes that "describing mutations" opens up new possibilities.[45] Such a Harawayesque faith in the future, however, seems to neglect the sinister ways in which the presentday "military-industrial-entertainment complex" is itself a mutant. And yet, as *Floating Life* has taught us, horror need not lurk in obvious generic signifiers. The horror of normality can be equally terrifying. In contrast to David Lynch, who feels compelled to expose the monstrous underbelly of suburbia, Law captures the relentless banality of the quotidian. She understands that fear is located primarily in the prosaic mind and its unsettled projections, and rarely in the ominous riddles of a psychopathic dwarf.

Mediocrity is thus the true horror, because it is the innocuous breeding ground of nationalistic violence, even as it remains profoundly severed from it. *Domesticity is its own alibi* (recalling Bhabha's comment concerning the interchangeability of public and private space). And yet the two horrors are connected via Abbas's "hyphen-nation." To romanticize a kind of rootless or nomadic subjectivity only reinforces the circuit of violence, as *Fallen Angels* vividly demonstrates. The "perfect forgetfulness" of the Angel is no solution to any equation linking homelessness and horror. Rather we might do well to consider the recent case – encapsulating the logic of "the object" that we have been tracing in this book – whereby an Australian family returned a seven hundred year-old Samurai sword to the Japanese family from which it was stolen as a spoil of war in 1945. While such an exchange is inscribed within the relative histories of imperialism and demonization, this weapon was temporarily re-figured as a symbol of reconciliation. Far from "giving up the ghost," this personal and political gesture invited a form of

recovery, prompting the Japanese family to issue a statement that "It is like our father has returned to us."[46]

In a technique employed by Mrs Chan in *Floating Life*, psychic family baggage, which has become lost in transit, is returned in a gesture less concerned with closure than with a familiar and relatively reassuring mode of haunting. Re-establishing contact with dead kin serves to confirm the new portability of the past. As a consequence, this particular spectre becomes confused with Marx's, which has wandered loose from the cellars of Europe. Together they embody DeLillo's recent observation that "All terror is local now."[47]

The Abject Object

Sovereignty, Sacrifice and the Sacred in Contemporary Australian Politics

The most incredible, cruel, outrageous, extravagant things happened every day in Australia, but there was nothing to give them any sense outside of their existential absurdity. There was no real patriotism, no religion, no history, no sense of cultural identity, no great stories.
 MICHAEL REYNOLDS[1]

The king or prince is a kind of Law, and the Law is a kind of king or prince. For the Law is a kind of inanimate prince; the prince, however, a kind of animate Law. And insofar as the animate exceeds the inanimate the king or prince must exceed the law.
 AEGIDIUS ROMANUS[2]

If people are put to death by a verdict and not by a poem, it is not because the law is not a fiction.
 BARBARA JOHNSON[3]

1. Exemplary Australians

In the vast work of postcolonial reconstruction that drives one of the primary, politically committed modes of contemporary global academic discourse, the Australian situation may appear of moderate, but not inordinate, interest. Australia is, geopolitically speaking, of only minor regional strategic importance; it is a notoriously peaceful place, devoid of violent public political struggles (unlike Sri Lanka, Northern Ireland, or Palestine); its population is nugatory by world standards (approximately twenty million inhabitants); it is a developed first-world nation, preponderantly suburban and middle-class; it is widely touted as a successful multicultural state. As a ubiquitous local idiom declares, Australia is, indeed, "the lucky country."

Given such factors, the various claims made for Australia's uniqueness may convey a sense of special pleading, if they are not simply received as implausible. After all – although a European settler-colonial state, with all the violence and bloodshed that such a denomination now implies – many Australians acknowledge the inequities of invasion (e.g., there are now excellent and detailed historical pro-

grammes well-established across the secondary school system) and, that being recognised, feel that everyone can now get on with the business of getting on. Australia is unlike North America, with its vast numbers of dead and extremities of violence, not to mention the ideological celebrations of Manifest Destiny and the Wild West; it is unlike the countries of South America, with their extraordinary gulfs between rich and poor; it is unlike South Africa, where the inheritors of the white colonists were massively outnumbered by the indigenous inhabitants, yet installed their domination in Apartheid; it is unlike New Zealand, where open warfare between the indigenous inhabitants continued well into the twentieth century (with treaties that can enable New Zealand to resemble a more "equitable" state), and so on. This "unlikeness" is, in other words, usually considered a smaller, less extreme or more contained version of situations elsewhere. If Australia is noted at all in an international frame, it is then no surprise that it is regularly coupled with other othernesses – even by those purportedly sensitive to little differences. Gayatri Spivak, for instance, in the course of a deconstruction of Kant's invocation of the "New Hollanders" and "the inhabitants of Tierra del Fuego," repeats Kant's conflation by running these together, both in the body of the text and a long footnote.[4]

Yet if, as local commentators on Australian politics frequently point out, "By international and historical standards, Australia is a very quiet place," they just as frequently continue: "Despite this appearance, things of world-historical significance have happened here."[5] The two most often adduced events of "world-historical importance" are, first, the ongoing ethnocide of the indigenous population and, second, the enormous post-WW II immigration programme, which has made Australia one of the most "multicultural" nations on earth. It is therefore no surprise that the after-shocks of these two events continue to inflect mainstream Australian politics in ways that few of the participants themselves would be pleased to acknowledge – indeed, will often go out of their way to disavow.

Our claim in this chapter is that there *is* something quite unique about Australia as a settler-colonial nation; that this uniqueness, moreover, has as yet gone unrecognised by scholars; that this unrecognised uniqueness paradoxically renders the Australian situation *exemplary* (in Giorgio Agamben's sense of the word) for understanding circumstances elsewhere.[6] Our claim is that this uniqueness hinges on the particular relationship in Australia between law, sovereignty, property and land, on the one hand, and indigeneity and immigration, on the other. The peculiar relationship, if conditioned by geographical and historical contingencies, offers – in its very clarity – a way of thinking about global contemporary political events and processes that are directed towards *dispossessed objection* or, simply, the creation of *abject objects*.

The specifics of this claim can be put very directly, if perhaps controversially: the Australian state was founded and sustained by a double negation, that is, *on neither blood nor soil*. For the only people who satisfy these criteria – the indigenous population – were precisely those excluded from belonging by the law of the land: *terra nullius* can mean nothing else. And the fact that Australia as a European colony began as a convict settlement, in which there are no citizens at all, only representatives of the Law, and a foreign, imperial Law at that (whether as administrators, military men, or prisoners), only confirms this state of affairs. An Australian "resident" – *contra* the citizen-subjects of almost every other modern nation – therefore has never truly been defined by residency, indigeneity, nativity, or other forms of family affiliation. This has meant that Australia has been, since its foundation, something approximating a *state-without-citizens*. This situation plays itself out in the most diverse and unexpected contexts; as we shall see, such apparently unrelated things as "mateship," water fountains, memorials and floral wreaths can be seen to be regulated by this logic of *neither blood nor soil*.

2. A First Fleeting Introduction

The geography of Australia remains crucial to an understanding of its political system, and particularly in its relation to land. A gigantic island, the mythical *Terra Australis* turned out to be inhabited by hundreds of different indigenous language- and tribal-groups. In addition to the Australian land-mass's size and ecological variation, the diversity of the indigenous populations proved to have crucial consequences for the settlement of the country. Coupled with the extraordinarily bizarre and hostile nature of the environment by European standards – to the extent that it was only relatively recently that white art, literature and assorted cultural artefacts could depict the land as anything other than mere raw material, or menacingly alien[7] – the very remoteness of the country from Europe has seen it imaginatively oppressed by what the historian Geoffrey Blainey has famously denominated "the tyranny of distance." Added to the fact that Australia was settled as a British penal colony in the late eighteenth century (the date of foundation is regularly assigned to 1788), the above have proved to be abiding factors in the socio-political imaginary of Australian life.[8] It is regularly speculated, for instance, that white Australia's continuing dependency on imperial powers (first Britain, more recently the USA) owes its particular brand of perverse servitude to these historical factors.[9]

We should also quickly underline a number of associated factors that schol-

ars have remarked about the legal, practical and imaginative consequences of the European invasion, particularly as they bear on territory. First, until recently (we shall shortly see *how* recently), Australia was built on a legal denial. In Judith Brett's words: "the historic denial of the prior occupancy of the Australian continent by the people who became known as the Australian Aborigines, and of the brutality and lawlessness with which their land had been taken."[10] This denial, as Brett points out, no doubt founded the abiding fear of white Australians that they themselves were prime targets for a foreign *invasion*, most likely by the "yellow peril" of the Asian hordes.[11] Moreover, despite the emphasis directed towards the *control* of territory in Australia, it has been noted that:

> We are confronted ... with an ambivalence which deserves serious and detailed study. There are two matching instincts: to possess land and to leave it. Perhaps this duality is especially marked in Australia where, as the novelist Christopher Koch once remarked, country people seem to have little love of the land. They may love "the country," but that is a different matter. And, in any case, the statistical evidence here, as in so many cases, casts doubt even on that supposition ... The land is a breeding ground and a killing ground.[12]

In other words, the Australian drive to territorial control has been bound up with a peculiar ambivalence and movement on the part of its agents. It has further been noted that, unlike comparable explorers' narratives from America and Africa, Australian exploration regularly absents both the indigenous population and major discoveries.[13] Many commentators have shown how such absentions go hand-in-glove with associated forms of self-censorship – the primary sources regularly failing, for instance, to note massacres and other colonial impositions.[14] The vacuum created by absention and self-censorship was, unsurprisingly, rapidly filled with malignant spirits of all kinds.[15] And, as aforementioned, the literary and artistic obsessions with the horror of the void of Australian space have received extensive treatment by critics.[16]

Denial of colonialism, fear of invasion, ambivalence towards land, the voiding of indigenes and notable discoveries, the lack of heroic narratives of foundation and independence, the uncanny return of spectres, and so forth – are features which, taken together, seem to render Australian settler-colonialism unique. As has been often noted, there is a relative paucity of treaties with the native peoples of Australia (and, if there were, they were characteristically ignored); there is, perhaps even more notably, a rigid refusal to acknowledge those peoples killed during the colonisation of Australia as victims of *war* (we shall return to this refusal below). These features, however, should not be permitted to camouflage

other characteristic techniques of Australian settler-colonialism, by means of which Australia's indigenous inhabitants were often forced to participate in their own subjection.[17] And the massively lower life-expectancy, health, economic and literacy-indices for indigenous Australians continue to speak for themselves.

But the crucial factor in the present context – and which can be seen as underpinning all the others – is *one that does not exist*: the efficacity of the doctrine of *terra nullius*. In Henry Reynolds' reconstruction, the doctrine of *terra nullius* was developed in the seventeenth century by Grotius from the Roman concept of *res nullius*, and subsequently extended by Christian Wolff and Emerich de Vattel in the eighteenth. John Locke's recipe, in his second *Treatise on Government*, also proved determining: to turn land into property requires the admixture of labour; unlaboured land is rightfully nobody's. Hence, as Reynolds puts it, "Locke's ideas were used to justify the dispossession of the Aborigines because they had apparently not mixed their labour with the soil. The argument was simple. If there was no sign of agriculture the natives *must* still be in a state of nature ... In terms of European thought the claim of sovereignty over Australia in 1788 was soundly based. Australia was a land without a sovereign as Europeans understood that term. In that sense it was a *terra nullius*."[18] The longstanding European link between *culture* and *agriculture* – however delusory – proved determining in the Australian situation, and in a way which also undermined the imaginative arguments for the emancipatory Romantic pathos of a *genius loci* or spiritual home.[19]

On 3 June 1992, the High Court of Australia found in Mabo vs. Queensland that the common law of Australia recognised native title to land:

> The Court rejected the doctrine that Australia was terra nullius (land belonging to no-one) at the time of European settlement and said that native title can continue to exist: where Aboriginal and Torres Strait Islander people have maintained their connection with the land through the years of European settlement; and – where their title has not been extinguished by valid acts of Imperial, Colonial, State, Territory or Commonwealth Governments. Further, the Court found that the content of native title – the rights which it contains – is to be determined according to the traditional laws and customs of the Aboriginal and Torres Strait Islander people involved.[20]

This decision, however, has not gone uncontested, and there are numerous native-title cases still pending in the Australian courts.[21] Our purposes here, however, are not to outline the consequences of the decision nor to track the social effects in post-millennial Australia (though these are legion); rather, we believe that the legal overturning of *terra nullius* in no way constitutes its destruction, and we

want to argue that, if the relationship between the indigenous inhabitants and land is crucial to understanding the peculiarities of Australian sovereignty, it is just as crucial to understand the other side of the equation: mass immigration, "asylum seekers" and "refugee intake" (as contemporary administrative parlance has it).

For if Australia is a "nation of immigrants," this fact has hardly made the state and populace particularly warm to questions of immigration. As we have already indicated, it has, on the contrary, rendered border "panics" and "anxieties" a central feature of Australian political life. Indeed, for much of the twentieth century, Australia had the "White Australia policy," a policy so notorious that Theodor Adorno, speaking of the mutability of positive affects, mentions it in passing in *Minima Moralia* (1951):

> from this touching feeling, without which all warmth and protection would pass away, an irresistible path leads, by way of the little boy's aversion for his younger brother and the fraternity-student's contempt for his "fag," to the immigration laws that exclude all non-Caucasians from Social-Democratic Australia, and right up to the Fascist eradication of the racial minority.[22]

It seems to us no accident that, in Adorno's escalation of examples, "Social-Democratic Australia" is invoked a mere comma-break before the "Fascist eradication of the racial minority." One of the things that seems peculiar about Australian "racism" (this concept is too general and confused to be of much use in this context) is that, as Castles *et al.* have noted, "the mass settlement of migrants from a wide range of countries has made the overt maintenance of a racist definition of the nation and of the Australian type impossible."[23] Apparently paradoxically, then, the White Australia policy and its covert avatars could happily couple with "multiculturalism." We have already touched on this apparent paradox in our discussion of the Tampa affair in chapter 6, where Australia's extraordinarily punitive policy towards "asylum seekers" has involved indefinite incarceration without trial in detention centers, both on Australian soil, and on the soil of small Pacific client states.[24] This dismal situation is, as we have been suggesting, nothing new; indeed, it is directly linked to issues deriving from the foundation of Australia as a state.[25]

This coupling is characteristically figured in the less fraught, less local terms of "identity." Symptomatically, since the election of John Howard as Prime Minister (1996) and the appearance of the populist One Nation as a genuine electoral force, the flood of academic books on Australian *identity* has been unstoppable. In fact, it is presently impossible to be an intellectual in Australia without

having to have an opinion about the "identity" of the place in which we live and die. This identity, moreover, seems to have everything to do with "race" and, in a slightly different but related sense, with "multiculturalism," "immigration," and so on. Writers as different as Inga Clendinnen, Ghassan Hage, Mary Kalantzis, Robert Manne, Humphrey McQueen, Henry Reynolds, Jennifer Rutherford, Jon Stratton, and so on, have all produced substantial works dealing with the integral and perhaps mutually-constitutive relationship between racial and ethnic issues and Australian identity.[26] This is not even to mention the proliferation of conferences, anthologies or themed journal issues that also turn about this question, most of which wear the word "identity" prominently on their flyleaves.[27]

In the remainder of this chapter, we will draw out some of the complexities of this relationship between indigeneity and refugees. Our argument will take the form of a theoretical meditation upon sovereignty, drawing on insights from Walter Benjamin, Carl Schmitt, Jacques Derrida, and Giorgio Agamben, among others, in order to show how reactions to the internal exclusion that founded the Australian nation (that of the indigenous peoples) are integrally bound up with the threat of external incursions (those who come from the outside). Although Australia incarnates a simple and brutal form of political institution, the complexities must not, for that, be underestimated: the indigenous peoples have been submitted to *excluded inclusion*; today's refugees are submitted to *included exclusion*.[28]

3. A King is a King is a King

The discourse of sovereignty is ubiquitous today. As Joseph Camilleri and Jim Falk put it, in a standard formulation of the problem:

> Sovereignty and the framework of ideas which surround it are a dominant feature of contemporary political debate, analysis and policy. We experience what amounts to a sovereignty discourse – a way of describing and thinking about the world in which nation-states are the principal actors, the principal centres of power, and the principal objects of interest.[29]

Indeed, the numerous traditional criteria of political sovereignty – not all of them compatible with each other – remain active today. Hence sovereignty is often invoked as: the monopoly of legitimate force within borders; self-determination; territorial integrity; freedom from interference; the executive power to declare war; autonomy; constitutional independence; indivisibility; the absence of voids

(i.e., that there is no place on the planet which is not subject to a sovereign power), and so on. This list is evidently incoherent. If the discourse of sovereignty is indeed ubiquitous, this is at the cost of its manifest inconsistency; the connections, for instance, between "absence of voids" and "executive power" are ramified and obscure. This inconsistency, moreover, implies the concept's lack of traction on the real.

In other words, it is clear that something quite serious has befallen sovereignty: it is no accident that Camilleri and Falk's book is entitled, precisely, *The End of Sovereignty?* One of the clearest indications of this otherwise obscure event is precisely the very ubiquity of the discourse of sovereignty, and the evident public anxiety over its possible extension. One might cite the United Nations' censuring of the Australian Government over a number of the latter's policies, including the notorious policies of mandatory sentencing in Western Australia and the Northern Territory. Prime Minister John Howard himself strenuously protested the intervention of "unrepresentative and unelected bureaucrats" in the domestic affairs of a sovereign state.

The lineaments of such a situation seem clear. On the one hand, we have the elected Prime Minister of a modern nation-state invoking the principle that that state is invested with total sovereignty over all matters of life within its territorial boundaries, and that this sovereignty is incarnated in the rule of law; on the other hand, we have representatives of a post-WWII global organization insisting that the Universal Human Rights spoken of in its Charter subtend all differences of culture, nation and state – indeed all "human" differences whatsoever. In the latter case, nevertheless, the insistence on the absolutely generic nature of "human rights" founds an attention to precisely those rights which are actually vitiated within and by states through such allegedly contingent specificities as, say, "race."

To stick for the moment to the terms of this debate, it seems that we are confronted by some stark oppositions: the individual state versus the international community; representative democracy versus unelected administration; state sovereignty versus human rights; law versus justice; political reality versus idealist fantasy; the local versus the global, and so on. The incoherence in this case is staged around a peculiar double antagonism: a dispute as to the location of sovereignty and a dispute as to the *force of law*: that is, how law itself is to be made and enforced. These problems are profoundly connected. The difficulty here is, paradoxically, founded on an agreement: for the sovereignty of nations is recognised in the UN Charter, as it is by the current Australian government.[30]

Certainly, one could envisage all sorts of ways of reducing or explaining this difficult agreement; and, indeed, it has been widely argued that this apparent ten-

sion in fact marks a peculiar complicity (for example, an economic one). After all, as Zygmunt Bauman points out: "No longer capable of balancing the books while guided solely by the politically articulated interests of the population within their realm of political sovereignty, the nation-states turn more and more into the executors and plenipotentiaries of forces which they have no hope of controlling politically."[31] This unstoppable movement of economic globalisation purportedly destroys the pre-existing "sovereignty tripod" (military, economic and cultural) that stabilised modern nation-states, and opens up every form of life to the rigours of a capital finally unbound.

On the other hand, it is perhaps not capitalism alone that is responsible for the vitiation of sovereignty. To turn to a famous passage from Michel Foucault's *The History of Sexuality*:

> The principle underlying the tactics of battle – that one has to be capable of killing in order to go on living – has become the principle that defines the strategy of states. But the existence in question is no longer the juridical existence of sovereignty; at stake is the biological existence of a population. If genocide is indeed the dream of modern powers, this is not because of a recent return of the ancient right to kill; it is because power is situated and exercised at the level of life, the species, the race, and the large-scale phenomena of population.[32]

Foucault's well-known hostility towards the traditional analyses of sovereignty takes the form here of an analysis of "bio-power," that is, the micro-capillary dissemination of new organizations of bodies and spaces. These – and not economic interests – provide the precondition for capitalism's ultimately global extension. For Foucault, "sovereignty" as a concept is incapable of specifying the tiny, almost imperceptible processes of domination that organise contemporary societies.

But if sovereignty as a concept is incoherent; if sovereignty as a supposed reality is radically divided; if the bond between concept and reality seems tenuous at best – this in no way means that "sovereignty" can be dispensed with. On the contrary: the situation demands a clarification of the incoherence, inadequation, and irreality of the concept and reality of sovereignty.

4. Kill the Enemy, Sacrifice the Friend

In the example given above, sovereignty, clearly, is integrally linked to the law. But if we turn to questions of law to clarify the situation, it is immediately apparent that the law is, for its own part, self-divided. Both the Australian government and

the UN, for example, insist on the sanctity of sovereignty, and both insist that this is ultimately a matter of law. But both also insist on the primacy of human rights. As Christian Joppke says: "All Western constitutions ... contain a catalogue of elementary human rights, independent of citizenship, which are to be protected by the state and thus limit its discretionary power."[33] Neither simply "international" nor "state" law, then, the "law" upon which these different bodies agree is itself recognised as at once sovereign in its power and divided in its application.[34]

What, then, is the law of this law? The question is a *political* one.

For Carl Schmitt – an influential German political theorist and Nazi collaborator – politics has a logic that is specifically its own. Just as morality ultimately hinges on the question of good and evil, economics on profit and loss, and aesthetics on the beautiful and the ugly, politics ultimately hinges on the problem of "friend and enemy." For Schmitt, "friend and enemy" in no way designates a private or individual vendetta; on the contrary, there is politics if and only if "one fighting collectivity of people confronts a similar collectivity."[35] Politics is thus integrally linked to the possibility of waging war. But the possibility of war, by the same token, also presumes that there is a specific and identifiable political entity, an executive body, capable of deciding and declaring war against one collectivity on behalf of another. For Schmitt, the crucial political entity *is* the sovereign; it is "always the decisive entity, and it is sovereign in the sense that the decision about the critical situation, even if it is the exception, must always necessarily reside there."[36]

Whence Schmitt's notorious principle: "sovereign is he who decides on the exception." In modern times, the sovereign power is the state, and a state is a state precisely to the extent that it has the power to decide on the exception. The state fixes a relation between frontiers and populations; its power is linked integrally to its capacity to maintain this relation; its legitimacy is therefore founded directly in its potential to unleash – and even monopolize – violence.

There is nothing "natural" about such violence; on the contrary, political violence is absolutely unnatural. If it seems to bear some resemblance to animal violence or to evolutionary struggle, this resemblance is on condition of a radical non-identity. Indeed – so the story goes – animals can neither engage in war nor celebrate a sacrifice. (Carl Schmitt and Peter Singer, in other words, have nothing in common.) But this does not mean that animality is absolutely foreign to politics; on the contrary, as we shall see below, it is often precisely the fraught exclusion of "animality" as a pre-political state that founds the domain of politics proper. This exclusion, this expulsion of animality from politics, then regulates the

necessity of a re-incorporation, or re-ingestion of animality – if in a transfigured and unrecognisable form.

Crucially, such a power necessarily reserves for itself the ultimate say over life and death *for its own people*. The *jus belli*, as Schmitt points out,

> implies a double possibility: the right to demand from its own members the readiness to die and unhesitatingly to kill enemies ... As long as the state is a political entity this requirement for internal peace compels it in critical situations to decide also upon the domestic enemy. Every state provides, therefore, some kind of formula for the declaration of an internal enemy.[37]

A genuine political decision is thus always a decision in which life and death are, at least in principle, at stake; but it therefore also means that those who are "friends," those who by definition receive the protection of the law, must legally support the law by their preparedness to die. To coin a phrase whose full significance will hopefully become apparent below: *friends must be prepared to sacrifice themselves in the name of the state*.[38] Although Schmitt never states this explicitly, at least in *The Concept of the Political*, his conception of politics requires that the state be Trinitarian, at least in principle: that there be a sovereign, a pool of potential sacrificial victims ("friends") and those who can be killed-without-being-sacrificed ("enemies," whether "internal" or "external").

Against the deleterious tendencies towards "depoliticization" that he discerns in the contemporaneous situation, Schmitt wants to reinject a sense of the essential *polemos* at the heart of political being. For Schmitt, total depoliticization would give rise to people who aren't – are no longer – *people*. Yet Schmitt also cannot quite decide why such a depoliticization would be so bad. Is depoliticization bad because it *misses or misleads* about the essence of politics (e.g., liberal ideology)? Because it *neutralises* the grounds of humanity *per se* (i.e., destroys political life by turning it into administrative games)? Or because such depoliticization ultimately entails the worst kind of re-politicization (idealist hypocrisy and genocide through the *refusal* to treat the Other as an enemy worthy of recognition)? All three possibilities can be discerned in Schmitt's text: they are not always explicitly canvassed, and they are certainly never resolved.[39]

This irreducible indecisiveness on Schmitt's part derives from his inability to stabilize the friend/enemy distinction.[40] This instability is evident in those peculiar sentences where Schmitt telescopes rival political orientations in a single sentence: "Humanity according to natural law and liberal-individualistic doctrines is a universal, i.e., all-embracing, social ideal, a system of relations between individuals."[41] Schmitt symptomatically runs natural law doctrines and liberalism togeth-

er, because he has run into an *aporia*: if humanity has no essence, then, as he fears, the political could well disappear altogether; if humanity has an essence, then natural law doctrines cannot simply be dismissed, and certainly not as merely individualistic.[42] And if Schmitt quite brilliantly discerns the tight bond between ethics and economics as constituting the essence of liberalism, Strauss' critique, just as brilliantly, demonstrates how Schmitt's account itself remains on the terrain of liberalism.

Perhaps Schmitt's problem is that he is attempting to prosecute two completely different cases at once, each case, moreover, being split by a fundamental *aporia*: 1) a *foundational* polemic against false theories of the political (which ends up, as Strauss shows, reducing to an ethical anthropological foundation "men are good," "men are bad"); 2) a *description* of the political and its limits (which ends up oscillating unresolvably between two contrary convictions "the political is indestructible" and "the political is on the verge of destruction"). These antagonistic, self-divided chains collide on the terrain of the relation of power to life, the contradictions legible down to the symptomatic pathos of heroism that suffuses Schmitt's text.

Schmitt clearly has a sense of these difficulties (undoubtedly one reason why he remains contemporary), acknowledging the obliteration of *recognition* as a possibility and as a genuine political category. Hegel had made recognition a transitive, affirmative operation that takes place between the brothers of a political community (I recognise you because he recognises you and I recognise him); Schmitt renders recognition an intransitive operation dividing communities comprised, not simply by liberal brothers, but of those who *recognise their own sacrificeability*. You are a political animal to the extent that you can recognise yourself as a friend-who-can-be-sacrificed; you must put yourself on the line to save others with whom you have no personal affiliation whatsoever; you must be prepared to die for the continuation of a polity whose very essence enjoins that you must be prepared to die for its continuation…. There is a sense in which Schmitt has developed a very strange concept of the political bond: the relation that binds a "fighting collectivity" together is not familial affection, *philia*, *agape*, Romantic erotics, or even transference love, but something approximating "a love of (self) sacrifice." Theology, as Schmitt himself knew as well as anyone, is an integral torsion in the topology of the political.[43]

In a famous essay entitled "Critique of Violence," Walter Benjamin had already both extended and criticized these Schmittian theses, particularly as regards the problems raised by the irreducibly theological or religious aspects of violence *per se*.[44] As he states, the "task of a critique of violence can be summarized as that of expounding its relation to law and justice."[45] Benjamin deploys his

axiom that violence is integral to the realm of *means*, to draw a distinction between "lawmaking" and "law-preserving violence." Violence, in other words, violence as a pure end-in-itself, is not, strictly speaking, *political* violence. Yet Benjamin proceeds to remark that:

> When the consciousness of the latent presence of violence in a legal institution disappears, the institution falls into decay. In our time, parliaments provide an example of this. They offer the familiar, woeful spectacle because they have not remained conscious of the revolutionary forces to which they owe their existence ... They lack the sense that a lawmaking violence is represented by themselves; no wonder that they cannot achieve decrees worthy of this violence, but cultivate in compromise a supposedly nonviolent manner of dealing with political affairs.[46]

If states and institutions decay when they forget the very violence which constituted them and by which they live (thereby falling into the most servile routines of "negotiation" and "compromise"), this, however, means that they are thereby both capable of and susceptible to prosecuting the most insidious violences of all. This dissolutory oblivion is thus tantamount to a savage unbinding: the violence of law becomes an immediate, irreparable and invisible fact of everyday life itself. Law therefore works precisely by dissimulating its own characteristic operations; it is most active and forceful in its eclipse. Indeed, law itself encrypts within it a relation between "written" and "unwritten" law, a doubleness that remains to the present day in the strictures around "ignorance" ("ignorance is no defence"). The persistence of such a relation only underlines the fact that the foundations of law reside not in knowledge or justice, but in force. And hence also Benjamin's remarks about the "unnatural," "spectral," and "formless" powers of the police, who act as a law-making *and* a law-preserving institution.

Following Benjamin, then, we can expand upon Schmitt's theses: that the relation between "law" and "justice" is at the center of state sovereignty; that sovereignty is founded on "exceptional" violence which both exceeds and supports the law; this violence ultimately bears on the question of "life" and "death"; that such violence is linked to a decision-making executive that, precisely, alone "decides" on who is able to be sacrificed; that the prohibitions and injunctions that issue from the Law exhibit a kind of "coherent incoherence," i.e., the Law effectively functions through its inconsistency and not its clarity, through its splitting of address and agency, through its self-suspension; that there is no simple outside of the Law; that the Law is essentially fictional in its structure, even "mythical."[47]

Yet Benjamin goes further, linking matters of law to their religious founda-

tions. To do so, he draws another fundamental distinction, between "divine" and "mythical" violence, which essentially corresponds to the differences between the Greek gods, whose power is manifested in bloody, guilty violence, and the God of the Old Testament, whose power is manifested as bloodless, expiatory violence. In Benjamin's words:

> a deep connection between the lack of bloodshed and the expiatory character of this violence is unmistakable. For blood is the symbol of mere life ... with mere life the rule of law over the living ceases. Mythical violence is bloody power of mere life for its own sake, divine violence pure power over all life for the sake of the living. The first demands sacrifice, the second accepts it.[48]

If Benjamin does his best to distinguish "mythical" and "divine" violence, it is still symptomatic that, once again – and more explicitly than in Schmitt – we are returned to the intersection between sacrifice and law. Indeed, Benjamin's attempts to forge a clear and irrevocable distinction between "mythical" and "divine" violence here has recourse to another distinction, one which nowhere receives a satisfactory explanation: the distinction between "demanding" and "accepting" sacrifice.[49] What Benjamin does note, however, is that "mythical" violence is *both* law-making and law-preserving – and that both of these forms are "perfidious" at best. Divine violence, on the other hand, is *almost unrecognisable*: it alone truly deserves the title of "sovereign violence."

Hence raising the question: what, precisely, is political violence, such that it can be "demanded" or "accepted" in the register of a religious sacrifice? What sorts of acts can count as "violent" acts? And to whom, in any case, is a sacrifice directed?

5. More About Sacrifice

What, after all, is sacrifice? Building on the work of Benjamin, Jacques Derrida offers a thumbnail definition of sacrifice, which we will have occasion to complicate below: "a noncriminal putting to death."[50] The very possibility of sacrifice therefore requires:

- that sacrifice be a *special* kind of operation, i.e., that there be a clear distinction between sacrifice and non-sacrifice (even if this distinction is not necessarily clear to the participants themselves);
- that sacrifice be a *violent* operation, i.e., that it operate at the frontier of life and death, even if every sacrifice does not itself necessitate death;

- that sacrifice be a *lawful* operation, i.e., that it plays an integral part in sustaining the political community.

To these, we might add a corollary:
- that sacrifice be a *self-dissimulating* operation, i.e., that it not necessarily appear as sacrifice (e.g., it might appear as a primitive operation, no longer viable in modern society, at the very moment that it continues to operate).[51]

Sacrifice, in other words, is not a "primitive," or "uncivilised" phenomenon; on the contrary, it presupposes the prior existence of Law; moreover, it presupposes a law that prohibits indiscriminate killing. But sacrifice is itself essential to the maintenance of law insofar as it operates at one paradoxical frontier of the social – where what is prohibited globally (unrestrained killing) returns locally (as legitimate killing). And, as these theses imply, sacrifice is *never simply* sacrifice of an enemy, either internal or external, for the relation to an enemy is of another order, that of war (of which more below). Sacrifice is always a *sacrifice of the same*. We can speculate that the otherwise very diverse rituals of "purification" that anthropologists have discerned in sacrificial practices share, at least, this perhaps unexpected function: to ensure that the victim is nothing but *the exemplar of us*. The victim is not sacrificed because they are "other" to the community, but because they have been turned into the representative of the community in its purest form. So these rituals do not function merely to "exclude" the proposed victim, but rather to turn the victim into an emblem of the *res publica*, the public thing itself. That *thing* is, to resort to a Lacanianism, "what is in us more than ourselves."

As Benjamin notes with regards to the arguments around capital punishment, its defenders suspect,

> perhaps without knowing why and probably involuntarily, that an attack on capital punishment assails, not legal measure, not laws, but law itself in its origin. For if violence, violence crowned by fate, is the origin of law, then it may be readily supposed that where the highest violence, that over life and death, occurs in the legal system, the origins of law jut manifestly and fearsomely into existence.[52]

We are thus faced with an extraordinarily paradoxical situation: sacrifice presupposes law, but law is sustained by sacrifice; moreover, one sacrifices one's own, not another's – although this is precisely what needed to be prohibited to found society. And if sacrifice (here figured by Benjamin in terms of the death penalty) is attacked, then so also is the Law itself. Finally, if one sacrifices – and *must* sacri-

fice – one's own, it is still necessary to ask: to whom? What is the entity that can "accept" or "demand" a sacrifice?

Slavoj Žižek identifies at least three different forms of sacrifice. The first is very simple: one sacrifices in order to get something from the Other – that is, an economic benefit of one kind or another (better harvests, the death of an enemy, a propitious marriage, etc.). The second is a little more complicated: one sacrifices to the Other to prove – by the very fact and act of the sacrifice itself – that there does exist something to which one sacrifices, whether or not this Other ever actually responds.[53] The third sacrifice is even more complicated: one cunningly sacrifices to the Other to convince it of one's own lack. Let us give an example.

As Alain Destexhe, a former Secretary-General of *Medicins sans frontières* and Belgian senator, writes, in "The Shortcomings of the 'New Humanitarianism,'" of a Serbian strategy:

> humanitarianism, while siding with the victims, also became an arm in the hands of the aggressors. The Serbian army quickly understood the advantage that could be drawn from it when all they had to do to rid themselves of the Moslems was to open up "corridors of ethnic cleansing" for them and bring them to the "humanitarian front line." On several occasions, UNPROFOR directly contributed to the enforcement of ethnic cleansing by "helping" in the exchange of population.[54]

According to this account, the Serbs were not really interested in "ethnic cleansing" or "genocide" *per se*; on the contrary, they were simply after the very sovereignty still enjoyed by other European powers (i.e., state control of land and people). Precisely because of the humanitarian provisions in the UN and EU charters, it became clear that one innovative way to have the Bosnians removed from their land was to *simulate* genocide, because evidence of genocide would *ensure* Western intervention. And given that such intervention would first and foremost be "humanitarian" and not "military" (given the West's constant oscillation in its decisions in regards to infringing upon sovereignty), then the Serbs had almost nothing to fear; the West would come in and do their dirty work for them. The "real horror" (as Žižek might put it) is thus the West itself, whose policies directly encourage and maintain: 1) the fantasy of the horrific Balkan Other; 2) that the West is responsibly dealing with this Other at the very moment that *it places genocide at the center of its agendas.* The ongoing war crimes tribunals in The Hague, in which Slobodan Milosevic is being prosecuted for "crimes against humanity," both camouflage and reveal the extent to which the West is the true author of this genocide. Humanitarian aid *is* the sacrifice with which the West simulates its own lack, and thereby also "proves" the genocidal drive of the Other.

Nonetheless, what all of these different forms of sacrifice share is, precisely, their insistence on the Other ("God," "society," the "sovereign," etc.) as guarantor of sense, that the price of entry into social existence is sacrifice. This helps to clarify the possible agency of sacrifice. On the one hand, it is those who enact the sacrifice who decide how the Other is to take it – but in the guise of the opposite (i.e., the Other is demanding of me). To speak metaphorically: it is Abraham who demands Isaac's sacrifice, not God – although it must be understood by Abraham himself to be God who is making the demands. Sacrifice is of one's own. What is critical is that all these kinds of sacrifice are in the sphere of *recognition*: they are identifiable forms of sacrifice, which produce potential victims who must be recognisable in and as such. "Recognition," paradoxically, is therefore *never* recognition of a simple person, right, or substance, but of *sacrificeability*. On this account, then, contemporary social struggles that demand "recognition" as their justification and end, should be careful what they wish for.

Against these versions of sanctioned sacrifice – what, in the terms of the present discussion, we are considering as fundamental operations of the "State" – Žižek ultimately identifies two *subjective* moments of sacrifice which are more truly "political" insofar as their routines come to threaten the symbolic foundations of the state itself: 1) "Kantian" sacrifice, in which the subject sacrifices everything, including his or her most cherished and intimate desires, purely out of love for the object-cause of his or her desire; 2) "Post-Kantian" sacrifice, in which the subject sacrifices even the cause of his or her desire, i.e., sacrifices his or her love itself out of love....[55] In such sacrifices, sacrifice itself is (supposedly) sacrificed. It is thus no wonder that Žižek, in his attempt to re-think politics, comes – as if by some obscure necessity – to bind four themes: the unwilled *passivity* of the genuine "Act," beyond consciousness or voluntarism; the "undead" nature of such an Act, i.e., its subject is "beyond" the identifiable opposition of "life" and "death"; the ultimate self-destructiveness of the agent of the Act (what emerges afterwards bears no relationship to the prior state of affairs); and the *indiscernibility* of this Act in regards to established routines of State identification. The oxymoronic nature of an indiscernible sacrifice for Žižek implies that: i) liberal, "Kantian" politics can be considered an attempt to force the existing State to recognise a previously indiscernible act *as* an act of sacrifice, thereby requiring a radical change in the laws of the State itself; ii) what is sacrificed is *not simply* a living being, i.e., a raw animal body, but the "fantasy" that underpins established social reality itself, the "exemplar of us" of which we spoke above. Žižek, finally, considers that these routines don't go far enough for a truly radical politics: what, however, might be put in their place, and how, are *the* open questions of contemporary political activism.

"Self-sacrifice," at least in its *recognisable* forms, is the *production* of the self in its un-willed sacrifice for the State, as identifiable – and hence memorialisable – as a consequence of the death-in-life that sacrificeability entails. Hence, also, the peculiar insistence of the State on the "immortality" of its sacrificial victims, those *actually-sacrificed-sacrificeabilities* which it celebrates in a variety of culturally-specific forms (We will return to such celebrations below). What complicates this schema further is the presence of another term, inevitably associated with all these, whose place and significance as yet remains unclear.

That term is "the sacred."

6. From Sacrifice to the Sacred

Drawing on a tradition of French thought about the sacred which goes back at least to Durkheim, Michel Serres declares: "Herein lie the origins of the sacred: to sacrifice means to kill, put to death, by hatred and violence, and also to render sacred, sacralize, honor and adore. Slaughter and deify ... "[56] Serres is well aware of the expulsory and murderous essence of the sacred. As he later remarks:

> We've never needed grand philosophy to enable us to recognize, in the man who's been sentenced to death by the power of men (Roman or otherwise), man himself. We need no philosophy, either, to recognize the man who has been sentenced by a power which is beyond us, and which we study every day in order to keep it at our measure.[57]

The sacred, for this tradition, is precisely what founds the origins of society: the social bond, the "Other," is sacrality. But are sacrifice and the sacred really related as Serres seems to suggest? What is interesting in the first quote above is the slip between "the origins of the sacred" and "to sacrifice": after all, the "power" which sentences to death is not necessarily itself sacred, and neither is its sentence necessarily in the register of sacrifice. Indeed, on Serres' minimal account, it is difficult to tell whether the sacred precedes or postdates the rituals of sacrifice. It is even possible that the identification of the sacred founds the very difference between self and Other which then becomes the realm in which sacrifice becomes meaningful.

In his terrifying and compelling book *Homo Sacer: Sovereign Power and Bare Life*, Giorgio Agamben attempts an analysis of the "politicization of bare life" effected by modern State power.[58] He begins by returning to what may initially

appear to be a simple philological problem: the relation between the terms *zoe* and *bios* in Aristotle's *Politics*. Both words mean "life" in Greek and, indeed, have the same root. But Agamben focuses on a peculiar chiasmatic relation that Aristotle forges between these terms: *zoe* is the "bare life" which must be excluded from the *polis* over which *bios*, qualified human life, holds sway. For Agamben:

> Politics therefore appears as the truly fundamental structure of Western metaphysics insofar as it occupies the threshold on which the relation between the living being and the *logos* is realized. In the "politicisation" of bare life – the metaphysical task *par excellence* – the humanity of living man is decided. In assuming this task, modernity does nothing other than declare its own faithfulness to the essential structure of the metaphysical tradition. The fundamental categorial pair of Western politics is not that of friend/enemy but that of bare life/political existence, *zoe/bios*, exclusion/inclusion.[59]

But this relation of exclusion-inclusion is not a simple outside-inside division that can be represented by a line. On the contrary, and according to the Aristotelian formulation, what is excluded from human political life is precisely still included by its exclusion, that is, it is included as an *exception*. The topology of this "invagination"[60] (to invoke a Derridean concept) is extremely complex; it is further complicated by its relation to a shadowy double – the *example*. Whereas the exception is that which is included in a set through its exclusion, the example is that which is excluded from its set by the fact that it *shows its own inclusion*.[61] The example and the exception therefore function as the twinned limits of politics, and Agamben will proceed to demonstrate the logic of their operations in a number of apparently very different fields.

Indeed, it is a juridical figure of this paradoxical *included-exclusion* of Western political sovereignty that gives the book its name. *Homo sacer* is an obscure figure from archaic Roman law of whom it is said (by Pompeius Festus) that: "he can be killed but not sacrificed." Agamben – after persuasively dispensing with the ubiquitous scholarly mythologeme of "the originary ambivalence of the sacred"[62] – glosses this figure as constituted by a double exclusion, i.e., subject to neither divine nor to human law. *Homo sacer* is a human life that can be killed by anyone, without the killer thereafter being subjected to any religious or juridical punishment.

For Agamben – in direct opposition to Durkheim – sacrality is not the originary bond of society *qua* positivity of sense, but the name given to the exclusion on which political community founds itself. And precisely because this exclusion is global, it can only manifest itself everywhere and nowhere – in zones that are

literally considered by the state to be non-places, irregular, almost unrecognisable, unpredictable. This is why the sacred simultaneously appears absent and omnipresent: it is also why the "sacred" consistently seems to be double, para-doxical – and it is, but only *from the point of view of the state itself.* Wherever there is the state, there is sacrality. The sacred is thus in no way a healing spiritu-al force: on the contrary, the sacred designates and determines the impossibility of reconciliation. Nor is the sacred in any *dynamic* relation with modernity: the sacred is a *topological* figure of political life, and an insistence on its political via-bility is purely and simply an insistence on the state that is only apparently its other. Whoever affirms the power of the sacred affirms the power of the state.[63]

Hence the *homo sacer* is seemingly opposed to the sovereign – the latter is he who *decides* on the exception – and yet they are bound irreparably together by an antagonistic complicity: "once brought back to his proper place beyond both penal law and sacrifice, *homo sacer* presents the originary figure of life taken into the sovereign ban and preserves the memory of the originary exclusion through which the political dimension was first constituted."[64] Agamben can thus conclude:

> The sovereign sphere is the sphere in which it is permitted to kill without com-mitting homicide and without celebrating a sacrifice, and sacred life – that is, life that may be killed but not sacrificed – is the life that has been captured in this sphere.[65]

The "sacred" is not at all a realm of numinous ambivalence, economic excess, or radical potentiality: it is rather the simple political exposure of a specific and spec-ified population as bare life, as abandoned life, as life-to-be-killed-but-not-sacri-ficed. Hence, also, its identification with animality. For reasons we will adduce below, it is quite clear that the indigenous population precisely fulfil this function for Australia: they are literally sacred. Those theorists of the sacred who wish to link it to numinous and mystical spirituality without also recognizing its funda-mentally legal structure – and hence its originary violence – are fooling them-selves and, perhaps, others.[66] Law is integrally linked to sovereignty *and* to sacral-ity.

We have one (purely technical) difficulty with Agamben's position. For us, how a particular social organization determines the indiscernible yet crucial threshold between sacrificial and non-sacrificial violence will also determine how the transition between political localisation (inside/outside) and political deci-sionism (friend/enemy) is effected. This means that the "fundamental structure" of "Western metaphysics" cannot be reduced to either distinction. On the contrary, their differential disposition is precisely a matter of power. "Power," in other

words, bespeaks the residues of the non-sacrificial violence that founded the community-that-sacrifices; it is what mediates between a significant or a senseless death.

There are therefore at least three different forms of "noncriminal putting to death": 1) "sacrifice proper," a special, lawful, and violent programme which ritually operates on "the friend-same"; 2) "war," as a special, lawful, and violent programme which sporadically operates on "the enemy-other"; 3) "sacred," as an extra-legal status which cannot be fully recognised nor expunged, and which provides the ultimate support for the edifice of sovereignty. The sacred is then defined by a double negation: it can be the object of neither sacrifice nor warfare; it is, strictly speaking, a-political or pre-political – and, at the same time, *the true object of politics*. In such a context, the testimony of Marlow, stepping into the *Heart of Darkness*, is extraordinarily precise:

> They were dying slowly – it was very clear. They were not enemies, they were not criminals, they were nothing earthly now – nothing but black shadows of disease and starvation, lying confusedly in the greenish gloom. Brought from all the recesses of the coast in all the legality of time contracts, lost in uncongenial surroundings, fed on unfamiliar food, they sickened, became inefficient, and were then allowed to crawl away and rest. These moribund shapes were free as air – and nearly as thin.[67]

"Free as air": the sacred bodies of those submitted to imperial rule. And, on the other side of the line, one should remember: "the exemplary obedience of the German people, their military and civil valor in the service of the nation, and the secondary consequences that we can call, in a kind of intellectual shorthand, Auschwitz (as symbol of the Jewish holocaust) and Buchenwald (as symbol of the extermination of communists, homosexuals, Gypsies, and others)."[68] Caught in the raw miasmal mist of sovereign law, central contemporary issues such as car accidents, euthanasia, *in vitro* and cloned human babies, organ transplants, and suicide begin to acquire all sort of ambivalent properties – not to mention wars which take place without ever really being declared (Gulf War I); wars based on manifestly-transparent-but-nonetheless-desperately-prosecuted-public-relations-fabrications (Gulf War II); the state sanctioned assassinations of political figures (Israeli killings of Palestinian leaders); indefinite incarceration of refugees (Australia); international trials of war criminals (The Hague).[69] As Benjamin remarked over seventy years ago, the state of emergency has now become the rule; or, as Agamben rephrases it, bio-power and sovereign power have reached a point of fundamental indistinction.

7. Back to Australia

We began this chapter by stating that we: 1) believe in the uniqueness of the Australian state; 2) believe that this uniqueness hinges on the particular relation that the Australian state forges between indigeneity and immigration; 3) believe that this relation is ultimately a direct consequence of the specificities of Australian colonial expropriation of the indigenous people from their land. As Stephen Castles and his collaborators put it:

> Racism and the utilization of migrant labour have been crucial factors in the history of the Australian economy and cultural identity both in the colonial era and since ... The analysis of these factors is complicated, for we are dealing with two distinct, though interlocking, processes: the first is the colonial land grab, which dispossessed the Aboriginal people, and which was based on physical and cultural genocide. The second is the process of labour recruitment, migration and settlement, necessary to provide a workforce for an emerging industrial society. The first process is one of destruction and partial exclusion from the developing society; the second is one of incorporation.[70]

This double process underwritten by the Australian state – of destruction-exclusion and of suspension-inclusion – undoubtedly regulates a number of the recurrent symptomatic deadlocks in the secondary material. For example: is *terra nullius* still an effective doctrine, despite the fact that it was overturned in the Mabo/Wik decision? Was Australian colonial law racist or not? Do white Australians "love the land" as much as indigenous Australians? And so on.

Perhaps, however, the central aporia in the historical literature concerns the status of Australian Law in the ethnocide of the Aboriginal population. As Henry Reynolds writes:

> despite coming under the protection of the common law, over 20,000 Aborigines were killed in the course of Australian settlement. They were not, in a legal sense, foreign enemies struck down in war although a few were shot down during periods of martial law. Most were murdered – nothing more nor less. Yet the law was powerless to staunch the flow of blood – and neither lawyers nor judges appear to have done much to bring the killing to an end.[71]

How much the "Law itself" is responsible for these massacres continues to be – for obvious reasons – a matter of the most intense dispute. Reynolds' own "nothing more than less" – an apparently neutral, even incontestable statement – is com-

pletely incapable of explaining the extreme, apparent powerlessness of the law in the face of such extraordinary transgressions. Indeed, Reynolds' statement functions here precisely as an index of opacity; as a simple fact before which all explanation stops.

This "fact," however, cannot be sustained without contradiction. Inga Clendinnen, for instance, after declaiming her conviction that "I think we are rather fortunate indeed to have that British legacy of law rather than violence as the ultimate arbiter, and an ideal of civil conduct which sustained itself even in the thick of military violence," can thereafter only register violence against the indigenous population as simply happening *outside* the Law.[72] Hence she can write of Protector George Robinson's trip from Melbourne to Portland in 1841: "What he sees troubles him deeply. In the rush to grab the land – to grab it from white competitors even more urgently than from its Aboriginal owners – blacks are being thrust off their tribal lands and left to starve. If they show the least resistance, if they spear a single sheep, whole mobs are likely to be murdered. The Law is elsewhere, in distant Melbourne. It offers no protection."[73] Yet, a few pages later, Clendinnen can remark that, even in "distant Melbourne," the fate of the Aborigines arouses neither moral concern nor legal retribution – which indicates the Law's positive, *motivated* indifference. Clendinnen's "kettle-logic" verges on the hallucinatory: the Law is good, and we are lucky to have it; the Law can't be everywhere, and so can't be blamed for atrocities; even where the Law is, it offers no protection, but that's not its fault.

Beyond her rather shaky grasp of the facts, Clendinnen is not alone in conceiving the law as *at once* implicated and innocent in the slaughter of indigenes – indeed, this contradiction could be shown to regulate the work of the most diverse commentators.[74] This contradiction, moreover, is integrally bound up with others. Recent academic valorisations of political struggle as constant "contestation" and "negotiation," as strategic movements within ever-shifting, overlapping regimes of power – although certainly correct in a restricted sense – are thereby incapable of deciding whether there is any identity to, say, Australian law over time. What they miss is the consistency and insistency of the *frame* in which such struggles take place. From our point of view, the law cannot be exculpated from atrocity; on the contrary, the law functions precisely as an incitement to atrocity. (This is not at all a moral judgement: to the present day, a community without violence has proven absolutely unthinkable, let alone practically possible. Our point is simply to ask, as neutrally as we can, as to how – beyond any particular ideological affiliations – the law actually works.) Those who apparently flouted or transgressed the law in their maltreatment of aborigines were precisely those who enabled the law to extend its dominion, to areas and peoples from which it was

previously excluded or from which it had even excluded itself.[75] Such *illegal* or *extralegal* acts of violence – one could confirm this easily with comparative studies – are precisely the condition of the law's effectiveness.

Moreover – and this is a fact which receives more general agreement – it was precisely the imposition of colonial law that produced the "Aboriginal" population as "Aboriginal" in the first place. As Eric Michaels put it in an unsurpassable formulation of the situation, "colonial Australian administration has always refused to recognize that there is no one Aboriginal culture but hundreds of them, as there are hundreds of distinct languages, all insistently autonomous ... The overarching class 'Aboriginal' is a wholly European fantasy, a class that comes into existence as a consequence of colonial domination and not before."[76] Australian law and the Aboriginal people were thus born together; violence and law, nomination and peoples, constitute, in Australia, the *unavoidable* foundations of the state itself.

8. Neither Blood Nor Soil

Although the Nazis made "*Blut und Erde*" one of their catch-cries, it is often forgotten that almost all nation-states founded on a modern European model retain "blood and soil" as the necessary and sufficient conditions of citizenship (as *terra nullius* is itself said to do, these criteria derive from Roman law). That is, for an individual to be immediately and unproblematically registered as a full citizen of such a state, the parents of this individual must themselves be citizens of that state, and the child must also be born on its territory. As Miriam Feldblum puts it:

> Traditional citizenship has meant full membership in a polity. In the modern world, the polity has been understood to be a nation-state: that is, citizenship is integrally linked to a territorial state and to the people (or nation) belonging to that state ... Citizenship regulations cover the formal state membership policies, which set the legal procedures and parameters of state membership. In an administrative, legal sense, these rules tell us who is a citizen and who is not.[77]

If an individual fails to meet these criteria, there are a number of state-sanctioned rituals which enable what is now so symptomatically denominated "naturalisation": extraordinarily complicated and fraught administrative procedures which permit the ritual cleansing and assimilation of aliens into the social body. It is also symptomatic that it is easier to treat a *citizen* of another country with such procedures than it is to treat a refugee, that is, an existing state-ratified citizen can change states far more easily than a "stateless" human being can become a citizen. So what, then, of Australia in particular?

Given such a context, Mike Salvaris makes the following pertinent remarks:

> Among modern democracies, Australia is unusually reticent in spelling out the form and substance of its citizenship. In law and policy, it is difficult to find unequivocal statements about the underlying values of citizenship, much less a clear definition of the actual rights, duties, institutions and policy standards that give it flesh and bone.[78]

This has meant that Australia has been, since its foundation, essentially a state-without-citizens. This claim thus distinguishes itself from the more familiar idea that there are citizens-without-rights (Chesterman and Galligan): on the contrary, one should rather say that Australia has always been occupied by bundles of rights-without-citizens – which is far more disturbing. In this place, Australia, in which blood and soil are unacceptable as criteria of belonging and yet remain the only criteria of belonging, the *statification* of aliens (whether internal or external) occurs *just like nowhere else*. And it is precisely this role of exception, bequeathed to Australia by a concatenation of historical accidents, that renders it an exemplary and determining state for anywhere, everywhere else.

The consequences of this under-remarked fact are extremely complex. They speak, furthermore, of a situation at once so extreme and exemplary that it has, and perhaps for that very reason, remained illegible or incomprehensible. Even Robert Hughes' remark that Australia was the first gulag relies too heavily on analogy to be accepted without further precision.[79] This is not to say that it is not true – on the contrary, we are in accord with Hughes on this point – but that the *abstract administrative logic* that binds the prison island of the Imperial British Government to the post-Holocaust terrors of our Antipodean Gulag Archipelago begs a far more extensive analysis in its own right.

The overturning of *terra nullius*, then – far from constituting a welcome liberation from a deleterious fantasy – has rather had the double, unexpected effect of *exposing* the foundations of Australian law *and* rendering these foundations all the more immutable. The moment at which "native title" is recognised in law is also the moment at which its claims are totally assimilated by the state in the guise of the *suspension* of common law. For every native title claim must now proceed through the very legal system that has "recognised" it as such; claims for native title made in such a system must, even if they are successful, strictly conform to the procedures of common law.

But such a situation is familiar to many "first nation" claims to sovereignty world-wide; they fail to distinguish the singularity of the Australian experience. Is it possible to specify in even more detail the ruses of *terra nullius*, and its role in forging a peculiarly Australian form of sovereignty?

9. The Australian Sacred: Some Examples

Terra nullius rendered the Aboriginal people literally sacred, in the sense that we have been outlining above. This fact is verified by the intense and ongoing struggles for control of this much abused word. In the first week of August 2001, there was a public outcry over the decision to call the Australian athletics team, "The Diggers." John Howard – a man highly sensitive to the real qualities and effects of symbolic public acts – denounced the move, calling the name "sacred." Howard, along with many other public figures and media commentators, has also applied the name to famous sites of Australian war efforts (Gallipoli, the Kokoda trail, etc.).

In the Australian context, "sacred site" was originally coined by anthropologists and gained wider currency after the 1967 referendum gave Federal Parliament responsibility for Aboriginal affairs – which makes clear its links to colonialism and state-formation. Moreover, "sacred site" bespeaks the state demand that kinship relations and land be knotted inextricably and inexpropriably, in order that such a knot can then be held to characterise a *pre*-political form of politics. For insofar as modern politics entails a certain notion of property, the "sacred" as the name for this pre-political situation in no way changes anything.[80] For reasons that we have already adduced, the effects and affects of sacrality are precisely the hallmarks of a situation founded on the paradoxical excluded inclusion of Aborigines from the true political life of the nation.

Certainly, it is very difficult in certain circumstances to discern the difference between sacrificial and non-sacrificial and, in Benjamin's terms, between "mythical" and "divine" violence – for example, the denomination of Anzac Cove as an (extra-territorial) "sacred site," an exemplary place of national self-sacrifice. But this appropriation of the signifier "sacred" (on the analogy of Aboriginal sacred-sites) only goes to show that the difficulties of *distinguishing* how the "sacred" mediates between "sacrifice" and "non-sacrifice," are integral to the *effectivity* of the underlying identity of "sacred" and "nonsacrificeable."

This is why the recent dispute between Keith Windschuttle and his critics in the Australian media over the sense and reference of the words "massacre" and "genocide" in the local context – a dispute which can stand here for the many others around essentially the same question – somewhat misses the point.[81] If it may well be both necessary and desirable to total the dead, such accounting procedures often divert analyses away from the central and determining issue: that the Australian state was instituted and sustains itself on the legislative production of "Aborigines" as those who can be killed-but-not-sacrificed. This "instituting violence" is such that – whatever the treatment of the indigenous population there-

after, in the very different social and historical contexts that the last two centuries have witnessed – to be identified or identifiable as "Aboriginal" is to continue to bear the traces of this inauguratory, "establishment" violence.[82] This is not in any way to underplay the massive and continuing sufferings experienced by so many groups in Australian history; it is simply to show how "Aboriginality" serves a *qualitatively* different function in the formation and maintenance of the Australian state – a function that is often *designedly* rendered invisible by the number-crunching procedures alluded to above.[83]

We should also cite here the work of David Tacey, who exemplifies fatuous establishment discourses of "sacrality" in the Australian context. His project is not illegitimately simplified by its reduction to the propositions: "Aborigines have a relation to the land that is different from ours; we too must now forge a similar relation, in order that the whole land can become sacred for everyone."[84] But this injunction is directly opposed to Aboriginal claims for land, insofar as Tacey confonts us with a reflux movement which now wants to colonise not only politics, but pre-politics as well. As Peter Read argues, in a remarkably similar vein:

> colonialism – not racism – is responsible for the practice of extinction by legislation. I will look at the national unease caused by issues of belonging that emanate from the demands from *unequal* citizenship now being made by Aboriginal people. As a solution, I will suggest that indigenous and non-indigenous Australians accept their shared status as second-class citizens – and that we find ways to benefit mutually from this bond.[85]

Now Read is, of course, the historian who coined the term "stolen generations" (in a 1981 article) – and who has also recognised the motivated inconsistency in early colonial definitions of Aborigines and their relation to the land. On the other hand, his argument here that *both* aborigines and non-aborigines are now "second-class citizens" runs the risk of reducing the abiding political incommensurability between these populations; moreover, his claims that white Australians now have as close an affective bond with the land as the indigenous population is to further confound their qualitatively different statuses in the formation and sustenance of the state, implicitly reducing the question of *political domination* to a question of *affective experience*. If there is any logic whatsoever to these discourses of the sacred, it is: *my unheard claims are justified because I feel them as deeply as you*. If such a proposition is logically risible and politically reactionary, it undoubtedly betrays the truth of one flash-point of white Australian politics.

A recent example of this reflux was provided by the Hindmarsh Island affair, in which the so-called "traditional" divisions within the Aboriginal community

could only be publicly represented as an abuse of the very sacred proper to Aboriginality. The indigenous players in the drama were thus denounced as precisely betraying their Aboriginality to the extent that they had left the charmed circle of sacrality, and entered the secular realm of the political (e.g., possible lying, propaganda, engaging in internecine conflict, being internally stratified and divided, etc.). We are not simply making the point that sacrality is an instrumentalized technique of contemporary power-politics; we would also suggest that Aborigines are the *real* matter of Australian politics, insofar as its sovereignty ultimately rests on their unsacrificeable, sacred bodies.[86]

We were reminded again of the links between sacrifice and community when watching the recent Australian TV series *Australians at War* (ABC TV, 2001) which was replete with genuine pathos over Australian war dead. But this pathos, it was clear, derived not from the simple fact that hundreds of thousands of human beings were meaninglessly butchered, but because these men had actually died for "reasons-of-state." They fought together, suffered terrible agonies and, finally, died *meaningfully*. These young white Australian men had made "the supreme sacrifice" – a phrase that apparently bears too much repeating.[87] With such symbolic gestures as memorials to the war dead and the solemn media-ministerial acclamations of those who "made the supreme sacrifice," death is sublimated into the destiny of the community, insofar as that community is ultimately *legitimated by the state form*.[88] It may well be the case that far more of the indigenous population has been murdered on their own earth than any other Australians in extraterritorial conflicts; but it is clear that, even if somebody like Windschuttle could, impossibly, be brought to admit a "massacre," *no-one* would claim that "the Aborigines made the supreme sacrifice," or "they died with their mates." And, in a certain sense, it is true that the violence that accompanied the imposition of the Law in Australia cannot, strictly speaking, be considered a "war" – which precisely presumes the clash of already-existing-sovereignties in order to be war or, at least, has to be prosecuted *in the name of* sovereignty.[89] Neither was it a simple police operation.

For the emphasis on "mateship" is, beyond the homosocial community bindings it makes possible, one of the central emblems of Australian state power and integrally connected to its capacity to wage war.[90] As it happens, Australians usually fight as a subservient faction of somebody else's imperial war machine. As one of Michael Reynolds's characters meditates (she is a depressed American *emigré* anthropologist):

There was the ignominious debacle on the beaches of Gallipoli. Then that ambiguous and inexplicable local phenomenon known as "mateship." Some

connection existed between these lonely two Australian mythic super-structures. But what did either of them amount to in the end? The image rose in her mind; phalanxes of Australian "mates" happily diphthonging their way through the Dardanelles only to be shot to bits on the beaches of Gallipoli.[91]

In other words, the many denunciations of John Howard's desire to get the word into his and Les Murray's proposed preamble to the Constitution in many ways missed the point: to the extent that the dissenters still paid at least lip service to the liberal-democratic state, then they should have realised that the sovereignty of this state has been maintained at a number of different levels – legal, social, cultural – by a sacrificial economy of mateship.[92] To sacrifice this sacrifice, in other words, would require a total rearticulation of the state's relationship to indigeneity – more specifically, a *destruction* of aboriginal sacrality. To our minds, this would also entail a destruction of the present form of the Australian State. Precisely because – against many of the standard views on the subject – sacrifice and sacrality are mutually exclusive yet sustain each other, it is necessary to wage a double war against them and repeat, from another angle, what many others have already clearly stated: the seductive myth of the Aboriginal sacred is a white man's mythology. The underbelly of this "idealising" myth is its "real" truth: the indigenous population as able to be killed, but not sacrificed.

On the basis of the theoretical material surveyed in the central sections of this article, it is now possible to identify – as we have in the examples provided above – the motivated linkages between: 1) recent white claims for "sacred sites" of their own; 2) the *pathos* of white Australian war-dead; 3) the centrality of "mateship" in white Australian culture; 4) the failure to memorialise the Aboriginal dead of the colonial era; 5) the continued dismissal-through-recognition of Aboriginal claims to land. In the Australian situation, law, politics and citizenship – entangled as they are with sovereignty, sacrifice and the sacred – present a peculiarly intricate Gordian knot to activists and intellectuals.

For the Australian indigenous population was precisely what had to be excluded for Australia to become "Australia" in the first place – and, indeed, "Aboriginality" was thereby *created* as such, as the *excluded inclusion* which founded the Australian state. But this excluded inclusion is, equally, connected to the paradox of the refugee. Refugees threaten the state as its external other, as anti-citizens. No laws protect them; no state will guarantee them; they have the protection of no global or national authority, other than the ambivalent declarations and actions of the UN and certain NGOs. Refugees are divided figures who, on the one hand, attract the public's goodwill and sentimentality insofar as they are considered "defenceless" and "pathetic" and, on the other, can continue to be

treated as such. At the "heart" of the Australian state, we find the excluded inclusion of Aboriginality; at its "borders," we find the included exclusion of refugees. Both are figures of sacrality, the unsacrificeable.

It is therefore symptomatic that – at the very moment when the central Indigenous issue of the Stolen Generation has disappeared almost altogether from the media and public political debate – the horror of maltreated children returns to be projected directly onto the "threat" of the refugees. As we saw in chapter 6, the Tampa crisis and the "Children Overboard" affair raised the spectre of the mistreatment of children, exemplary figures of innocence.[93] So it seems the constitutive Australian bio-political fracture is now resolved by projecting it onto the evil of the outside; the internal dispossession of Australian Aborigines that founded the Australian State will be doubled and salved by the justified exclusion of refugees at its external borders. It couldn't be a simpler ideological operation; yet the *only* people who can be definitively identified as systematically, officially and brutally maltreating children are white Australian representatives of the State.

So perhaps it is worth asking, with Samuel Beckett,

...if it is still possible at this late hour to conceive of other worlds as just as ours but less exquisitely organized?[94]

A Spanner in the Works

Conclusion: A Spanner in the Works

It comes as the Revealer. Showing that no society can protect, never could – they are as foolish as shields of paper ...
THOMAS PYNCHON, *GRAVITY'S RAINBOW*

As told by Dominic:
The first time I saw somebody die was while standing in a queue at the UBS bank in Geneva. Switzerland is a country famous for its anonymous banking system, and I was taught a swift lesson in the priorities of finance over any unexpected eruptions of "the real" that may occur in the marbled shrines of capitalism. An old man, waiting to make a deposit or withdrawal, or simply an inquiry, had a heart attack and collapsed. The already hushed bank went totally silent for a moment, as the echo of his cry dissolved in the distant corners of that vast open space. Several people certainly did the humane thing, and ran to his aid. An ambulance was called. But soon enough a man – who may or may not have been a doctor – pronounced him already dead. Still, they waited for someone in uniform to make this opinion official.

Nobody, however (including myself), was going to let this unfortunate incident disturb our business affairs. The show must go on; and when the show is global capital, it will go on twenty-four hours, seven days a week. The didactic part of this experience occurred when people in the queue *actually stepped over the corpse to continue their banking*. The silence continued, perhaps a sign of some kind of lingering guilt, and fortunately for me, I was in a different queue. I did not have to make this most explicit and blasphemous of gestures: to step over a fresh corpse. To ignore the dead.

Thinking back on the incident later that day, I realized that I had mixed up my terms. It wasn't blasphemous to *ignore* the dead (since it is, after all, something we do every day). No, the blasphemy was to die, and to die so publicly. This is the biggest *faux pas* one can make in our society (hence the traditional insistence on clean underwear, as if that is a token of apology for making such a fuss). Western culture distinguishes itself from all others, and indeed its former self, through its inability to enjoy symbolic commerce with the dead. Where only a century ago, Victorians would have a picnic in the municipal graveyard in order to share the day

with deceased grandparents, we now build cemeteries as far away as possible. Out of sight, and out of mind.

Watching the respectable citizens of Geneva continue to question their balance statements, or pick up their traveller's cheques, having just crossed the threshold between the quick and the eternally slow, forced me to consider the ways in which contemporary culture relies on networks which can reroute themselves around such troubling aporias. Just as the Internet was first designed as a communication tool which could withstand nuclear strikes (for there is no center to "strike"), global capital can reroute itself around any "situation" which may appear to threaten it: whether it be a political demonstration, a corruption inquiry, a civil war, or the banality of personal mortality.

Like ants marching towards the tellers, the bank's customers were quickly filling the void left by this old man. Just as nature abhors a vacuum, culture abhors a void, and it will do anything to avoid this void. To do otherwise would necessarily expose the knowledge that "the system" is built on nothing, and that every social transaction is based on a stubborn "consensual hallucination"; specifically, that strips of paper are worth something. The fundamental obscenity which Marx first alerted us to accounts for the discomfort which emerges when the restricted economy of capitalism is confronted with the wider, symbolic economy of human interaction and finitude. Thus the money which flows through the veins of global credit agencies is shot through with the antibodies of a larger economy which cares as little for the stock market as it does for the gentleman now permanently relieved of his tax obligations.

Almost exactly one year later, on September 11, 2001, two hijacked 767 airplanes slammed into the twin towers of Manhattan's World Trade Center, resulting in a spectacular and horrific loss of life. This was a strike against capitalism itself; via the people who tend the machine, and, in fact, comprise the machine. Watching the BBC's Business Report in the days following the disaster, concerning the repercussions on the world's stock markets, the astonishing truth became clear: that capitalism still has "a heart" that its enemies can strike; that it is still possible, in this age of decentralized global commerce, to bring the world economic system to its knees. And all this *with the equivalent of a hammer blow* – the twenty-first equivalent of a spanner in the works. Not a sophisticated computer virus. Not an engineered biological virus. But rather the hard technology of steel, fuel, concrete, and knives, harnessed by the operating instructions of ideology.

Much was made of the symbolic nature of this terrorist attack, but it was all the more effective for paralyzing *both* the symbolic *and* the restricted economy. Of course, the same process described above in the Swiss bank redeployed itself after some shaky moments, but on a much larger scale. The market began rerout-

ing itself around the casualties and through Europe and Asia until the New York Stock Exchange could begin to function again. Indeed, it was considered the height of patriotism to get back to work, as bosses around the country put out their "call to alms."

Nevertheless, for a brief moment this violent act ripped a hole in the smooth, prophylactic layer of reified human interaction, revealing that – despite the rhetoric of the digital consultants and corporate security experts – the system still runs on paper and blood. Just as the Russian submariner Dmitri Kolesnikov scribbled his final message of love and terror to his wife at the bottom of the Barents Sea in the doomed Kursk submarine, thousands of office workers attempted to contact their loved ones through email or cell phones before these vertical titanics crumbled to the ground.

The city is a rhizome, or at least obeys rhizomatic principles. This is its strength and its strategy. As proved by the attack on the World Trade Center, rhizomes have no Achilles heel, no central nervous system towards which an attack can be launched, *and have a long-term effect*. The only genuine threat is total (nuclear) or heterogeneous and ubiquitous, like the virus (hence the panic surrounding both "biological" and "computer" versions of the virus). Lower Manhattan came to a standstill for several days, but slowly the people began to trickle back into the area and rebuild their shattered lives. As any kid knows, if you pour water on an ant colony you may kill a lot of ants, but the colony itself overwhelms the dead with its incessant movement. Unfortunately for us, we have more than water at our disposal.

What does it all mean? we ask(ed) ourselves.

However, now more than ever perhaps, it is prudent to suspect this Western obsession with "meaning." Equally, it is revealing to realize that signifying something without significance is not necessarily the same thing as signifying nothing. In fact, this may be the most *significant* activity available to us in Deleuze's society of control. Take, for instance, the example of dancing for no reason whatsoever other than to dance; allowing oneself to become the medium for the music, either external or internal. Here there is no narrative, no content, no meaning – only movement. All is form, neither pure nor impure, but simply thus ... the perfect form of the Thai dancer following the spike of false fingernails. Utterly meaningless, and utterly beautiful: "There is ... nothing important to say; there are perhaps only the resources we deploy in order to avoid the traps of meaning in language."[1] Or better still, "I have nothing to say, and I am saying it" (John Cage).

But how does this obligation to produce or find so-called meaning explicitly relate to our commerce with and amongst objects? Well, take, for instance, a typical morning in the life of yours truly. I open my email and I have an official letter

from the Dean of my university. Nothing strange about that. This message, how-ever, is sandwiched between two other messages, the first marked "Young Virgin Fucks Donkey" and the other with the subject-heading "Brazillian She-Male Waiting for You (Dominic)." It seems that chance meetings and unexpected juxta-positions are no longer anything special, let alone beautiful, as they once were for Lautrèmont. As a consequence, I suspect that the post-spam generation would be underwhelmed by an umbrella and a sewing machine, discovered together on a dissecting table.

A very brief review of the tangent taken by this book, however, may re-inject some kind of potential or anti-utilitarian purpose between the elements of such chance encounters. To clarify: the previous chapters are emphatically *not* exercis-es in "letting the object speak" (as at least one prominent critic has encouraged theorists to do), since such phrasing is in danger of perpetuating a rather patron-ising, high-anthropological attitude towards subaltern substances – as if the mas-ter's magnanimity is all that is required to coax the voiceless to articulate a "sub-ject-position." Rather, we recognize and emphasize the fact that objects have been speaking to us since the beginning of discourse, and many people have been lis-tening and responding to objects in turn. In fact, more than that, "we" could never "speak" as humans without the existence and co-operation of objects (think of the delicate textual webs weaved by ochre, quills, pens, keyboards, and other prosthe-ses, such as "love").[2]

As an almost random example of this kind of weaving, we could point to Hermann Broch's novel, *The Anarchist*, in which he writes:

> Vaguely the traveller feels that by such reflections he lifts himself above the triv-ial daily round, and he would like to stamp them on his mind for the rest of his life. For though reflections of that sort might be deemed general to the human race, yet they are more accessible to travellers, especially to hasty-tempered travellers, than to stay-at-homes who think of nothing, not even if they climb up and down their stairs ever so often daily. The stay-at-home does not observe that he is surrounded by things of human manufacture, and that his thoughts are merely manufactured in the same way. He sends his thoughts out, as if they were trusty and capable commercial travellers, on a journey round the world, and he fancies that thus he brings the world back into his parlour and into his own transactions.[3]

For Heidegger, the object-thing *mediates* between the subject and its milieu: which is why, according to his lectures, the stone has no world, the animal is poor in world, and man makes his own world. The thing *mediates* between the subject

and its milieu: which is why, according to his lectures, the stone has no world, the animal is poor in world, and man makes his own world.

In chapter 2, however, we tried to peer over the edges of this claim; taking as our starting point the stones which comprised the Berlin Wall, and the particular world it manifests for a seemingly lonely Swedish woman. Again, this is not to resort to a kind of wilful animism ("hey Martin, how do you *really know* the stone has no world?"), but rather to come to grips with what Heidegger's muse, Hannah Arendt, called the "intentional object."[4] That is, to twist the hierarchy, as well as the terms of reference, in order to trace the gaps and overlaps between the essentially mobile and abstract categories of "object" and "thing" – up to and including the "injurious neglect" of the latter.[5] (And not only that, but the ontological feedback loops which produce such key categories as *presence, appearance, communication,* and *meaning.*)

The fact that a person can – at the moment of exposure or shame – experience the switch from subject to object (and immediately back again), alerts us to the fact that all our arguments rest on metaphysical quicksand. "Freezing" in front of a camera is both an instance of the modern Medusa myth, played out in front of electronic eyes, and a recognition that we are just as much *things* as the objects we either cherish, neglect, or treat as slaves. Which is not to flatten occidental cosmology, but to understand that it is dynamic, always moving, mediated, supplemented, prosthetic, and – above all – technological.

For example: in the case of the spider, the "media" is its web. However, the spider does not sit in the web, the master of all it surveys, but rather that molar entity we call "spider" is the weaving point of the web itself: the web intensified and crystallized into life. The web is not only a centrifugal net for harnessing nourishment, but a centripetal media conducting information to an organic central processing unit (one which is simultaneously central and rhizomatic, precisely because of the reach of the web, of which it comprises a symbiotic node). No doubt it is both tempting and unsatisfactory to apply this metaphor to ourselves (for it *is* only a metaphor when phrased outside the tacit assumptions of biology), sitting within the World Wide Web that we have weaved over the last decade or so. Mediation, in the case of the spider, and perhaps even of ourselves, is so instantaneous, internalized, and essential, that we could very well replace it with the term *immediacy* – albeit using a different tone than when uttered prior to poststructuralism.[6] The limits of binary thought are thus clear, when it is possible to push one term so far it spasms into its so-called opposite. The media no longer (if it ever did), mediate between subjects and objects, but constitutes those very nodes in the network, holding them in suspense. (Hence the popularity of *The Matrix* at its time of release, with its apocalyptic vision of battery humans providing energy for machines – Dante meets Gieger in Marx's drawing room.)

The tropes explored in the previous pages: public transport as a movement which gathers both community and solipsism within its own tailwind; those broadcast spaces (such as Reality TV, as much as melancholy art house movies) which produce similar "special affects"; the recycling and circulation of (often virtual) objects to create at least the simulation of solidarity (MP3s, manipulated photographs); the vectors which can as much be decoys as portals to what Heidegger calls "the open" (figures and totems); and, most glaringly, the techno-political operations of what Agamben calls "the anthropological machine," all constitute threads in the even wider web of this suspended (post)historical moment, in which – along with Hermann Broch – we can wonder if the First World War really ever ended at all.

Notes

Notes Introduction

1. N. Luhmann, *Observations on Modernity*, trans. W. Whobrey (Stanford: Stanford University Press, 1998), p. 93.
2. So we read museological studies: "what is observed in the museum today is no longer unequivocally an object; objects have been reconstituted as sites of experience, and museums increasingly hold themselves accountable for delivering experiences," H.S. Hein, *The Museum in Transition: A Philosophical Perspective* (Washington and London: The Smithsonian Institute, 2000), p. 5. Or we read fundamental ontology, as suggested in the title of A. Badiou, "On a finally objectless subject," in E. Cadava et al. (eds.), *Who Comes After the Subject?* (New York: Routledge, 1991), pp. 24-32.
3. Thomas Pepper, *Singularities: Extremes of Theory in the Twentieth Century* (Cambridge: Cambridge University Press, 1997), p. 14.
4. G. Agamben, *Homo Sacer: Sovereign Power and Bare Life*, trans. D. Heller-Roazen (Stanford: Stanford University Press, 1998). The phrase is originally Gershom Scholem's, and derives from an exchange between Scholem and Walter Benjamin over a point of Kafka interpretation.
5. Don DeLillo, *White Noise* (London: Picador, 1986), pp. 12-13.
6. Benjamin notes that incessant mechanical reproduction replaces the object's aura with "mystique," but his famous essay does not offer any practical distinctions between these terms. See "The Work of Art in the Age of Mechanical Reproduction," in *Illuminations*, trans. H. Zohn, intro. H. Arendt (London: Fontana, 1992), pp. 211-244.
7. See J. Lacan, *The Four Fundamental Concepts of Psychoanalysis*, trans. A. Sheridan (London: Penguin, 1994), in which Lacan tells an admittedly weak joke about Petit-Jean, the Breton fisherman who points out an empty sardine can floating in the water and remarks, "See that can? Well, it doesn't see you." Lacan, however, adds: "It was looking at me at the level of the point of light, the point at which everything that looks at me is situated – and I am not speaking metaphorically," p. 95.
8. Quoted from the original screenplay, written by Jim Uhls.
9. See G. Debord, *Society of the Spectacle* (Detroit: Black and Red, 1983) and T. Adorno, *Aesthetic Theory*, trans. C. Lenhardt (London: Routledge & Kegan Paul, 1984).
10. See the essays collected in D. Tofts et al. (eds.), *Prefiguring Cyberculture: An Intellectual History* (Sydney: Power Publications, 2002) for a variety of recent takes on the digital revolution.
11. M. Castells, *The Rise of the Network Society* (Oxford: Blackwell, 1996), p. 373.
12. See F. Kittler, *Literature Media Information Systems*, ed. and intro. J. Johnston (Amsterdam: OPA, 1997).

13. It could be argued that "the virtual" was *the* key term in Deleuze's *oeuvre*, should we seek such an old-fashioned hermeneutic tool. Indeed, he was working on an essay addressing this aspect of his thought in systematic, explicit terms when he committed suicide. This draft has been translated into English as "The Actual and the Virtual," available in *Dialogues, Second Edition* with Claire Parnet (London: Athlone Press, 2002).

14. Peter Sloterdijk. "The Elmauer Rede: Rules for the Human Zoo: A Response to the *Letter on Humanism*," trans. Mary Varney Rorty. Online. Internet.

15. Bernard Stiegler, *Technics and Time, 1: The Fault of Epimetheus*, trans. Richard Beardsworth and George Collins (Stanford: Stanford University Press, 1998), p. 15.

16. Samuel Weber, *Mass Mediaurus: Form, Technics, Media* (Stanford: Stanford University Press, 1996), p. 73. (For many thinkers – especially those influenced by Heidegger – "*worldness*" is "*always already technicity*," Stiegler, op. cit. p. 91).

17. Lucretius, *On the Nature and Origin of the Universe* (London: Penguin, 1994), p. 100.

18. Lucretius, p. 115.

19. Deleuze, Gilles. "Letter to Serge Daney: Optimism, Pessimism, and Travel," in *Negotiations, 1972-1990*, trans. Martin Joughin (New York: Columbia University Press, 1995), p. 76.

Chapter 1

1. Giorgio Agamben. *Stanzas: Word and Phantasm in Western Culture*, trans. Ronald L. Martinez. (Minneapolis and London: University of Minnesota Press, 1993), p. 144.

2. For it could be argued that even the Hellenic poets of antiquity dabbled in sampling, via the poetic form of the Cento, which the *Princeton Encyclopaedia of Poetry and Poetics* describes as a "patchwork," as well as a "poetic composition made up of passages selected from the work of some great poet of the past."

3. Bernard Stiegler. *Technics and Time, 1: The Fault of Epimetheus*, trans. Richard Beadsworth and George Collins (Stanford: Stanford University Press, 1998), p. 241.

4. This is an extract from Dominic Pettman's review of *Entroducing*, first published on the *Blackjelly* webzine, http://www.blackjelly.com.

5. In his brief discussion on this phenomenon, Claude Lévi-Strauss claims that "*musique concrète* may be intoxicated with the illusion that it is saying something; in fact, it is floundering in non-significance." See *The Raw and the Cooked: Introduction to a Society of Mythology, vol. 1.*, trans. John and Doreen Weightman (New York: Harper & Row, 1970), p. 23.

6. At the beginning of *A Thousand Plateaus*, Deleuze and Guattari make the point that: "A [work of art] has neither object nor subject; it is made of variously formed matters, and very different dates and speeds. To attribute the [work of art] to a subject is to overlook this working of matters, and the exteriority of their relations," p. 3. Here, we have simply replaced the word "book" with "work of art," so that the point still stands.

7. In Gilles Deleuze, *Difference and Repetition*, trans. Paul Patton (New York: Columbia University Press, 1994), p. xxii. London's *Independent* newspaper writes: "In June, after the British musical group The Planets introduced a 60-second piece of complete silence on its latest album, representatives of the estate of composer John Cage, who once wrote "4'33" (273 seconds of silence), threatened to sue the group for ripping Cage off (but failed, said the group, to specify which 60 of the 273 seconds it thought had been pilfered). Said Mike Batt of the Planets: "Mine is a much better silent piece. I (am) able to say in one minute what (took Cage) four minutes and 33 seconds" (June 21, 2002).

8. Jean Baudrillard. *The Illusion of the End*, trans. Chris Turner (Cambridge and Oxford: Polity Press, 1994), p. 5.

9. The theoretically minded DJ, Paul D. Miller (aka DJ Spooky), recently "remixed" D.W. Griffith's infamously racist film *The Birth of a Nation* (1915) in order to inject new and more progressive meanings and possibilities into the spliced up narrative. This only reinforces our point that genres, indeed media themselves, are all up for grabs in the digital age.

10. Another example of this asymptotic completion is word processing, in which cut-and-paste technology means no version is final. Thus writers no longer suffer from writer's block, but editor's block. (And thanks to Rob Crompton for this insight.)

11. Walter Benjamin. *Gesammelte Schriften, vol. 2.2* (Frankfurt a.Main: Suhrkamp, 1972), p. 536.

12. Giorgio Agamben. *The Man Without Content*, trans. Georgia Albert (Stanford: Stanford University Press, 1999), p. 108.

13. Agamben, *The Man Without Content*, p. 111. The question has been asked whether oral culture, such as folk tales, constitutes an example of "sampling" according to the definition outlined above. In terms of form they could feasibly qualify, since any "quotation marks" – i.e., personally attributable attributes – are erased; or more accurately, absent. However, oral culture does not enact the *logic* of sampling, since folk tales (along with jokes and urban legends) make up the substance of a shared history. Unlike sampling, there is no break in transmission. Oral culture *is* pure transmission: a cultural code to facilitate certain social programmes and communal commands. Sampling represents the rupture of oral culture through the aural.

 Were we to be granted the luxury of more space in which to unpack these thoughts, it would then become necessary to address Friedrich Kittler's compelling comments on the analogue interpretation of "tradition" (although he doesn't use this technical term) in *Discourse Networks 1800/1900*, trans. Michael Metteerand and Chris Cullens (Stanford: Stanford University Press, 2001). Here, tradition "produces copies of copies of copies and so on endlessly, until even the concept of the original is lost," p. 36. Thus, before both Baudrillard and Benjamin, *tradition is erasing itself through its very transmission* – a neat twist on Agamben's accumulation argument, since it predates the technologies of modernity.

14. Gilles Deleuze and Felix Guattari. *A Thousand Plateaus: Capitalism and Schizophrenia*. trans. Brian Massumi. (London: Athlone Press, 1999), p. xiv.

15. In *Jean Baudrillard: A Study in Cultural Metaphysics* (London & New York: Prentice Hall/Harvester Wheatsheaf, 1996), Charles Levin writes: "Even mediocre artists remind us, through the sheer pointlessness of their elaborate constructions, of the difficulty of composing an existence sufficiently interesting to satisfy our intelligence and to contain our feelings," p. 145.

16. In his novel *Noir*, K.W. Jeter writes: "There's a hardware solution to intellectual-property theft. It's called a .357 Magnum." Quoted in Steven Shaviro's *Connected: What it Means to Live in the Network Society* (Minneapolis: University of Minnesota Press, 2003).

17. See Jean Baudrillard's comments on the *trompe-l'oeil* as a re-fusing of painting, sculpture and architecture, in "On Seduction," in *Jean Baudrillard: Selected Writings*, Mark Poster, ed. (Cambridge: Polity Press, 1988). Regarding this transgeneric phenomena, it is also worth noting Luis Buñuel's comments on Fritz Lang's most famous film, as long ago as 1927: "if we put before the story the plastic-photogenic basis of the film, then *Metropolis* will come up to any standards, will overwhelm us as the most marvellous picture book imaginable." See Thomas Elsaesser *Metropolis* (London: BFI Press, 2000), p. 14.

18. J.G. Ballard. *High Rise* (London: Flamingo, 2000), pp. 80-81.

Chapter 2

1. Giorgio Agamben. *Stanzas: Word and Phantasm in Western Culture*. trans. Ronald L. Martinez (Minneapolis and London: University of Minnesota Press, 1993), p. 59.
2. Eija-Riitta Eklöf-Berliner-Mauer's homepage: http://www.geocities.com/berlinwall_se/ or http://www.algonet.se/~giljotin/eija.html.
3. Karl Marx. *Capital* (vol. 1), Available on the Internet. December 2002, pp. 111-112. http://csf.colorado.edu/psn/marx/Archive/1867-C1/.
4. Interestingly, Freud himself experienced an affective epiphany, triggered by bricks. See Kaja Silverman's *World Spectators* (Stanford: Stanford University Press, 2000), p. 97.
5. NBC Online News, June 12, 2003. Another interesting interaction between human and object, also in the context of space exploration, is the conversation between the protagonist Sergeant Pinback, and an "exponential thermostellar bomb" in John Carpenter's *Dark Star* (1974). This bomb is designed with "sophisticated thought and speech mechanisms," to allow it to make executive decisions in the event of a crisis situation. One of these bombs (number 20, to be precise), initiates its countdown sequence to detonation, but refuses to leave the bomb bay, and so the panicked crew are forced to "teach it phenomenology." The following conversation between Pinback and the bomb, incorporating several Cartesian meditations on the reliability of sensory input, as well as the resulting decision to act upon said information, is one of the reasons that *Dark Star* is still a minor cult classic.
6. Given the formulaic nature of *American Beauty*, we can only assume that the insistent novelty of this particular scene played the largest part in the overwhelmingly positive critical reception of the film. Less important than the middle-aged, middle-class angst was the objective-animist milieu within which it unfolded. (Were there more space, it would also be interesting to consider Marco Ferreri's 1986 film *I Love You*, in terms of objectum sexuality, for the protagonist of this film – played by Christopher Lambert – falls in love with a key-chain which says "I love you" at the touch of a button. Of course, this kind of automatic, indiscriminate response from the love-object leads to obsessional jealousy.)
7. J.G. Ballard. *Crash* (London: Panther, 1973), p. 34.
8. J.G. Ballard. *Super-Cannes* (London: Flamingo, 2001), p. 156.
9. Including an opera of the same name by Michael Nyman.
10. Agamben, *Stanzas*, p. 20.
11. Ibid., p. 121.
12. Ibid., p. 20.
13. Ibid., p. 21.
14. Ibid., p. 33.
15. Baudrillard "On Seduction," p. 160.
16. Nearly half a century after the original movie, some misguided person called Gregg Rossen has taken the surreal step of directing the film, *Revenge of the Red Balloon*. It is probably fortunate that we haven't seen it yet, and therefore cannot comment without prejudice, but its tag-line reads: "The Balloon is back... And he's pissed!!! The Red Balloon returns to hunt down the bad little boys (now middle-aged Frenchmen) who popped it in the original classic film 40 years ago. Filmed in Paris."
17. In *Matter and Memory* (New York: Zone, 1991), Henri Bergson states that "[p]sychologists who have studied infancy are well aware that our representation is at first impersonal," p. 46. Earlier in the same text he claims that "[e]verything thus happens for us as though we reflected back to surfaces the light which emanates from them, the light which, had it passed on unopposed, would never have been revealed," p. 36 – an interesting reversal of humanistic projections of meaning.

18. Two relatively recent meditations on the virtual objectivity of subjects are Victoria Nelson's *The Secret Life of Puppets* (Cambridge: Harvard University Press, 2002) and Spike Jonze's *Being John Malkovich* (1999).

19. Recall that the quintessential figure in post-human, cyberpunk fiction is William Gibson's Case, from *Neuromancer* (1984).

20. Jean-Paul Sartre. "Concrete Relations with Others," in *Being and Nothingness: An Essay on Phenomenological Ontology*, trans. Hazel E. Barnes (New York: Philosophical Library, 1956), p. 104.

21. Ibid., p. 367.

22. Ibid., p. 367.

23. Ibid., p. 367.

24. Ibid., p. 368.

25. Ibid., p. 374.

26. Significantly, the gaze of a third person is enough to freeze both actants in their abject-object state (see p. 376), but unfortunately there is no room here to unpack the implications of this crucial third term.

27. The slippages of gender in this text (both in the English translation and the original French) are most entertaining, and to a certain extent, no doubt revealing on the level of Sartre's own psychology. Nevertheless, to dwell on this aspect, however tempting, would be to prioritize the psychoanalytic over the phenomenological (which, to a large degree, would be against the spirit of this essay).

28. Sartre, "Concrete Relations with Others," p. 384.

29. The same can be said from a certain Marxist perspective: "Man himself, viewed as the impersonation of labour-power, is a natural object, a thing, although a living conscious thing, and labour is the manifestation of this power residing in him" (*Capital*, vol. 1). Compare this to Marx's hypothetical table, which, transformed into a commodity, "not only stands with its feet on the ground, but, in relation to all other commodities, it stands on its head, and evolves out of its wooden brain grotesque ideas, far more wonderful than if it were to begin dancing of its own free will."

30. Sartre, "Concrete Relations with Others," p. 386.

31. Martin Heidegger. *Being and Time*, trans. Joan Stambaugh (Albany: State University of New York Press, 1996), p. 43.

32. Sartre, "Concrete Relations with Others," p. 388.

33. Heidegger, *Being and Time*, p. 68.

34. See Michael Fried's classic essay, "Art and Objecthood," now available in a collection of essays published under the same name by the University of Chicago, 1998.

35. For recent critiques of rampant materialism and the commodified object, see Jane Hamerslough's *Dematerializing* (Perseus , 2001), and J. de Graef et al., *Affluenza* (Bennett Koehler, 2002).

36. Heidegger, *Being and Time*, p. 70.

37. Heidegger, *Being and Time*, p. 78.

38. This realization – that the object of desire originates from a world distinct from the lover's – is at the heart of all narratives of jealousy and resentment. See Deleuze's *Proust and Signs,* trans. Richard Howard (Minneapolis: University of Minnesota Press, 2000): "the beloved's gestures, at the very moment they are addressed to us, still express that unknown world that excludes us," p. 8. In terms of Heidegger's elaboration of the thing, and its essential collectability, see his lecture, "What is a Thing?", trans. W.B. Barton, Jr. and Vera Deutsch (Chicago: Henry Regnery Company, 1967), and "The Thing" in *Poetry, Language, Thought*, trans. Albert Hofstadter (New York: Harper & Row, 1971).

39. Incidentally, I once saw a promotional souvenir of this artefact in a glass case at my local record store. It had a sign attached, simply stating: "Led Zeppelin 'object,' $200" – D.P.

40. See also Serres' book *Statues* (François Bourin, 1994), a discussion of the continuous transition between subject and object, and vice versa: a process Lévy describes as the "dialectic of the objectivation of interiority and the subjectivation of exteriority, which are typical of virtualization," p. 18. It may also be useful to remember that Marx begins with the premise that "the circulation of commodities is the starting point of capital," p. 106.

41. So-called "smart buildings" may thus be smarter than we think. For when considered as concrete deposits of molecular intelligence, our architecture may simply be the crystallized anthills of those insects arrogant enough to consider themselves the master of their materials. (See also the magnificent constructions of the beaver and the Papua New Guinean birds of paradise.)

42. Pierre Lévy. *Becoming Virtual: Reality in the Digital Age*, trans. Robert Bononno (New York and London: Plenum, 1998), p. 93.

43. Lévy, *Becoming Virtual*, p. 142.

44. Lévy, *Becoming Virtual*, p. 57. Lévy's focus on this "hominization" exposes him as a closet humanist, despite the cyber-rhetoric.

45. Lévy, *Becoming Virtual*, p. 160.

46. Ibid., p. 145.

47. Ibid., p. 145.

48. Ibid., p. 156.

49. Ibid., p. 165.

50. Ibid., p. 163.

51. It may also be worth noting that the street fashions of 1998-2001 for young women incorporated hi-tech fabrics and gunmetal grey colours in an attempt, we believe, to "become-laptop": specifically the desirable urban attributes of portability-mobility, design(ed) elegance, and surprising processing power.

52. Agamben, *Stanzas*, p. 50.

53. Agamben, *Stanzas*, p. 59.

54. Which was in turn performed on the "site formerly known as the Berlin Wall" in an act which simultaneously conflated the autobiographical neurosis of Roger Waters, the simplistic psychological metaphor of his concept, the revolving dollar signs of the broadcast-music industry, and the seemingly limitless capacity of political freedom to turn itself into commodified kitsch.

55. René Girard. *Deceit, Desire and the Novel*, trans. Yvonne Freccero (Baltimore and London: Johns Hopkins University Press, 1988), pp. 29-30.

56. To say nothing of the verbal form, such as "Your Honour, I object!" See Samuel Weber's *Media Mediarus: Form, Technics, Media* (Stanford: Stanford University Press, 1996), especially "The Unravelling of Form," and "Objectivity and Its Others."

57. Sartre, "Concrete Relations with Others," p. 392.

58. Ibid., p. 392.

59. Ibid., p. 392.

60. A medium which is now unfortunately "contaminated" by the supplementary "security wall" built by Ariel Sharon's government in the West Bank to protect Israel from the Palestinian *intifada*.

61. Jean Baudrillard. "Plastic Surgery for the Other," Available on the Internet. *Ctheory*. 1995. http://www.ctheory.net/text_file.asp?pick=75

Chapter 3

1. Plato. *The Republic*, in *The Essential Plato*, trans. Benjamin Jowett (New York: Quality Paperback, 1999), p. 265.
2. Ibid., p. 265.
3. Ibid., p. 266.
4. Ibid., p. 268.
5. Jacques Lacan. *The Ethics of Psychoanalysis* (New York: W.W. Norton & Company, 1997), p. 284. Lest we forget, in relation to rabbits and hats, that Lacan's last words were, "I am disappearing."
6. At one point we see the person inside the suit, and notice he has a red-eye where a bullet seems to have lodged itself. The symptomatic resemblance with myxamatosis is perhaps worth noting, given that rabbits are a "plague vector" in biospherical discourse.
7. Anticipating the vertical tornado that kills his mother and sister in a plane crash – and indeed himself, several weeks before/after – in the key time loop of the narrative.
8. Nevertheless, red herring or not, there is much to be gleaned about the narrative's "intra-textual" logic from a Freudian or Lacanian reading of the film, since *Donnie Darko* clearly articulates an overwhelming anxiety around female sexuality, whether this be distilled in the mother, the girlfriend, the sister, the prepubescents who comprise the girl-group "Sparkle Motion," the analyst, the old lady, or the "good" and "bad" teachers. Donnie and his imaginary fake-bunny are a kind of ciphered plague-vector, whose coupled trajectory through the film serves to link otherwise utterly unconnected entities in series – and, moreover, forges an disjunctive synthesis (to resort to a Deleuzean vocabulary) between two otherwise unconnected series. On the one hand, we have the female beings linked by Donnie's *passion* (he is clearly a Christ-figure); on the other, the "obscene," repressed aspects of society: trauma, child-molestation, pornography and, ultimately, the premediated state violence of the first Gulf War. Women against the State (or, as Hegel put it, woman as "the eternal irony of community"): Donnie's passage to the act proposes such a conclusion. Indeed, such a focus (prefiguring the argument of this chapter a little), is consistent with the trope-function of the rabbit: for what is "female sexuality" for Lacan, other than a decoy that is simultaneously the thing-in-itself? (See also Jim Jarmusch's *Down By Law* [1986] for Roberto Benigni's memorable monologue on the role of rabbits in his own mother's "fatal distractions.")
9. Richard Grusin, "Premediation," a lecture delivered at the University of Amsterdam, March 7, 2003.
10. A role also played by telephone booths in *The Matrix, Bill and Ted's Excellent Adventure* (1989) and the BBC's *Dr. Who*, to name only a few. Bunnies thus function as secularised angel-demons, as well as mediatic operators.
11. Thomas Elsaesser (personal communication).
12. Adam Pirani, "Bob Hoskins, Animated Investigator," *Starlog*, August 1988. Robert Zemeckis has also stated that, "the thing that makes the animation interaction work is his [Hoskins'] side of the performance. It's him *believing* that the rabbit is really there" (*Behind the Ears*). Director of animation, Richard Williams also makes the link between credence and childhood, stating that animators are "like children, in that we haven't lost our ability to observe."
13. Essentially a black circle that can be thrown against any surface to allow movement from one dimension to another, or indeed one location to another in the same dimension.
14. The method of killing seemingly indestructible Toons involves a toxic cocktail of turpentine, acetone and benzene. This mixture, known colloquially as "the dip," gestures back only three or four years in the time of the movie to Hitler's use of Zyklon B in his proposed "final solution."
15. The conflation of "cute" and "sexy" is less paradoxical in some cultures than others. For

instance, sexualizing cutesy animals is standard practice in Japan, but seen as somehow suspicious in America. Hugh Hefner's original success was largely due to his instinct regarding the taboo power of playing on this suspicion. (The Playboy financial empire has, however, recently begun to crumble, with some commentators suggesting that the upkeep of eight resident "bunnies" is eating into profits. This may further be seen as a kind of karmic revenge for his policy in the 1970s and 80s to fire bunnies who became pregnant, despite the rabbit being a pagan fertility symbol.)

16. The message thus seems to be: "Ugly but funny, you can get the girl, as long as you're a cartoon rabbit." Which suggests that there is a bestial fantasy underwriting the double game of sexuality in this film: *Who Rooted Roger Rabbit?* Cross-species love is here celebrated by its incarnation *as* animation — and it is then no surprise that the film's most evil character is the Judge, himself a human Toon (disguised for most of the story). The good of interdicted rabbit-sex (Jessica) is thereby arrayed against the dissimulating evil of the Law (the Judge).

17. Significantly, Giorgio Agamben has cited *toons* as one of the privileged inhabitants of his *Coming Community* (Minneapolis: University of Minnesota Press, 1993), which is, in some respects, the looking-glass version of Plato's *Republic* (see pp. 10-11).

18. Gibson, William. *Idoru* (London & New York: Penguin, 1997), p. 237.

19. When Eddie Valiant's girlfriend Dolores (Joanna Cassidy), catches him with Jessica Rabbit in a position of clear lustful intent, she asks if he's "dabbling in watercolours."

20. Steinbeck, John. *Of Mice and Men* (New York: Bantam, 1955), p. 46. Michel Foucault discusses a similar encounter: "One day in 1867, a farm hand from the village of Lapcourt, who was somewhat simple-minded, employed here then there, depending on the season, living hand-to-mouth from a little charity or in exchange for the worst sort of labor, sleeping in barns and stables, was turned in to the authorities. At the border of a field, he had obtained a few caresses from a little girl, just as he had done before and seen done by the village urchins round him; for, at the edge of the wood, or in the ditch by the road leading to Saint-Nicolas, they would play the familiar game called 'curdled milk.' So he was pointed out by the girl's parents to the mayor of the village, reported by the mayor to the gendarmes, led by the gendarmes to the judge, who indicted him and turned him over first to a doctor, then to two other experts who not only wrote their report but also had it published. What is the significant thing about this story? The pettiness of it all; the fact that this everyday occurrence in the life of village sexuality, these inconsequential bucolic pleasures, could become, from a certain time, the object not only of a collective intolerance but of a judicial action, a medical intervention, a careful clinical examination, and an entire theoretical elaboration" (*The History of Sexuality: An Introduction,* trans. R. Hurley, Harmondsworth: Penguin, 1987, p. 31).

21. Ibid., p. 5.

22. Ibid., p. 17.

23. Ibid., p. 18.

24. Ibid., p. 64.

25. Heidegger, Martin. "The Age of the World Picture," *The Question Concerning Technology and Other Essays,* trans. William Lovitt (New York: Harper Torchbooks, 1977), p. 147. This angle adds another dimension to the dancing objects in Disney's *Fantasia* (1940), one of the primary sites of world-picture construction, and yet also a site for the "revenge" of such objects.

26. Crooks "the Negro" puts it like this: "I seen hunderds of men come by on the road ... an' every damn one of 'em's got a little piece of land in his head. An'never a God damn one of 'em ever gets it. Just like heaven," p. 81. Of course, religion and capital both know the power of virtual promises; with the result being a strange blending of the two in postmodern times. This is why a French-Algerian suicide-bomber-in-training can be quoted on TV as saying he wants to get to Paradise as quickly as possible, since in this promised land he will drive a Mercedes Benz.

Although such statements should be taken with more than a grain of salt, it certainly provides some evidence towards Hardt & Negri's claim that today's fundamentalism is a symptom of Empire, and not a pre-modern superstition.

27. Steinbeck, *Of Mice and Men*, p. 112.

28. There is a continuity error in the painting itself, since the rabbit is clearly too small to be in ratio with the sitting Elwood p. Dowd. Although this could indeed be explained if the mystery painter was working from his or her own imagination, rather than direct visual reference (which is quite likely the case, given the rarity and exclusivity of Harvey's actual appearances).

29. In this sense the film conflates psychiatry and psychoanalysis. And while contemporary psychoanalysts would probably see the phenomena of the "imaginary friend" as a form of resistance to the rigidity of the symbolic order, psychiatrists have offered a more biological basis for these hallucinations. One theory, in fact, suggests that the flood of hormones and other chemicals in the brain can lead to more benign versions of Donnie Darko's "daylight hallucinations," since children are practically tripping on this cocktail in their bloodstream. Such a theory issues from the ongoing attempt to demystify the intangible and the non-material in scientific terms. Nevertheless, there is a strong resistance to such demystification, as seen in the films under discussion, as well as in the commonly held belief that the demise of *Sesame Street* can be dated to the exact moment when all the diegetic residents could finally *see* Big Bird's "imaginary friend" Mr. Snuffaluffagus.

30. At one point, when Dr. Sanderson thinks he's been fired for wrongful committal, he admits to the nurse: "I'm gonna miss every one of the psychos and the neuros and the schizos in the place."

31. Exactly *how* science has "overcome" time and space is not made clear.

32. The Hays Code was in effect from 1934–1968, elaborately and pedantically censoring the presentation of sexual matters for Hollywood's public.

33. This other-worldly influence probably accounts for the "superstition" of keeping a rabbit's foot for good luck.

34. There is a direct reference to its spiritual predecessor in *Who Framed Roger Rabbit?*, when a "rumpot" seems ready to betray the fact that Roger is hiding from the authorities in the back room. This man admits to seeing a rabbit, but then gestures into thin air and says, "Say hello ... Harvey." This is itself a nice piece of retrospective prolepsis, since the setting of the film is 1947, three years before the release of *Harvey*.

35. Heidegger, "The Age of the World Picture," p. 154. Compare with Lucretius' account, in which "a shadow can be nothing but air deprived of light. Actually the earth is robbed of sunlight in a definite succession of places wherever it is obstructed by us in our progression, and the part we have left is correspondingly replenished with it. That is why the successive shadows of our body seem to be the same shadow following us along steadily step by step," *On the Nature of the Universe*, trans. R.E. Latham (London: Penguin, 1994), p. 104. What Lucretius is offering here, also mentioned in the introduction, is nothing less than a model of matter and motion which deconstructs those distinctions between "animation" and "live action" – a distinction ironically affirmed as much by animators who work their entire lives to blur this distinction.

36. Adams, Richard. *Watership Down* (New York: Avon, 1972), p. 167.

37. Ibid., p. 476.

38. Ibid., p. 33.

39. Ibid., p. 15.

40. Ibid., p. 27.

41. Ibid., p. 26.

42. Ibid., p. 74.

43. Adams, *Watership Down*, p. 73. In another anticipation of chapter 6, specifically the fate of the

HSS Tampa, the epigraph to chapter 12, "The Stranger in the Field" quotes R.M. Lockley's, *The Private Life of the Rabbit*: "Nevertheless, even in a crowded warren, visitors in the form of young rabbits seeking desirable dry quarters may be tolerated … and if powerful enough they may obtain and hold a place," p. 65.

44. Ibid., pp. 81–82.
45. Ibid., p. 82.
46. Ibid., p. 122.
47. Ibid., p. 123.
48. Ibid., p. 123.
49. Wittgenstein, Ludwig. *Remarks on the Philosophy of Psychology* (Chicago: University of Chicago Press, 1980), p. 70.
50. Deleuze and Guattari remind us that "[w]e form a rhizome with our viruses, or rather our viruses cause us to form a rhizome with other animals," *A Thousand Plateaus*, trans. Brian Massumi (London: Athlone, 1988), p. 10. According to this same logic, all post-1788 Australians are in fact examples of an "introduced species," only compounding the irony underlying a culture which releases molecular viruses, like the calici-strain, in order to combat a molar "plague" of bunny rabbits themselves. Were we to have the luxury of more space to develop our argument beyond the limits of this chapter, it would be necessary to include a discussion of Phillip Noyce's 2002 film *Rabbit-Proof Fence*, for which the titular object serves as a symbolic borderline between such terms as civilization and colonization, orientation and loss, home and alienation, contagion and containment.
51. Interestingly, rabbits play a role in the species distinction used by scientists to solve crimes, including war crimes: "The Teichmann and Takayama tests, both of which rely on a reaction with haemoglobin, are confirmatory tests for blood. Human blood can be differentiated from the blood of other species by the precipitin test, which involves the reaction between blood and antihuman rabbit serum" (*Encyclopaedia Britannica*).
52. *The Age Online* reports: "British authorities have arrested a man believed to head a group of cyber attackers known as 'Fluffi Bunni', which used a stuffed pink rabbit to mark attacks that humiliated some of the world's premier computer security organisations" (April 30, 2002). Sticking for the moment to the domain of new media, we would note the use of coded decoys called "honeypots" – a kind of real-world version of William Gibson's "black ice." More precisely, honeypots are deliberate network traps whose purpose lies in being "probed, attacked, or compromised" (Lance Spitzner) in the interests of security testing.
53. Given the totemic power of bunny rabbits in regard to both visual coercion and the coming-to-presence of objects (as in, for instance, the "object of fear") it should not surprise us that the Coney Island amusement park was formerly known to Dutch settlers as "Konijn Eiland" (*Bunny Rabbit Island*). Coney Island has since been adopted in media theory as a primal scene of "modern enchantments" (Simon During) and "spectacles of attraction" (Elsaesser), as well as of American postmodernism itself (see Mark Dery's *The Pyrotechnic Insanitarium*).
54. Broadcast during the "No Comment" segment of *EuroNews* war coverage, April 4, 2003. Retrospectively relevant in this context is the decision of head *Roger Rabbit* animator Richard Williams to base the design of this character's costume on the *Stars and Stripes*. "It looked like an American flag – subliminally speaking – so everybody liked it." Presumably "everybody," in this case, refers to that rather slim percentage of the planet who are patriotic Americans or foreign fans of the US.

Chapter 4

1. Let it be noted that software brand names are increasingly becoming accepted verbs pertaining to their function(s).
2. Such pictures could be classed amongst an emerging millennial genre, namely "e-scatology." (See also Leo Bersani's influential essay, "Is the Rectum a Grave?"[*October*, 43, 1987: 197-222] for his perspective on post-Freudian excremental nihilism.)
3. Memes are concepts or ideas which transmit themselves virally, such as jokes, pop songs, or religious intolerance.
4. One of the pictures makes this overlap between business and warfare clear: "Dear Mr. Bin Laden," begins the caption. "Now that you have taken the time to get to know Boeing's fine line of commercial aircraft, we would like to get you acquainted with Boeing's other fine products" (i.e. military hardware).
5. One successful New York advertising agency, PsyOp, even goes so far as to take its name and inspiration from the CIA manual on Psychological Operations. In such a case, where ideological influence calls attention to itself, the line between complicity and critique seems to vanish.
6. Ironically enough, "Al-Qaida" (also spelt Al-Qaeda and Al-Qu'ida) translates as "the base."
7. Who exactly controls this particular form of power is unclear, but these icons usually refer to the reserves of the player (as opposed to the digital foe), in which case "bitch power" can be mobilized *against* Bin Laden. Perhaps this is a semi-conscious, although highly offensive, allusion to the oppression of women by the Taliban. However, the complete and consistent conflation of Bin Laden with the government that harbours him, in almost all these pictures, only serves to simplify the connection.
8. A *charivari* is a traditional practice whereby members of the community, displeased by unorthodox behaviour or situations (such as a wife who cannot or will not have children), gather into a mob and intimidate those who transgress the unspoken laws of a society. This practice visibly culminated in late medieval Europe, but it survives in more subtle forms all over the world whenever anyone feels pressured by a group to behave in a certain way (or refrain from behaving in a certain way). Indeed, the most recent example – one highly relevant to the present discussion, albeit in a far more benign form – was the practically instantaneous online ridicule of the French football team after their humiliating early exit from the World Cup in 2002. Digitally manipulated photos of Zidane and his teammates appeared within minutes of their last defeat, suggesting that this is just the beginning of a new form of global expression.
9. For an extensive exploration of this theme, see D. Pettman, *After the Orgy: Toward a Politics of Exhaustion* (Albany: State University of New York Press, 2002).

Chapter 5

1. M. Kundera, *The Art of the Novel*, trans. L. Asher (London: Faber and Faber, 1988), p. 125. As the Australian artist Thomas Deverall remarked to us: "When did collaboration become OK? I always thought collaborators were people you shot."
2. R. Burton, *The Anatomy of Melancholy* (New York: New York Review of Books, 2001), p. 18.
3. U. Beck, *Risk Society: Towards a New Modernity*, trans. M. Ritter (London: Sage, 1992), p. 13.
4. Z. Bauman, *Intimations of Postmodernity* (London: Routledge, 1992), p. xvii.
5. M. Castells, *The Rise of the Network Society* (Oxford: Blackwell, 1996), p. 373.
6. M. Carruthers, "*Imaginatif, Memoria*, and 'The Need for Critical Theory'," in J. Alford and J. Simpson (eds.), *The Yearbook of Langland Studies: Volume 9* (East Lansing: Colleagues Press, 1995), p. 108.

7. M. Carruthers, *The Book of Memory* (Cambridge: Cambridge University Press, 1990), p. 29.

8. W.H. Gass, "Introduction" to *The Anatomy of Melancholy*, p. viii.

9. Burton, *The Anatomy of Melancholy*, p. 22.

10. P. Lacoue-Labarthe, and J-L. Nancy, *The Literary Absolute: The Theory of Literature in German Romanticism*, trans. p. Barnard and C. Lester (Albany: SUNY Press, 1988), p. 42.

11. R. Tiedemann, "Dialectics at a Standstill: Approaches to the *Passagen-Werk*", in W. Benjamin, *The Arcades Project*, trans. H. Eiland and K. McLaughlin (Cambridge and London: The Belknap Press, 1999), p. 93.

12. See Z. Bauman, *Intimations of Postmodernity* (London: Routledge, 1992).

13. In Jessica Helfand's phrase, "what appears increasingly true is the striking degree to which information, education, and entertainment each employ a closely intertwined combination of design, technology, and psychology to engage audiences in increasingly invasive ways", *Screen: Essays on Graphic Design, New Media, and Visual Culture*. New York: Princeton Architectural Press, 2001), p. 30.

14. Bauman, *Intimations*, p. xx.

15. Significantly, it seems that several contestants realised that the best way to win (or, at least, survive in the house as long as possible) was by opting out through sleeping. Given that it is both risky and boring to spend every day interacting with the same people in the same place under the unnumbered eyes of unknown others, sleep turns out to be the only way to be there and not be there at the same time. In the context of *Big Brother*, there is almost nothing less telegenic than a sleeping body.

16. G. Deleuze, *Negotiations*, trans. M. Joughin (New York: Columbia University Press, 1995), p. 179.

17. As Slavoj Žižek remarks, "what if Big Brother was always-already there, as the (imagined) Gaze for whom I was doing things, whom I tried to impress, to seduce, even when I was alone? What if the "Big Brother' show simply makes this universal structure apparent?" *Did Somebody Say Totalitarianism? Five Interventions in the (Mis)use of a Notion* (London: Verso, 2001), p. 252.

18. H. Arendt, *The Origins of Totalitarianism* (London: Allen and Unwin, 1967), p. 287.

19. E. Santner, *My Own Private Germany: Daniel Paul Schreber's Secret History of Modernity* (Princeton: Princeton University Press, 1996), p. xii.

Chapter 6

1. Franz Kafka, "On the Tram," in *The Complete Short Stories* (London: Vintage, 1999), pp. 388-89. See also the Ratman's elaborate engagement with public transport, financial obligation, and postal vectors, in Freud, *The Wolfman and Other Cases* (London: Penguin, 2002), pp. 137-8.

2. Pierre Lévy. *Becoming Virtual: Reality in the Digital Age*, trans. Robert Bononno (New York and London: Plenum, 1998), p. 186.

3. Heidegger, *Being and Time*, p. 119.

4. Ibid.

5. Ibid.

6. Ibid., p. 120.

7. Jean-Paul Sartre. "Concrete Relations with Others," in *Being and Nothingness: An Essay on Phenomenological Ontology*, trans. Hazel E. Barnes. (New York: Philosophical Library, 1956), p. 381.

8. Sartre, "Concrete Relations with Others," p. 424.

9. The limousine with tinted windows would be the ultimate instance of such private spheres in terms of transport.

10. An anecdote from personal experience: I'm sitting next to a young woman on a crowded train. She starts complaining loudly to her gum-chewing friend sitting opposite. "I hate crowds," she says, as if, by articulating an act of sheer will, she is somehow exempt from comprising part of it. (DP)

11. Marcel Proust, *Swann's Way*, trans. C.K. Scott Moncrieff. In this "passage," Proust meditates on "that 1.22 train into which I had so often clambered in imagination, I should have wished to stop, for preference, at the most beautiful of its towns; but in vain did I compare and contrast them – how to choose, any more than between individual persons who are not interchangeable ..."

12. Sartre, "Concrete Relations with Others," p. 424.

13. Peter Sloterdijk's series of books on the subject of spheres contains a wealth of insights on the iconography of globes as not only often objects of movement (as with the Earth itself), but as symbolic systems protecting against otherness (as with the Star Wars missile defence programme).

14. Niklas Luhmann. *Love as Passion: The Codification of Intimacy*, trans. Jeremy Gaines and Doris L. Jones (Stanford: Stanford University Press, 1998), p. 35.

15. Martin Heidegger. "The Principal of Identity," Identity and Difference, trans. Joan Stambaugh (Chicago: University of Chicago Press, 2002), p. 33.

16. When a book, film or piece of music affects us, we say it was "moving." (Music and plays, of course, are composed in, and of, *movements*.) Heidegger also tells us that an absence of reflection can create the necessary (meta)physical vacuum to push things "forward" ("Age of the World Picture," p. 137). And yet there is a counter-tendency to stay put, to quarantine oneself and one's environment from movement, or the influence of kinetic objects and forces. For every campervan and houseboat, there are thousands of anchored apartment blocks and houses. (On this tension, see Terry Gilliam's short film, The *Crimson Permanent Assurance* (1983), about office buildings that insist on tearing themselves from the moorings of immobility, in order to "sail the wide account-sea.")

17. Heidegger, "The Age of the World Picture," p. 120.

18. Heidegger, "The Age of the World Picture," p. 125. It would be a mistake to read this species division as a romantic elegy for the latter, since the scholar is but a representative of "the increasingly thin and empty Romanticism of scholarship." To what degree Heidegger is employing an ironic instance of the indirect free mode (that is, ventriloquizing "the research man") – especially when claiming that "the university will still be able to persist for some time in a few places" – is open to question. (See p. 125, and also p. 139).

19. Ibid., p. 127.

20. Ibid., p. 130.

21. Ibid., p. 132.

22. Ibid., p. 128.

23. James Joyce. *Ulysses: The Corrected Text* (Harmondsworth: Penguin, 1986), pp. 80-81.

24. Also published in some editions as *Tiger, Tiger*.

25. Alfred Bester. *The Stars My Destination* (London: Gollancz, 1988), p. 11.

26. One limitation of jaunting, other than the issue of distance, is familiarity with the destination, and the ability to visualize the body's passage there: hence the utilization of these labyrinths as pre-emptive distraction for would-be jaunters. Just as important, however, is familiarity with the place of departure, since the jaunte is a form of psycho-kinetically connecting the dots. (Which is why twenty-fifth century prisons are underground and unlit, so prisoners have no capacity to visualize how to link point A with a desired point B. The only option for desperate prisoners is thus to "blue jaunte" into the nowhere land of oblivion.)

27. Bester, *The Stars My Destination*, p. 13.

28. Ibid., p. 12.

29. The contrast and conflation of old and new technologies is performed by the novel itself – since art, literature, cinema, television, the mass-media, imagination, and memory are all overlapping methods of "jaunting" to places in which we are not currently, physically present. In this premediatory sense, a book can be as cutting-edge as a special-effects blockbuster, or indeed a time machine.

30. Bester, *The Stars My Destination*, p. 153.

31. Concerning the connection between the Tiananmen Square demonstrators in 1989, Lawrence Grossberg states, "there is no common identity, no property that defines them apart from the fact that they were there, together, in that place. It was the fact of belonging that constituted their belonging together. Such a singularity operates as a '*transport machine*' following a logic of involvement, a logic of the next (rather than of the proper). It refuses to take any instance as a synecdochal image of the whole," p. 104 (our emphasis). See "Identity and Cultural Studies: Is That All There Is?" in *Questions of Cultural Identity*, Stuart Hall and Paul du Gay, (eds.) (London: Sage, 1996), pp. 87-107.

32. While in many ways being the emblem of the Everyman, Foyle is also clearly an exceptional case. The novel thus plays on the tension identified by both Heidegger and Sartre between the "singular-plural" dynamic of the subject in relation to both themselves, and to society conceived of as a whole. Foyle's exceptionalism is manifest in his unique ability to "space-jaunt" enormous distances across the galaxy. The ontological attempt to orient the "self" – incalculable by any modern Global Positioning System – is explicitly thematized in the psychedelic, multimedia end sequence (which may or may not have had an influence on Kubrick's climax to *2001: a Space Odyssey*): "He did not jaunte to Elsewhere, but to Elsewhen. But most important, the fourth dimensional awareness, the complete picture of the Arrow of Time and his position on it which is born in every man but deeply submerged by the trivia of living, was in Foyle close to the surface. He jaunted along the space-time geodesics to Elsewheres and Elsewhens, translating " i," the square root of minus one, from an imaginary number into reality by a magnificent act of imagination," pp. 235-36. (For an interesting short piece on the differences between author's intention and typographer's action in the climax of the book, see "The Editor My Destination," available online at: http://www.ansible.demon.co.uk/writing/bester.html).

33. Bester, *The Stars My Destination*, p. 193.

34. As Bourdieu puts it: "The object which 'insists on being enjoyed', as an image and in reality, in flesh and blood, neutralizes both ethical resistance and aesthetic neutralization; it annihilates the distanciating power of representation, the essentially human power of suspending immediate, animal attachment to the sensible and refusing submission to the affect, to simple *aistheisis*. In the face of this twofold challenge to human freedom and to culture (the antinature), disgust is the ambivalent experience of the horrible seduction of the disgusting and of enjoyment, which performs a sort of reduction to animality, corporeality, the belly and sex, that is, to what is common and therefore vulgar, removing any difference between those who resist with all their might and those who wallow in pleasure, who enjoy enjoyment." *Distinction: A Social Critique of the Judgement of Taste*, trans. R. Nice (London: Routledge & Kegan Paul, 1986), p. 489. See also J. Kristeva, *Powers of Horror: An Essay in Abjection*, trans. L.S. Roudiez (New York: Columbia University Press, 1982).

35. Slavoj Žižek, "Against the Double Blackmail," *The Nation*, vol. 268, no. 19, 25 May 2000.

36. Cited in J. Bernstein, *The Fate of Art: Aesthetic Alienation from Kant to Derrida and Adorno* (Cambridge: Polity, 1993), p. 181.

37. Jacques Derrida, "History of the Lie," in R. Rand (ed.), *Futures of Jacques Derrida* (Stanford: Stanford University Press, 2001), p. 73. Unsurprisingly, Derrida asks whether the "word and concept of 'lie'" remain "appropriate" in our own era.

38. Less publicized Australian attempts to block refugees from entering the country are vividly documented in *Le Dernier Caravansérail*, a multimedia play by Théâtre du Soleil, that was playing in Paris as we were writing this (April 2003). Without a trace of mercy, a very authentic sounding Australian coast-guard yells threats and instructions through a megaphone; not unlike the experience of arriving at Sydney airport.

39. An excellent recent book on the subject is Peter Mares, *Borderline: Australia's Treatment of Refugees and Asylum Seekers* (Sydney: UNSW Press, 2001).

40. Tuvalu has the unfortunate distinction of being the first populated island to sink below sea-level due to global warming, projected within fifty years. Considering this fact, Australia's intention to move refugees there is more than a little short-sighted. To add insult to injury, Australia has repeatedly rejected requests for the inhabitants of Tuvalu to relocate to there when this disaster takes place; and yet these same officials see no shame in trying to bully Tuvalu in to taking refugees. In response, Tuvalu's Prime Minister, Koloa Talake, is taking Australia and the United States to court for compensation, since these countries felt no pressure to sign the Kyoto Protocol pledging to reduce greenhouse gases.

41. We rely here on the extraordinary book about the Tampa affair by David Marr and Marian Wilkinson, *Dark Victory* (Sydney: Allen & Unwin, 2003), which provides an unprecedented wealth of detail – most of it horrifying. Many of the details Marr and Wilkinson have uncovered have remained to the present wreathed in indirection and secrecy; the summary we offer here necessarily misses most of these.

42. Ibid., p. 25.

43. Ibid., p. 119.

44. Montaigne, "On Cannibals," in *Essays*, trans J.M. Cohen (London: Penguin, 1970), p. 108.

45. Heidegger, "The Age of the World Picture," p. 142.

46. The socio-cultural obsession with administration – what Deleuze dubs "the control society" – finds an epistemological ally in the science of cybernetics, which considers the world largely in terms of information transmission, reception, signal and noise. Significantly here, the Greek root of cybernetics, *kubernetes*, means governor or steersman: a term which also links Heidegger's project with the case of the *Tampa*.

47. Heidegger, "The Age of the World Picture," p. 150.

48. Ibid., p. 151.

49. Ibid., p. 154.

50. The nickname of Australian cricketer Shane Warne, who is more famous for his sporting skills than his academic intellect.

Chapter 7

1. Massimo Cacciari, *The Necessary Angel* (Albany: SUNY Press, 1994), p. 1.

2. R.C. Scharff & V. Dusek (eds.), *From Philosophy of Technology: The Technological Condition*. Oxford Blackwells, 2003, p. 62.

3. Jet Tone Productions. The Cantonese title is *Duoluo Tianshi*.

4. Ackbar Abbas, *Hong Kong: Culture and the Politics of Disappearance* (Minneapolis: University of Minnesota Press, 1997), p. 4.

5. Abbas hedges his bets somewhat by defining this culture of disappearance as "a kind of pathology of presence," p. 8.

6. Abbas, *Hong Kong*, p. 145.

7. Ibid., p. 36.

8. See Abbas, *Hong Kong*, p. 14. Much of the credit for Wong's sublime and subliminal aesthetic

should be shared by his Australian cinematographer, Christopher Doyle. The significance of this artistic link between Sydney and Hong Kong should become clearer below, as we trace the flows between these different hemispheres.

9. Cacciari, *Necessary Angel*, p. 1.
10. Ibid., pp. 33, 13.
11. Ibid., pp. 9, 11.
12. Ibid., p. 24.
13. Ibid., p. 3.
14. Michel de Certeau, *The Practice of Everyday Life* (Berkeley: University of California Press, 1988), p. 115.
15. Ibid., p. xx.
16. Ibid., p. 103.
17. Ibid., p. 107.
18. The popularity of the Hong Kong horror film – along with its cinematic sibling, the martial art flick – cleared the way for the Western mainstream embrace of directors such as Michael Mok and Ngai Kai Lam. Initially only finding a "cult" audience in America, Europe and Australia, Hong Kong horror earned the dubious attention of Hollywood after the art house success of both the *Chinese Ghost Story* and *Sex and Zen* series.
19. Fyodor Dostoyevsky, *Crime and Punishment* (New York: Vintage, 1998), p. 289.
20. Woody Allen, *Deconstructing Harry*, Jean Doumanian Productions, 1997.
21. This representation of the Australian suburbs is in sharp contrast to a movie like Rolf de Heer's *Bad Boy Bubby* (1993), which opts for an almost post-apocalyptic *grand guignol*.
22. De Certeau, *Everyday Life*, p. 108.
23. The younger brothers of the Chan family also meet an amiable Chinese version of Dr. Frankenstein in Sydney, who jokingly suggests that he can transplant bones into their bodies in order to make them taller.
24. De Certeau, *Everyday Life*, p. 105.
25. Abbas, *Hong Kong*, p. 10.
26. This sentence becomes even more significant when we remember that *aerial* was a messenger spirit of the air, and consequently a kind of pagan angel. The blurring between roots and aerials is also encouraged by the Australian Collins Dictionary when it refers to the "aerial roots of a plant."
27. David Stratton's introduction to the screening of *Floating Life* on SBS.
28. Rainer Maria Rilke, *The Duino Elegies*, trans. Leslie Norris and Alan Keele (Columbia: Camden House, 1993), p. 21. See also Rilke's poem *Orchards*.
29. Alfred Hitchcock, *The Birds*, Universal, 1963.
30. Abbas, *Hong Kong*, p. 4.
31. In fundamental, symptomatic ways the antipodean equivalent of Jean-Marie Le Pen's National Front party in France (although the differences are as marked as the similarities, in this case).
32. The reference is to Senator Tim Fischer's relaunch of the National Party, which was specifically designed to win back the "disenchanted" defection of rural Australian voters to One Nation. (Reported on ABC News, April 17, 1999.)
33. Ken Gelder and Jane Jacobs, *Uncanny Australia: Sacredness and Identity in a Postcolonial Nation* (Melbourne: University of Melbourne Press, 1998), p. 47.
34. Ibid., p. 46.
35. Ibid., p. xvi.
36. Ibid., p. 138.
37. Norman O. Brown, *Love's Body* (Berkeley: University of California Press, 1990), p. 247.
38. Homi K. Bhaba, *The Location of Culture* (New York and London: Routledge, 1994), p. 9.

39. Giorgio Agamben, *The Coming Community*, trans. Michael Hardt (Minneapolis: University of Minnesota Press, 1993), pp. 17-8. The second sentence is italicized in the original citation.
40. Bhabha, *Location of Culture*, p. 9.
41. Ibid., p. 11.
42. Ibid., p. 12.
43. This is not to privilege some kind of nostalgic stability, but rather to plea for the recognition of the link between sacrality, power and bare life. (Giorgo Agamben's book, *Homo Sacer: Sovereign Power and Bare Life* [Stanford: Stanford University Press, 1998] is particularly crucial here.) If colonialism was/is a vampire, then post-colonialism (in its globalist form) is a relentless terminating cyborg.
44. Abbas, *Hong Kong*, p. 142.
45. Ibid., p. 62.
46. This quote is taken from a story aired on ABC Television News, February 1999.
47. Don DeLillo, *Underworld* (London: Picador, 1999), p. 816.

Chapter 8

1. M. Reynolds, *Sunday Special* (Paris: Optimystic Research, 2002), p. 42.
2. Aegidius Romanus, *De Regimine Principum* (1277-9), cited in J. Bartelson, *A Genealogy of Sovereignty* (Cambridge: Cambridge University Press, 1995), p. 93.
3. B. Johnson, *The Critical Difference* (Baltimore: Johns Hopkins, 1980), p. 60.
4. See G. Spivak, *A Critique of Postcolonial Reason: Towards a History of the Vanishing Present* (Cambridge & London: Harvard University Press, 1999), esp. pp. 26-30.
5. S. Castles et al., *Mistaken Identity: Multiculturalism and the Demise of Nationalism in Australia* (Sydney: Pluto Press, 1988), p. 1.
6. "One concept that escapes the antinomy of the universal and the particular has long been familiar to us: the example. In any context where it exerts its force, the example is characterized by the fact that it holds for all cases of the same type, and, at the same time, it is included among these. It is one singularity among others, which, however, stands for each of them and serves for all....Neither particular nor universal, the example is a singular object that presents itself as such, that *shows* its singularity," G. Agamben, *The Coming Community*, p. 9. For alternative understandings of "the example," see J. Derrida, *The Other Heading*, trans P.-A. Brault and M. Naas (Bloomington: Indiana University Press, 1992), esp. pp. 71-2; I. Harvey, "Structures of Exemplarity in Poe, Freud, Lacan, and Derrida" in J.P. Muller and William J. Richardson (eds.), *The Purloined Poe: Lacan, Derrida & Psychoanalytic Reading* (Baltimore: Johns Hopkins University Press, 1988), pp. 252-267.
7. For an interesting historical account of some of the vagaries of landscape imaging in Australia, see L. Duggan, *Ghost Nation: Imagined Space and Australian Visual Culture 1901-1939* (St. Lucia: UQP, 2001).
8. See R. Hughes, *The Fatal Shore: A History of the Transportation of Convicts to Australia, 1787-1868* (London: Collins Harvill, 1987).
9. The classic reference here is A.A. Phillips's essay on "the cultural cringe." Some — alluding to the North American model — have characterized Australian cultural attitudes as tantamount to a "Declaration of Dependence." See J. Clemens and D. McCooey, "Local and/or General: Australia, Theory," *Salt* vol. 15 (2002), pp. 132-144.
10. J. Brett, *Robert Menzies' Forgotten People* (Sydney: Pan Macmillan, 1992), p. 273.
11. By far the best historical account to date is David Walker's superb *Anxious Nation: Australia and the Rise of Asia 1850-1939* (St Lucia: University of Queensland Press, 1999). Walker per-

suasively argues that the "powerful masculinising and racialising impulse in Australian nationalism would have been a good deal less intense, had it not been for the geo-political threat attributed to awakening Asia from the 1880s," p. 5.

12. V. Buckley, *Cutting Green Hay: Friendships, movements and cultural conflicts in Australia's great decades* (Ringwood: Penguin, 1983), p. 9.

13. See p. Carter, *Living in a New Country: History, travelling and language* (London: Faber and Faber, 1992), esp. Chapter 1. As Simon During comments of 1950s and 1960s Australian existentialism (in the form of A.A. Phillips and H. Heseltine), "Today, from a postcolonial point of view, they are most usefully analysed as a recodifying of old ideas of Australian 'emptiness,' which were signs both of nostalgia for Europe and of a disavowed white guilt over the invasion of the land," *Patrick White* (Melbourne: Oxford University Press, 1996), p. 18.

14. See T. Griffiths, "Past Silences: Aborigines and convicts in our history-making," in P. Russell and R. White (eds.), *Pastiche I: Reflections on Nineteenth Century Australia* (St. Leonards: Allen & Unwin, 1994), pp. 7-23.

15. See J. Jacobs and K. Gelder, *Uncanny Australia: Sacredness and Identity in a Postcolonial Nation* (Melbourne: Melbourne University Press, 1998).

16. See H.P. Heseltine, "The Literary Heritage," in J. Lee *et al.* (eds.), *The Temperament of Generations: Fifty years of writing in Meanjin* (Melbourne: Meanjin/Melbourne University Press, 1990 [first published in *Meanjin* 1, 1962]), pp. 154-166. A very interesting account of the "work of the negative" in Australian verse is P. Kane, *Australian Poetry: Romanticism and Negativity* (Cambridge: CUP, 1996).

17. We are confronted here by all the familiar bio-technologies of colonialism (outright massacres, rape, poisoned goods, setting tribal groups at odds with each other, the setting-up of native police troupes), as well as to such ambitious state schemes as "breeding out" the Aboriginal race: hence the ongoing scandal of the so-called "Stolen Generation." See, for instance, J.M. Jacobs, *Edge of Empire: Postcolonialism and the City* (London: Routledge, 1996) and "Resisting Reconciliation: the secret geographies of (post)colonial Australia," in S. Pile and M. Keith (eds.), *Geographies of Resistance* (London: Routledge, 1997); H. Reynolds, *Frontier: Aborigines, Settlers and Land* (St Leonards: Allen and Unwin, 1987), *The Law of the Land*, 2nd ed. (Harmondsworth: Penguin, 1992) and *The Other Side of the Frontier: An interpretation of the Aboriginal response to the invasion and settlement of Australia* (Townsville: James Cook University, 1981); P. Wolfe, "The Limits of Native Title," *Meanjin* 3 (2000), pp. 129-144, and *Settler Colonialism and the Transformation of Anthropology: The Politics and Poetics of an Ethnographic Event* (London: Cassell, 1999).

18. Reynolds, *The Law of the Land*, pp. 26-7. It has been proven that certain indigenous tribes did indeed engage in a variety of agricultural practices — including burning-back forested areas, and so on.

19. A recent version of the empancipatory potential of Romantic images of place has been propounded by Geoffrey Hartman, in *The Fateful Question of Culture* (New York: Columbia University Press, 1997). Hartman's logic, relatively plausible in the context of modern European politics, cannot easily be applied to the Australian situation, for reasons that we are about to suggest.

20. Commonwealth of Australia, *Mabo: The High Court Decision on Native Title Discussion Paper* (Canberra: Commonwealth of Australia, 1993), p. 1.

21. For good introductory accounts of the (often devilishly complex) legal and ethical niceties, see M. Bachelard, *The Great Land Grab*, forewords by P. Dodson, Cheryl Kernot and Jack Waterford (Melbourne: Hyland House, 1997); T. Rowse, *After Mabo: Interpreting indigenous traditions* (Melbourne: Melbourne University Press, 1993). As it turns out, only a very restricted set of indigenous peoples are able to make claims under the legislation — the reference to "valid acts

of Imperial, Colonial, State, Territory or Commonwealth Governments" certainly insinuates this.

22. T. Adorno, *Minima Moralia: Reflections from Damaged Life*, trans. E.F.N. Jephcott (London: Verso, 1997), p. 79. The last vestiges of the White Australia policy were only abolished by the Whitlam government in 1973.

23. Castles, *Mistaken Identity*, p. 9.

24. For a very substantial investigative account of recent refugee policy, see P. Mares, *Borderline: Australia's treatment of refugees and asylum seekers* (Sydney: UNSW Press, 2001).

25. Despite the vicious rumours fomented and promulgated by the Liberal government about the "fake" claims of the Tampa refugees, the latter have all finally been "processed" — and proven to have had genuine claims to asylum-seeker status. A recent psychoanalytically inspired argument by Tamas Pataki suggests that the extraordinary hatred of *sea-borne* immigrants to Australia is founded on an unconscious *identification*. Indeed, any number of commentators have pointed out that nobody seems particularly upset by the massive numbers of people — at any given moment, in the tens of thousands! — who fly into the country and overstay their visas. Since Australia was founded as a penal colony, the criminal refuse of Britain was originally *shipped over*, and hence Pataki argues that the real horror inspired by the new boat-people derives from the unconscious equation *Refugees = Us*. T. Pataki, "Racist Objects," Unpublished seminar paper, delivered at the Deakin Masters Seminars in Psychoanalysis, Melbourne (2002).

26. See, for instance, the otherwise very different projects of P. Carter, *The Lie of the Land* (London: Faber and Faber, 1996); I. Clendinnen, *True Stories: The Boyer Lectures 1999* (Sydney: ABC, 1999); G. Hage, *White Nation: Fantasies of white supremacy in a multicultural society* (Sydney: Pluto Press, 1998); M. Kalantzis and B. Cope, *A Place in the Sun* (Pymble: Harper Collins, 2000); R. Manne, "In Denial: The Stolen Generations and the Right," *The Australian Quarterly Essay*, no. 1 (2001); H. McQueen, *Temper Democratic: How Exceptional is Australia?* (Kent Town: Wakefield Press, 1998); H. Reynolds, *Why weren't we told? A Personal Search for the Truth about our History* (Melbourne: Penguin, 1999); J. Rutherford, *The Gauche Intruder: Freud, Lacan and the White Australian Fantasy* (Melbourne: Melbourne University Press, 2000); J. Stratton, *Race Daze: Australian in identity crisis* (Sydney: Pluto Press, 1998).

27. See D. Bennett, *Multicultural States: Rethinking Difference and Identity* (London: Routledge, 1998); G. Stokes (ed.), *The Politics of Identity in Australia* (Cambridge: Cambridge University Press, 1997); *Law/Text/Culture: In the Wake of Terra Nullius*, vol. 4, no. 1 (1998); J. McDonell and M. Deves (eds.), *Land and Identity: Proceedings of the 1997 Conference* (ASAL, 1998).

28. This claim attempts to provide a more general account of the logics underpinning such facts as the following: "Under John Howard, Australia saw the most prolonged campaign ever mounted by a government against the judiciary — mostly over decisions involving race: native title and refugees," D. Marr and M. Wilkinson, *Dark Victory* (Sydney: Allen & Unwin, 2003), p. 32.

29. J. Camilleri and J. Falk, *The End of Sovereignty? The Politics of a Shrinking and Fragmenting World* (Aldershot: Edward Elgar Publishing, 1992), pp. 1-2.

30. Chapter I, Article 2.1 of the UN charter states "The Organization is based on the principle of the sovereign equality of all its Members"; Chapter I, Article 2.7 states "Nothing contained in the present Charter shall authorize the United Nations to intervene in matters which are essentially within the domestic jurisdiction of any state or shall require the Members to submit such matters to settlement under the present Charter; but this principle shall not prejudice the application of enforcement measures under Chapter VII," etc.

31. Z. Bauman, *Globalization: The Human Consequences* (Cambridge: Polity Press, 1999), p. 65.

32. M. Foucault, *The History of Sexuality: An Introduction*, trans. R. Hurley, (Harmondsworth: Penguin, 1987), p. 137.

33. C. Joppke, "Immigration Challenges the Nation-State," in C. Joppke (ed.), *Challenge to the Nation-State: Immigration in Western Europe and the United States* (Oxford: Oxford University Press, 1998), p. 18. He immediately goes on: "The legal system, not civil society is the key protective institution for immigrants. The legal system is also the true domain of self-limited sovereignty," p. 18. Joppke and other contributors to the volume speak at length about a number of ways in which sovereignty is currently being reconceived. See also such anthologies as G.M. Lyons and M. Mastanduno (eds.), *Beyond Westphalia? State Sovereignty and International Intervention* (Baltimore: The Johns Hopkins University Press, 1995), and A.J. Paolini et al. (eds.), *Between Sovereignty and Global Governance: The United Nations, the State and Civil Society* (Houndsmills: Macmillan, 1998).

34. This claim would be contested by Jean-Luc Nancy who argues that, "So-called international law, where this 'inter', this 'between', causes all the problems, is only graspable as that common space devoid of law, devoid of every sort of 'setting in common' (without which there is no law), and is structured *by* the techno-economic network and the supervision of Sovereigns," J.-L. Nancy, *Being Singular Plural*, trans. R.D. Richardson and A.E. O'Byrne (Stanford: Stanford University Press, 2000), p. 105.

35. C. Schmitt, *The Concept of the Political*, trans., intro. and notes G. Schwab, comments by Leo Strauss (New Brunswick: Rutgers University Press, 1976), p. 28.

36. Schmitt, *The Concept of the Political*, p. 38.

37. Schmitt, *The Concept of the Political*, p. 46. This statement shows just how far Schmitt is from Hobbes. Leo Strauss, in a superb article entitled "Comments on Carl Schmitt's *Der Begriff des Politischen*," now republished with the English translation of *The Concept of the Political*, would dispute such an attribution: "the political, which Schmitt brings out as fundamental, is the 'state of nature' prior to all culture; Schmitt restores Hobbes's conception of the state of nature to a place of honor," pp. 87–88. Nonetheless, Strauss recognises that Schmitt "defines the state of nature differently from Hobbes," p. 88. If, for Hobbes, the sovereign can compel obedience up to the point of death but not beyond (for Hobbes, life-death are the matter of pure, indiscriminable nature), for Schmitt "sovereignty" precisely means: symbolic identity *qua* politics overrides animal death. One truly lives, is individuated as an effective political being, only insofar as one is a potential sacrificial victim; i.e., a creature of the sovereign.

38. The case of John Locke is of interest in such a context. If Locke, in the wake of Hobbes, is often understood as attempting to mitigate the extremities of the Hobbesian philosophy in its consequences for individual liberty under law, one can actually see just how much more vicious Lockean liberalism can potentially be compared to its nominally illiberal predecessor. Book II opens with the declaration: "Political power, then, I take to be right of making laws, with penalties of death, and consequently all less penalties for the regulating and preserving of property, and of employing the force of the community in the execution of such laws, and in the defence of the commonwealth from foreign injury, and all this only for the public good," Chapter I. 3, *Two Treatises of Government* (London: Everyman's Library, 1986), p. 118. Fair enough — but the good liberal runs into certain difficulties on the extent of the state's executive and legislative powers: "the preservation of the army, and in it of the whole commonwealth, requires an absolute obedience to the command of every superior officer, and it is justly death to disobey or dispute the most dangerous or unreasonable of them; but yet we see that neither the sergeant that could command a soldier to march up to the mouth of a cannon, or stand in a breach where he is almost sure to perish, can command that soldier to give him one penny of his money," pp. 188–9. In other words, representatives of the liberal state can legally kill you (i.e., *sacrifice* you), but not go through your pockets — after all, this is where an *individual's* identity truly resides. Death is a public affair for liberal states, whereas economics is private; indeed, more primordial and private than sex and sexuality, which can simply be referred to a "merely animalistic" realm of pre-political, "natural" life.

39. This problem of "the end of history" — a central theologico-political problem whose avatars continue to determine so much thought today (from J.-F. Lyotard's definition of postmodernity as an "incredulity towards metanarratives" to F. Fukuyama's liberal utopianism to J. Derrida's interest in "messianism without messiah") — was also a central *topos* for humanities intellectuals of the early-mid 20th century. The other indispensable references here would be A. Kojève's extraordinarily influential Paris seminars on Hegel (attended by Bataille, Queneau, Sartre, Lacan, among others), and M. Heidegger's work on the "end of metaphysics," culminating in his extraordinary Nietzsche seminars of the 1940s.

40. See J. Derrida, *The politics of Friendship*, trans. G. Collins (London & New York: Verso, 1997); G.C. Spivak, "Schmitt and Poststructuralism: A Response," *Cardozo Law Review*, vol. 21 (2000), pp. 1723-1737.

41. Schmitt, *The Concept of the Political*, p. 55.

42. Moreover, as Catherine Pickstock argues, "Aquinas' natural law, beyond the minimum we share with animals (self-preservation, care of the young and so forth) concerns the prudential judgment of equity and not the reading-off of norms from a pre-given nature," *Antonianum* LXXVI-II (2003), p. 24. See also A. Macintyre, *Three Rival Versions of Moral Enquiry* (London: Duckworth, 1990).

43. Critics have also argued that Schmitt remains fundamentally Catholic — indeed, a veritable Knight of God!

44. On the relationship between Schmitt and Benjamin, see G. Agamben, *L'état de l'exception*, trans. J. Gayraud (Paris: Seuil, 2003).

45. W. Benjamin, "Critique of Violence," in *Reflections: Essays, Aphorisms, Autobiographical Writings*, ed. p. Demetz (New York: Schocken, 1986), p. 277.

46. Benjamin, "Critique of Violence," p. 288.

47. As Benjamin wittily puts it in his article on Karl Kraus, "the secret of authority: never to disappoint. Authority has no other end than this: it dies or it disappoints. It is not in the least undermined by what others must avoid: its own despotism, injustice, inconsistency...The characteristic of such unlimited authority has for all time been the union of legislative and executive power," *Reflections*, p. 248.

48. Benjamin, "Critique of Violence," p. 297. In an astonishing essay on the *Iliad*, which unearths a number of fundamental propositions relevant to modern politics, Simone Weil comments that the poem is, above all, "a poem of force," which explores "the ability to turn a human being into a thing while he is still alive," *The Iliad, or The Poem of Force* (Pennsylvania: Pendle Hill, 1973), p. 4.

49. From a different perspective, Jacques Derrida has pointed out the difficulty for Benjamin in sustaining the mythical/divine violence distinction, to the point of suggesting that, indeed, the Nazi "Final Solution" itself appears to have all the characteristics of the very divine violence that Benjamin praises. See J. Derrida, "*Force de Loi: Le 'Fondement Mystique de L'Autorité*,'" in *Cardozo Law Review*, vol. 11, nos. 5-6 (July/August 1990), 919-1045. Agamben, for his part, has described Derrida's position here as subject to a "peculiar misunderstanding."

50. J. Derrida and J.-L. Nancy, "Eating Well," in E. Cadava *et al.* (eds.), *Who Comes After the Subject?* (New York: Routledge, 1991), p. 112.

51. In a related context, see M. Taussig, "*Maleficium*: State Fetishism," in E. Apter and W. Pietz (eds.), *Fetishism as Cultural Discourse* (Ithaca: Cornell University Press, 1993), pp. 217-247. As Taussig writes, in what he intends as "a decisive critique," what is missing from such accounts of instrumental state violence as Max Weber's are "the intrinsically mysterious, mystifying, convoluting, plain scary, mythical, and arcane cultural properties and power of violence to the point where violence is very much an end in itself," p. 223. And see also J.-L. Nancy, "The Unsacrificeable," in *Yale French Studies*, no. 79 (1991), pp. 30-38, in which he argues that the

West's relationship to sacrifice is "decisive and foundational," hinging on a "mimetic rupture" with what is thereby figured as "older" forms of sacrifice. This mimetic rupture, as exemplified by Socrates and Christ, has four essential characteristics: it is 1) self-sacrifice; 2) a unique and universal sacrifice; 3) the truth of sacrifice in general; 4) the infinite sublation of sacrifice itself. Agamben adds that, "It is not because life and death are the most sacred things that sacrifice contains killing; on the contrary, life and death became the most sacred things because sacrifices contained killing. (In this sense, nothing explains the difference between antiquity and the modern world better than the fact that for the first, the destruction of human life was sacred, whereas for the second what is sacred is life itself)," *Potentialities: Collected Essays in Philosophy*, ed. and trans. with intro. D. Heller-Roazen (Stanford: Stanford University Press, 1999), p. 136.

52. Benjamin, "Critique of Violence," p. 286.
53. As Žižek puts it, "The sacrificial gesture does not simply aim at some profitable exchange with the Other to whom we sacrifice: its more basic aim is, rather, to ascertain that there is some Other out there who is able to reply (or not) to our sacrificial entreaties," *Did Somebody Say Totalitarianism?* (London: Verso, 2001), p. 65. See also his essay "The Thing from Inner Space," in R. Salecl (ed.), *Sexuation* (Durham and London: Duke University Press, 2000), pp. 216-259. Žižek's tripartite distinction, by the way, no doubt alludes to – as it displaces – Aquinas's three *functions* (remission of sins, the preservation of grace, and acquisition of glory) and three *modes* of sacrifice (martyrdom, austerity, works of justice and worship).
54. A. Destexhe, "The Shortcomings of the 'New Humanitarianism," in *Between Sovereignty and Global Governance*, p. 87. As R.K. Betts comments in his review of Wesley Clark's memoir *Waging Modern War: Bosnia, Kosovo and the Future of Combat*, "One of the most striking features of the Kosovo campaign, in fact, was the remarkably direct role lawyers played in managing combat operations – to a degree unprecedented in previous wars....The role played by lawyers in this war should also be sobering – indeed alarming – for devotees of power politics who denigrate the impact of law on international conflict," "The compromised commander," *The Australian Financial Review*, Friday 17 August 2001, p. 4.
55. In addition to the text already cited, see also Žižek's, *For they know not what they do: Enjoyment as a political factor* (London: Verso, 1991), and *The Ticklish Subject: The Absent Centre of Political Ontology* (London: Verso, 1999). For a solid and relatively accessible account of the philosophical issues surrounding the Kantian ethical act, see A. Zupančič, *Ethics of the Real: Kant, Lacan* (London: Verso, 2000).
56. M. Serres, *Angels: A Modern Myth*, trans. F. Cowper (Paris: Flammarion, 1995), p. 183.
57. Serres, *Angels*, p. 197.
58. The term is Karl Löwith's; see *Martin Heidegger and European Nihilism*, ed. R. Wolin, trans. G. Steiner (New York: Columbia University Press, 1995). It is immediately opposed to Brecht and Benjamin's famous and influential dictum that Fascism was the intrusion of aesthetics into the political realm. See, for example, Benjamin's essay "The Work of Art in the Age of Mechanical Reproduction," in *Illuminations*, trans. H. Zohn (London: Fontana, 1992). Hannah Arendt's work is also an indispensable reference here. And somewhere behind all these stands Martin Heidegger, colleague of Schmitt, Nazi collaborator – and perhaps also the greatest philosopher of the twentieth century.
59. G. Agamben, *Homo Sacer: Sovereign Power and Bare Life*, trans. D. Hellier-Roazen (Stanford: Stanford University Press, 1998), p. 8.
60. See J. Derrida, *Dissemination*, trans. B. Johnson (Chicago: University of Chicago Press, 1981).
61. Agamben also investigates the complexities of exemplarity, which "escapes the antinomy between universal and particular," elsewhere. See, for instance, G. Agamben, *The Coming Community*, trans. M. Hardt (Minneapolis: University of Minnesota Press, 1993), esp. pp. 9-10.

62. With respect to this mythologeme, it continues to recur in all sorts of contexts. See, for example, Ken Gelder and Jane M. Jacobs, *Uncanny Australia: Sacredness and Identity in a Postcolonial Nation* (Melbourne: Melbourne University Press, 1998).

63. As Agamben says in another context, "*Sacred* here can only mean what the term meant in Roman law: *Sacer* was the one who had been excluded from the human world and who, even though she or he could not be sacrificed, could be killed without committing homicide (*'neque fas est eum immolari, sed qui occidit parricidio non damnatur'*). (It is significant from this perspective that the extermination of the Jews was not conceived as homicide, neither by the executioners nor by the judges; rather, the judges presented it as a crime against humanity. The victorious powers tried to compensate for this lack of identity with the concession of a State identity, which itself became the source of new massacres," *The Coming Community*, trans. M. Hardt (Minneapolis: University of Minnesota Press, 1993), pp. 86-87.

64. Agamben, *Homo Sacer*, p. 83.

65. Ibid., p. 83.

66. Although the literature on this subject is endless, see G. Bataille, *The Absence of Myth: Writings on Surrealism*, trans. M. Richardson (London: Verso, 1994), in which the sacred is directly linked to terror, domination and death. As Yve-Alain Bois glosses Bataille: "the sacred is only another name for what one rejects as excremental," Y.-A. Bois and R.E. Krauss, *Formless: A User's Guide* (New York: Zone, 1997), p. 51. See also René Girard's suggestive but flawed text, *Violence and the Sacred*, trans. p. Gregory (The Johns Hopkins University Press, 1977), e.g., "The function of sacrifice is to quell violence within the community and to prevent conflicts from erupting," p. 14. To our minds, where Girard's work requires supplementation hinges on the question of the residues of that *non-sacrificial* violence that founded the community-that-sacrifices.

67. J. Conrad, *Heart of Darkness* (Harmondsworth: Penguin, 1988), p. 44.

68. M. Hardt and A. Negri, *Empire* (Cambridge: Harvard University Press, 2000), p. 110.

69. Modern medical technologies are a particularly fruitful source of new conundrums: "Three months ago, a 24-year-old South Carolina woman, Regina McKnight, was sentenced to 12 years in prison. An addict, she had used crack cocaine during pregnancy. When her baby was stillborn at 35 weeks, she was arrested and charged with homicide. The jury took just 15 minutes to come to its verdict, upholding an earlier state Supreme Court ruling that once a foetus was sufficiently developed to be able to live outside the womb it was a child, for purposes of law. Mothers could be charged with child abuse if they took harmful drugs while carrying a foetus developed to that stage; and if the baby died as a result, it was culpable murder. It was the first time a woman had been convicted of murder under the controversial law," M. Cosic, "Long before a baby is born..." *The Weekend Australian Magazine*, August 11-12, 2001, p. 35.

70. Castles *et al.*, *Mistaken Identity*, p. 16.

71. Reynolds, *The Law of the Land*, pp. 1-2.

72. Clendinnen, *True Stories*, p. 19.

73. Ibid., p. 36.

74. The concept of "kettle logic" is Sigmund Freud's. Its abiding image derives from the variety of excuses proffered by a bad borrower: "I returned the kettle undamaged, it had those holes in it when you lent it to me, and I never borrowed a kettle from you anyway": see S. Freud, *Jokes and Their Relations to the Unconscious*, trans. J. Strachey (New York: Norton Library, 1963), p. 205. What is important to note is that, if any one of these statements may be plausible and consistent in itself (although not, for that, necessarily true), *taken together they are incoherent*. For Freud, such "coherent incoherence" is of course evidence of an unconscious desire. In the case of the *bien pensant* authors we are examining here, one would have to say that their true political desire (unconscious) may well be, despite appearances, to exculpate invasion.

75. Further confirmation of this work of the "suspended law," of "law as suspension," is legible in

the Australian government's new powers to withdraw "Australia" temporarily from itself, i.e., those various little islands which will no longer be Australian if refugee boats land on them, so that those refugees cannot apply for asylum under Australian and international law. When the "crisis" is passed, of course, the islands once again become Australia(n).

76. E. Michaels, *Bad Aboriginal Art: Tradition, Media and Technological Horizons* (St. Leonards: Allen and Unwin, 1994), p. 150. Or, as Fiona Nicolls has it: "In contrast to the category 'Aboriginal culture', which is always defined *in opposition* to a dominant 'non-Aboriginal culture', the concept of 'Aboriginality' must be thought *in relation* to 'non-Aboriginality'. For it was the white settlers who lumped the various indigenous peoples under the homogenizing name of 'Aborigines', then brought into being the categories of 'Aboriginal history', 'Aboriginal culture', 'Aboriginal experience' and 'Aboriginal conditions'," "The Art of Reconciliation: Art, Aboriginality and the State," *Meanjin* 4 (1993), p. 709.

77. M. Feldblum, "Reconfiguring Citizenship in Western Europe," in Joppke, p. 233.

78. M. Salvaris, "Political Citizenship," in W. Hudson and J. Kane (eds.), *Rethinking Australian Citizenship* (Cambridge: Cambridge University Press, 2000), p. 79. "In 1948 the Commonwealth parliament passed a Nationality and Citizenship Act. This Act created for the first time the formal legal category of Australian 'citizen', replacing the earlier formal legal category of British 'subject'. The new category applied equally to indigenous and other Australians but, like that of British subject before it, was an empty vessel to which virtually no rights and obligations were attached," Nicolas Peterson and Will Sanders, "Introduction" to *Citizenship and Indigenous Australians: Changing Conceptions and Possibilities* (Cambridge: Cambridge University Press, 1998), pp. 13-14. Or, as Wayne Hudson and John Kane put it, "Federation in 1901 did not make Australia a nation-state (this was achieved only retrospectively in 1939 in the passing of the *Statute of Westminster Adoption Act* of 1942), and there is no substantive mention of citizenship in the Constitution. Until 1948 Australians had the rights of 'Britons'. Even the *Nationality and Citizenship Act* of 1948 dealt only with how aliens could become citizens, and the distinction between Australian citizens and non-citizens was not legally enacted until the 1984 amendment to that Act," in Hudson and Kane, *Rethinking Australian Citizenship*, p. 2.

79. See Hughes, *The Fatal Shore*.

80. Against such a notion, we would like to remark here Frances Ferguson's superb concept of "UNland" — a literally utopian proposal for a specific *non-national, non-sacred* territory under the jurisdiction of the United Nations, which could function as a refuge for displaced persons; such a territory would in no way be a sacred site. Personal correspondence.

81. This debate, nominally over the "fabrication of Aboriginal history," and given a decisive impetus by Keith Windschuttle's recent book with this phrase in the title, has been joined by an astonishing number and diversity of major Australian commentators, from Bain Attwood and Tony Birch through Inga Clendinnen, Germaine Greer, Robert Manne and Stuart Mcintyre to Windschuttle himself. It would now be impossible to reconstruct and represent this debate in any totalising way, prosecuted as it has been in letters, articles and editorials in all the major Australian newspapers (*The Age*, *The Sydney Morning Herald*, *The Herald/Sun*, *The Australian*, the *Financial Review*, as well as in magazines such as *The Bulletin* and local papers), in radio, television and film (taking in all the five major Australian TV channels and talkback radio), in more specialised cultural journals (*Meanjin*, *Heat*, *Overland*, *Quadrant*, *Cultural Studies Review*, *Quarterly Essay*, etc.), in various books and anthologies, as well as at writers festivals, special events, and academic forums. To our knowledge, however, the debate has been primarily prosecuted in terms of *facts* and *feelings* — the double blackmail of what passes for contemporary reason, whereby "facts" (often based on self-confessedly incomplete and ambiguous information, e.g., "how many were killed?") mutate into "values" (or, more accurately, intense expressions of personal feeling) and back again. A few commentators (notably Birch) have attempt-

ed to point out just how unsatisfactory such a debate must be when it unthinkingly restricts itself to such personnel and procedures, but they have been few and far between.

82. As Patrick Wolfe puts it, the "ethnocide" of the indigenous peoples of Australia demanded only an assault on *collective identity*, and could thus leave individuals alive...see *Settler Colonialism*, p. 11, n. 15.

83. Rutherford's *Gauche Intruder* is a valuable contribution to the field insofar as it maintains that, no matter how nice or well-meaning a white person you are, no matter how hard you are struggling to reduce the often almost-imperceptible instances of exploitation and violence against indigeneity, you will never cleanse yourself by simple *fiat* or act of will, nor through the doing of "good deeds." On the contrary. The various ethics of "sympathy," "philanthropy," "shared humanity," and so on, comprise the sacrificial kernel of the very inequalities they claim to aim at mitigating. As Slavoj Žižek puts it, "One should not forget that the notion of Mercy is strictly correlative to that of Sovereignty: only the bearer of sovereign power can dispense mercy," "Love Without Mercy," *Pli* 11 (2001), p. 197. Thus, as the seamy underlining of white Australian "mercy" and "philanthropy," we find conditions denounced by every great Romantic writer from William Blake ("Pity would be no more/If we did not make somebody poor") to Samuel Beckett ("To those who have nothing it is forbidden not to relish filth").

84. See D.J. Tacey, *Edge of the sacred: transformation in Australia* (Melbourne: Harper Collins, 1995) and *Re-enchantment: the new Australian spirituality* (Sydney: Harper Collins, 2000). As he writes in the latter volume, "In the encounter between Europeans and Aboriginals...Aboriginal society will be changed forever by advanced technology, while European Australia will be constantly reminded of its own spiritual impoverishment and lack of soul," p. 42. What "advanced technology" and "spiritual impoverishment" can possibly mean in this context is either irremediably obscure or utterly vapid.

85. P. Read, "Whose Citizens? Whose Country?" in *Citizenship and Indigenous Australians*, p. 170.

86. The *only* exception to this rule is the notorious Myall Creek Massacre of 1838, in which approximately twenty-eight Aborigines were slaughtered by squatters, and for which seven white men were subsequently tried and hung. This "result" is inevitably invoked by conservatives when speaking of the Law's own "innocence" in regards to the destruction of the Aboriginal people. But this is no defence, as they say; one central lesson of recent theorizations of the Law is the recognition that the Law works *precisely through its own division/divisiveness*. It is the motivated inconsistency or incoherence of the Law's interpellations that forces a split of and in its subjects. As Søren Kierkegaard puts it in *Repetition*: "The exception explains the general and itself. And if one wants to study the general correctly, one only needs to look around for a true exception....The exception thinks the general with intense passion." Or — because Australian intellectual life is founded on a passionate repudiation of thought — some facts: "So far as I can tell Myall Creek was the only occasion during the entire history of the nineteenth-century frontier massacres when perpetrators were found guilty of murder. In a small number of other cases massacres were investigated but legal proceedings dropped. In an even smaller number, Europeans were brought to trial but either found not guilty or guilty of less serious offences, like causing grievous bodily harm. In the overwhelming majority of cases where Aborigines were massacred no official investigation took place," Manne, "In Denial," p. 61. See also p. 96. As for the Battle of Pinjara (1834), Waterloo Creek (1837) to Coniston Station and Forrest River well into the twentieth century...

87. In a different but related context Tom Griffiths has noted that, in Australia, "Another form of neutralising the past was the constant *yearning for sacrifice*, for the cleansing experience of fire on a national scale," "Past Silences," p. 20. Our emphasis.

88. As Helen Pringle puts it in her article "The Making of an Australian Civic Identity: The Bodies of Men and the Memory of War," "the modern loss of a substantive moral basis for 'the

autonomous dignity of the polity' goes hand in hand with a re-eroticisation of the bonds of combat...this eroticisation of combat is in fact wholly congruent with liberalism in the sense of providing it with the thickness of a civic identity whose very disappearance it had created, but which it continually laments," Stokes, p. 95. Extending this claim a little, we could say that it is the melancholic eroticism of mateship that effects the transition between kinship and state in the Australian context (or between private and public, *Gemeinschaft* and *Gesellschaft*, etc.). Inglis also implicitly makes this point in *Sacred Places*. Although there are certainly instances in Australia of non-Statist and sometimes anti-Statist individuals and communities erecting memorials to the dead (e.g., the miners killed at Eureka or the Jews who died during the Holocaust), Inglis constantly reminds his readers that, "like all such cemeteries and memorials elsewhere in the empire after 1918, those in Australia were created and maintained by the Commonwealth (formerly Imperial) War Graves Commission," p. 351. Since we are speaking here of "sublimation," it is symptomatic that the drinking-fountain became a worthy memorial: the blood of the dead usefully sublimated into the water of life — all the more significant given the celebrated "dryness" of the Australian continent.

89. Inglis, again: "Since pillars and inscriptions were not in their culture, Aborigines raised no legible monuments to either their own traditional civil wars or their resistance against invaders. It is more remarkable, since Europeans do build monuments, that the newcomers so seldom commemorated conflicts between black and white...Officially, by rules written at desks in Westminster, conflict with Aborigines was never warfare, whether the guns were fired by agents of the crown (policemen, soldiers) or by private citizens (squatters, stockmen, farmers); for the lands of Australia were deemed to belong to the British crown and were occupied entirely by British subjects," p. 21. One should also mention here the vitriolic frenzy that erupted after Sir William Deane's suggestion of a monument to the Aboriginal victims of the frontier massacres. As Ravi de Costa remarks, "The warrior-citizen narrative presents a great paradox for the nations of the New World. First peoples of what is now Australian territory are not included in the military story of the nation; they could not be, for they were always the undeclared enemy, living at the margins of settler society as it pushed relentlessly outward. So the only battles over this continent, its sovereignty and identity, are not commemorated in any systematic way," *Southern Review*, 33.1 (2000), p. 7.

90. Women, it goes without saying, are not "mates" — unless, of course, their sexual difference is absolutely repressed to the point that they too are permitted to masquerade as men and thus as potential killers of men. The problem posed by femininity to political community (Hegel once spoke of women as "the eternal irony of community") is thus exceptionally pronounced in the realm of sacrifice; women, it seems, must be forced to be spectator-victims in the theatre of fraternal community war (Pringle makes a similar point, p. 100). On the other hand, when women do become actors, the situation is not necessarily improved. As Judith Butler remarks in the course of a reinterpretation of Sophocles' *Antigone*, when women do become actors in state conflicts, they necessarily enter a zone of irreducible ambiguity. After all, Antigone "asserts herself through appropriating the voice of the other, the one to whom she is opposed; thus her autonomy is gained through the appropriation of the authoritative voice of the one she resists, an appropriation that has within it traces of a simultaneous refusal and assimilation of that very authority," *Antigone's Claim: Kinship Between Life and Death* (New York: Columbia University Press, 2000), p. 11. See also C. Clément and J. Kristeva, *The Feminine and the Sacred*, trans. J.M. Todd (New York: Columbia University Press, 2001), and F. Devlin-Glass and L. McCredden (eds.), *Feminist Poetics of the Sacred: Creative Suspicions* (Oxford: OUP, 2001). Where both these texts go astray, however, is in their extraordinarily nebulous invocations of "the sacred" as essentially synonymous with a vaporous if not vapid "spirituality."

91. Reynolds, *Sunday Special*, p. 42. The character continues: "As for the much-lauded Mateship,

her anecdotal research showed conclusively that the word 'mate' could be used to mean anything from 'you bastard' to 'old, dear friend and accomplice'. She supposed that even the Australians had no idea of who was and wasn't a mate, or why it was such a cornerstone of Australian culture, in as much as said culture existed at all," p. 42.

92. "In the face of horror and pity, which where it necessarily ends up, there would be no war without a war-like momentum of the imaginary. Its spectacle is inextricably bound up with the sometimes stupefying, mechanical constraint that makes the soldier march on. The psychologists of the American army took pleasure in explaining (on television) that the *boys* do not march for a cause, for right or democracy, but only so as not to give up in front of their companions. That is, what drives honor and glory already belongs to the order of the 'spectacle', and it cannot be dismantled by the simple denunciation of a modern age in which simulation is generalized and commodified," Nancy, p. 113. For more on the poetic ironies of the proposed preamble, see J. Clemens, "Review of Christopher Kelen's *Republics*" in *Meanjin*, vol. 59, no. 2 (2000), pp. 196-199.

93. For an interesting historical account of representations of children in Australian culture, see P. Pierce, *The Country of Lost Children: An Australian Anxiety* (Cambridge: CUP, 1999).

94. S. Beckett, *How It Is*, trans. S. Beckett (London: Calder, 1964), p. 156.

Conclusion

1. Leo Bersani. *The Freudian Body: Psychoanalysis and Art* (New York: Columbia University Press, 1986), p. 27.

2. In *Exotic Parodies: Subjectivity in Adorno, Said, and Spivak* (Minneapolis: University of Minnesota Press, 1995), Asha Varadharajan writes: "If the subject was never whole and undivided, was the object never powerless, traduced, and excluded? Whom shall the object hold accountable for its suffering? ... [Particularly when] the object in question is the feminine and ethnic other of the discourse of Western patriarchy and Empire," pp. 20-21.

3. Hermann Broch, *The Anarchist* (London: Penguin, 2000), p. 135.

4. See K. Silverman's "The Language of Things," in *World Spectators* (Stanford: Stanford University Press, 2000), in which she perceptively discusses Arendt, in order to claim that: "Our subjectivity is objectively intended," p. 133.

5. See Heidegger's "The Turning," in *The Question Concerning Technology and Other Essays*, trans. William Lovitt (New York: Harper Torchbooks, 1977), p. 45. And to quote Broch once more: "[T]his view of everything as the 'product of a product' guarantees the presence of the intelligible self in every object throughout the world ... [which] amounts to a kind of animism that reanimates the whole of nature, nay, the whole of the world in its totality, an animism that introduces a value-subject into everything ..." p. 224. Clearly, this is not the conclusion we wish to reach here (or anywhere else, for that matter), since it smacks of a delusional repentance from the brutal events of the twentieth century, and can lead to the perverse neo-humanist *deus-ex-utopia* offered by Houellebecq at the end of his novel *Les particules élémentaires*.

6. In this we are in sympathy with Thomas Elsaesser's call for a reconsideration of the term "immediacy," free from knee-jerk assumptions that everything is always already mediated: a once useful corrective which has perhaps now reached its use-by date, at the dawn of nanotechnology, and the consolidation of intramediality.

Index